The Unilever Series

Tate Publishing

Rachel Whiteread

EMBANKMENT

with contributions by
Catherine Wood and Gordon Burn

CONTENTS

SPONSOR'S FOREWORD

It is an enormous source of pride for us all at Unilever that for the last six years we have been able to play a part in bringing some of the world's greatest artists to the cavernous space of Tate Modern's Turbine Hall. Millions of people from the UK and beyond have been able to see, hear and touch vast installations.

This year we are delighted to welcome the Turner Prize winning artist Rachel Whiteread, who has brought her own challenging perspective to the Turbine Hall. Like all great artists Whiteread invites us to see the world differently. Through her use of casts she reveals what is hidden within, what lies beneath the surface of everyday objects, and prompts us to see the extraordinary in the ordinary.

This is an exploration that resonates deeply within Unilever. Our business is built on trying to better understand the everyday needs, desires and aspirations of people. It is a relentless quest for insight, where success is dependent on understanding what lies beneath the exteriors of people's lives.

As a founder sponsor of Tate Modern, Unilever is proud to have helped make inspirational contemporary art accessible to so many people. We hope you will be enriched by Rachel Whiteread's work.

Patrick Cescau
Group Chief Executive, Unilever plc

DIRECTOR'S FOREWORD

Now in its sixth year, Tate Modern's Unilever Series of commissions for the Turbine Hall has seen a succession of outstanding projects by leading international artists. Collective memory of the dramatic changes that have taken place between Louise Bourgeois's sculptures *I Do, I Undo, I Redo* and Bruce Nauman's sound installation, *Raw Materials*, last year, means that the nature and scale of the challenge the vast space presents increases year upon year. We were delighted to be able to invite Rachel Whiteread, one of Britain's leading sculptors, to be the next artist in the Series. It is testament to Rachel's extraordinary vision and integrity that she has created a piece that is entirely new for the space – exceeding even the monumental scale of her grand public works such as her celebrated early work *House* 1993 (destroyed 1994) or the Holocaust memorial in Vienna, completed in 2000 – and yet stays true to the intimate nature of her practice.

EMBANKMENT is a sculptural installation that cannot be taken in quickly, cannot be captured in a photograph. It truly needs to be experienced, to be explored on ground level as well as being viewed at different angles from the different heights of Tate Modern's concourses and from the bridge. To build the piece in situ was a giant feat of vision and organisation on the part of the artist, in collaboration with the Tate team. This publication was conceived by Rachel as a kind of 'artist's book', as a visual record of her rich sources of reference in the form of found images, her own and specially commissioned photographs and snippets of text, alongside the curator's essay and Gordon Burn's interview.

In creating *EMBANKMENT*, Rachel has worked closely with Sheena Wagstaff, Chief Curator, who

initiated the project, and Catherine Wood, Curator, who continued those discussions and wrote the catalogue essay. Phil Monk has worked with Rachel on the fabrication of the piece, and adroitly managed his team during the complex and time-pressured installation. Stephen Mellor provided essential support with technical calculations in the early stages of its inception. Steve Faulkener, Mark McKown and Mary Taylor have all worked with professionalism and dedication to help Rachel realise the piece.

Many thanks go to Larry Gagosian for his support of the project. Thanks also to Cristina Colomar at Gagosian Gallery, London, who has facilitated essential liaison with the artist. Rachel's studio team, especially Hazel Willis and Phil Brown, have been invaluable in ensuring that many aspects of the project have run smoothly and to the artist's satisfaction.

We would also like to thank everybody who contributed to the publication, in particular, Philip Lewis for his sensitivity to the project in designing the book so beautifully; Gordon Burn for his probing and insightful interview with Rachel, Marcus Leith and Andrew Dunkley for their enthusiasm and skill in the photographic project, as well as the installation documentation, Alessandra Serri and Lillian Davies for their creative and organised approach to the picture research, Michaela Weiss for compiling the biography and bibliography, Sarah Tucker for her calm efficiency in managing the production processes, and Judith Severne for bringing all of these aspects together in editing the catalogue.

The project could not have been realised without the collaboration of many different departments within Tate. Thanks go to Nadine Thompson and Ruth Findlay in the Press department, Jane Burton, Stuart Comer and Dominic Willsdon in Interpretation and Education, Caroline Priest and Emma Clifton in Marketing and Communications, and Hector Pottie of Cartlidge Levene for the intelligent design of the educational and marketing materials. Thanks also to Amanda Cropper and Sarah Howell in the Development department, Brad Macdonald, Emily Paget and Billie Lindsay in the Director's Office, Jemima Rellie and Sarah Tinsley in Digital Programmes, and Dennis Ahern, Brian Gray and Adrian Hardwicke, as well as to Wilson James for logistical support on the project, at Tate Modern.

Finally, we would like to thank Unilever, and its Group Chief Executive Patrick Cescau, for continuing to provide essential support for this ambitious and increasingly visible aspect of our programme. This commitment to Tate Modern was established by Unilever in 2000. Their vision helped bring the unique contributions of the artists commissioned in the first five years of The Unilever Series to a vast, diverse public. The Turbine Hall offers an exhibition space like no other and without Unilever's great contribution it would not be possible to invite artists to respond to its unique challenge.

Vicente Todolí
Director, Tate Modern

STORAGE, CONTAINER, BOX,
CARGO, ARK, PILE, CRATE
SPACE, VOLUME, HEIGHT,
WIDTH, DEPTH, PILE,
MASS, LOST, MEANDERING
BELONGINGS, RUBBISH,
HEIRLOOMS, ARCHIVE,
FILL, OVERWHELM,
STACK, REPEAT, BUILD,
SPREAD, FREIGHT, BOXES,
HEAP, PROPERTY, STUFF,

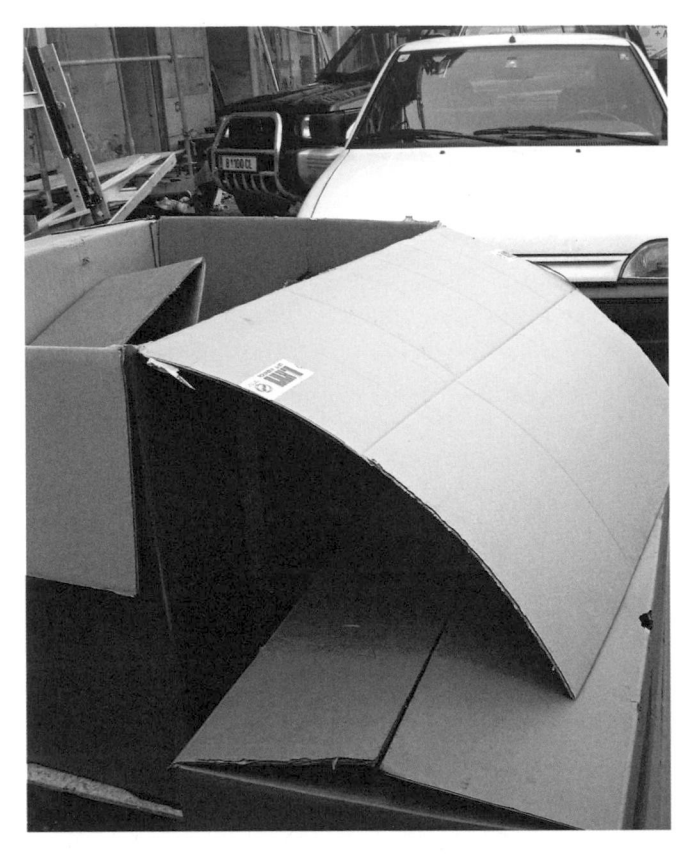

CARTONS

PROPERTIES

Materials	Recyclable cardboard
Features	Flat-packed for easy assembly
Dimensions	Choice of 6 medium and 3 heavy-duty sizes
Supplier	Key Industrial & Commercial Equipment
Function	Heavy-duty cartons for international freight
Rethink	Partition blocks

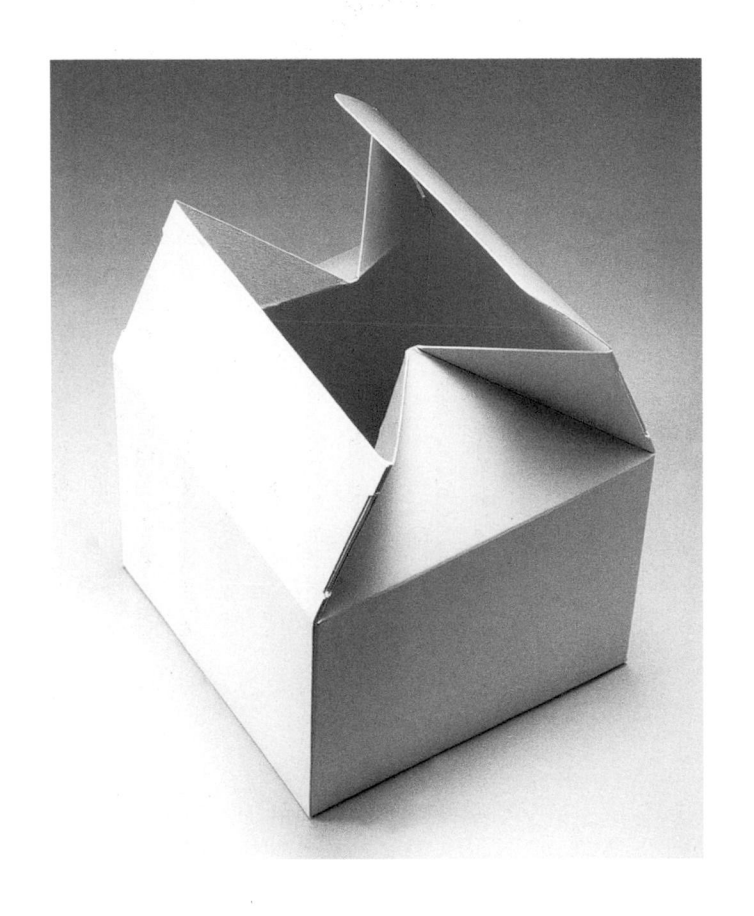

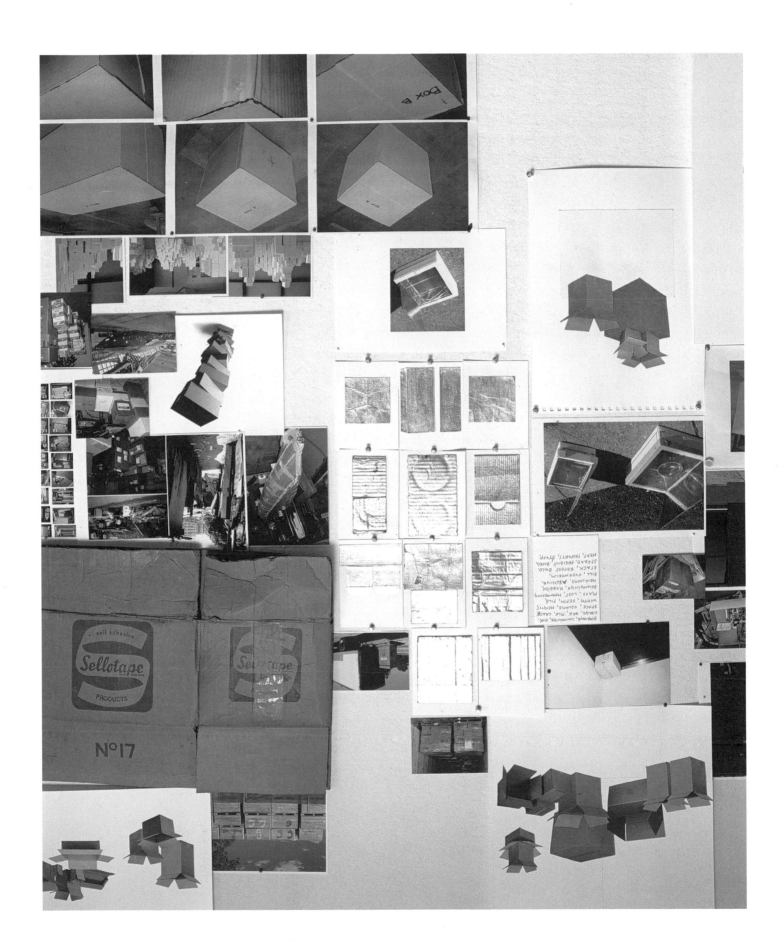

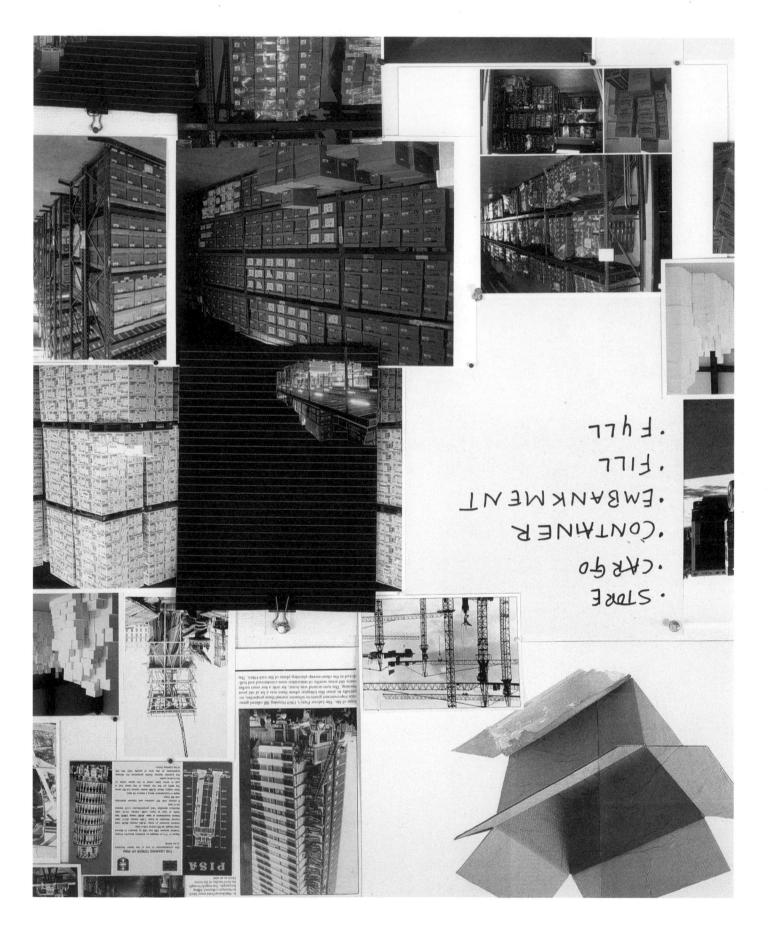

· STORE
· CARGO
· CONTAINER
· EMBANKMENT
· FILL
· FULL

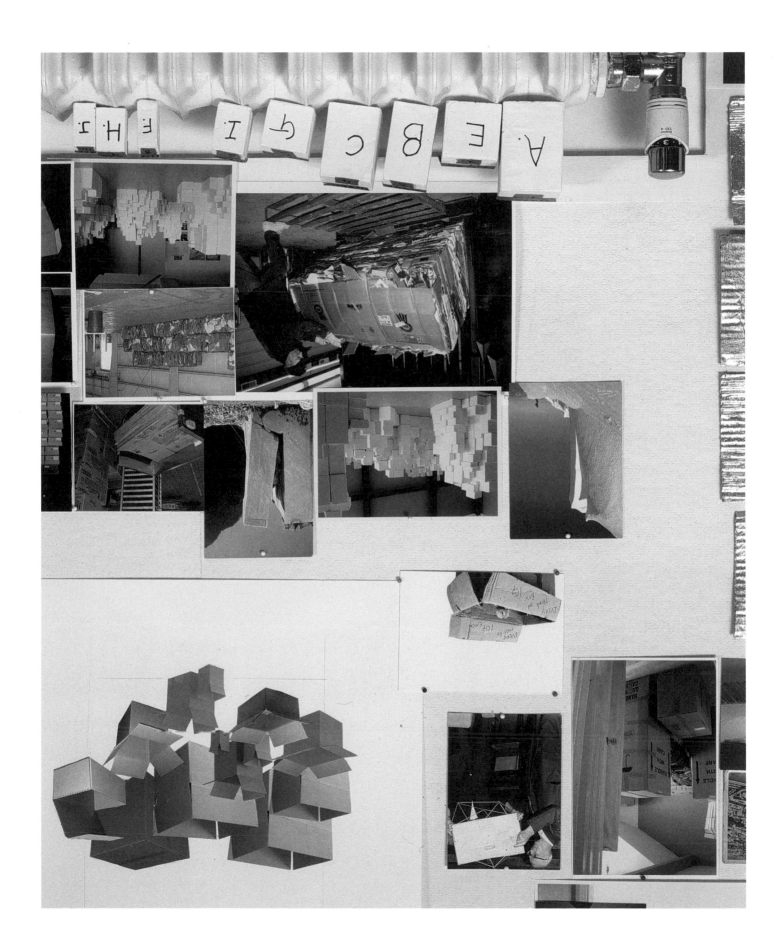

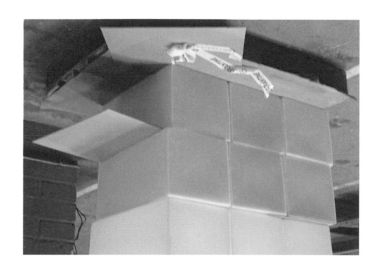

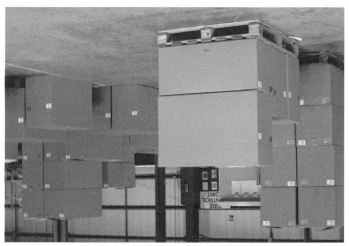

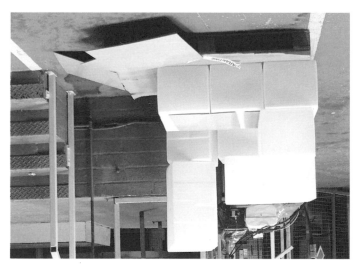

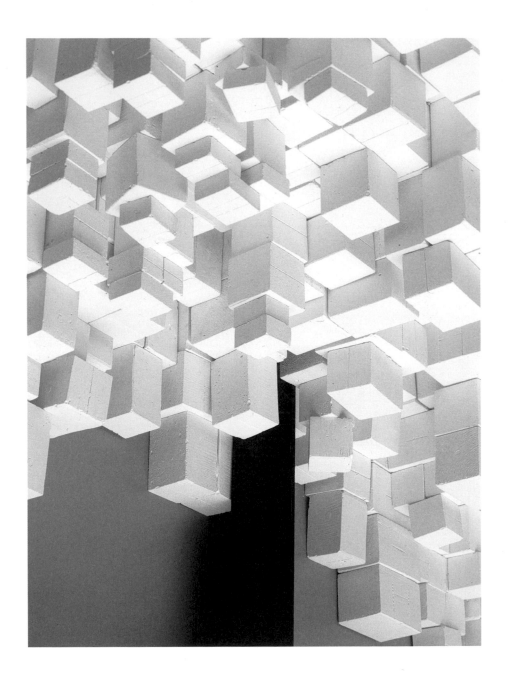

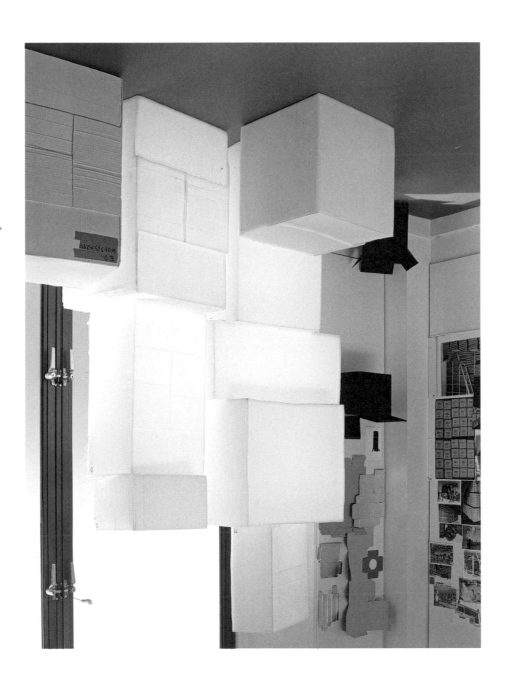

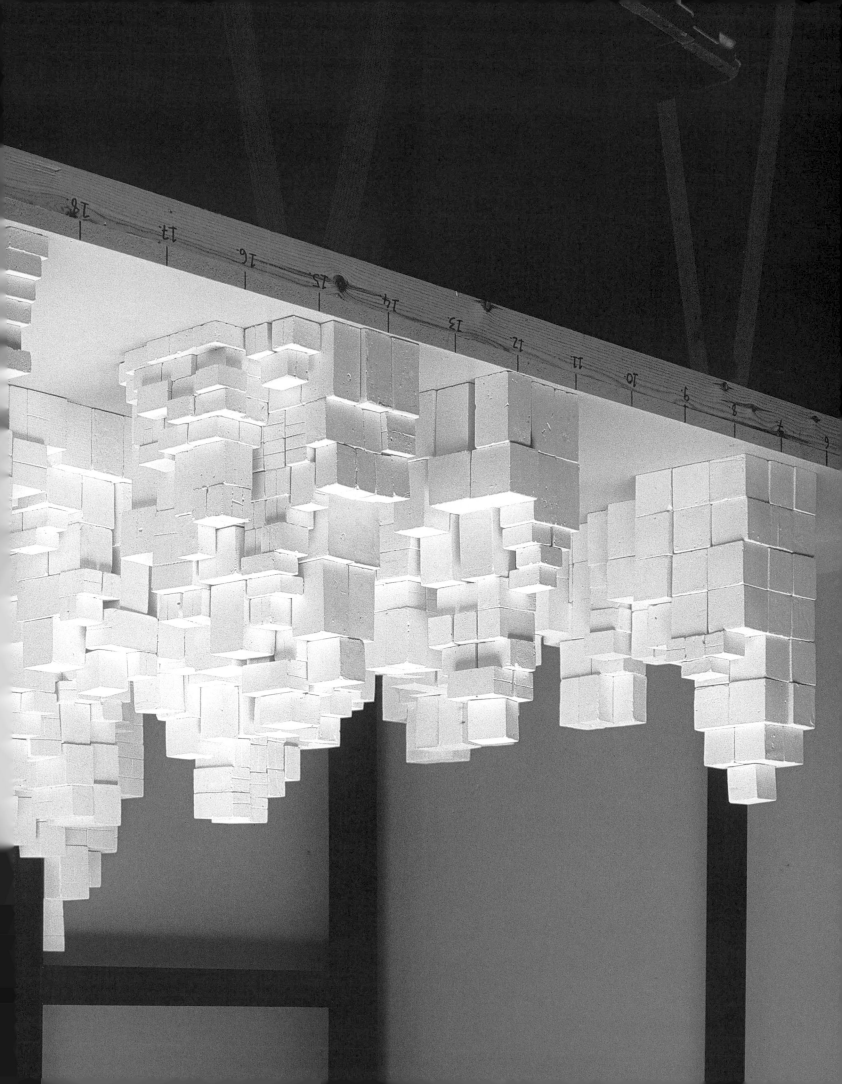

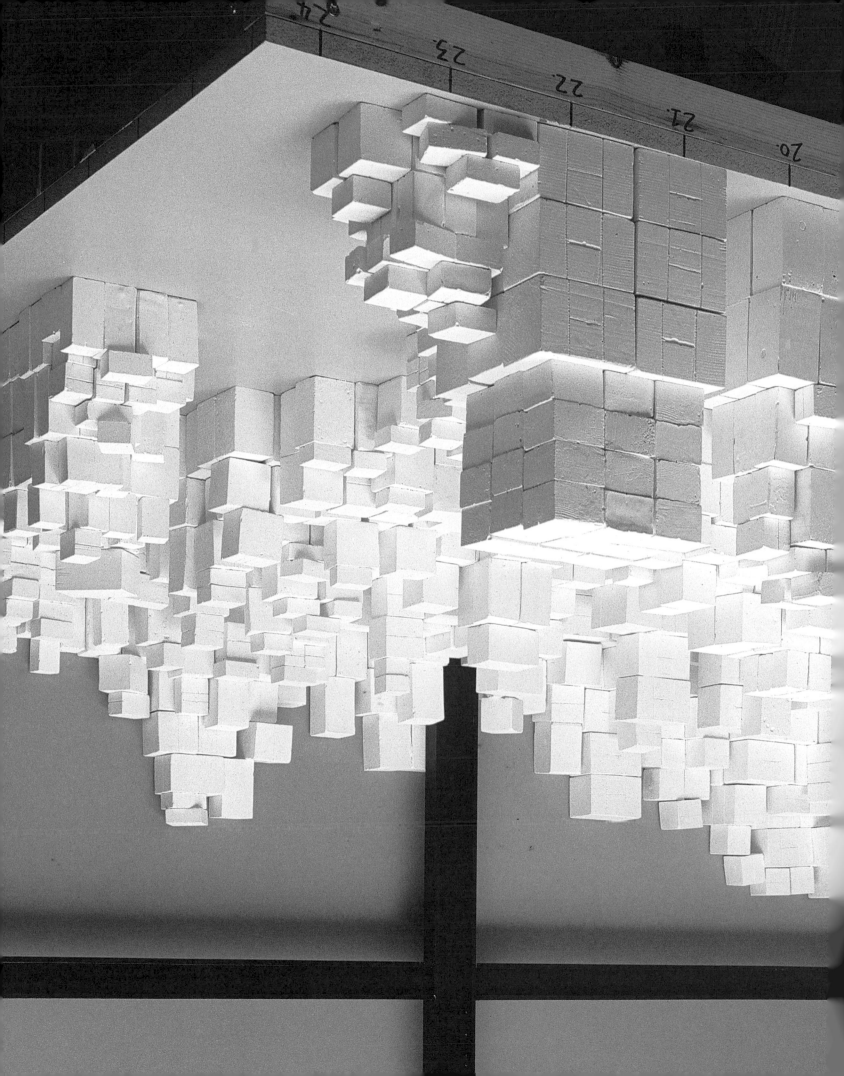

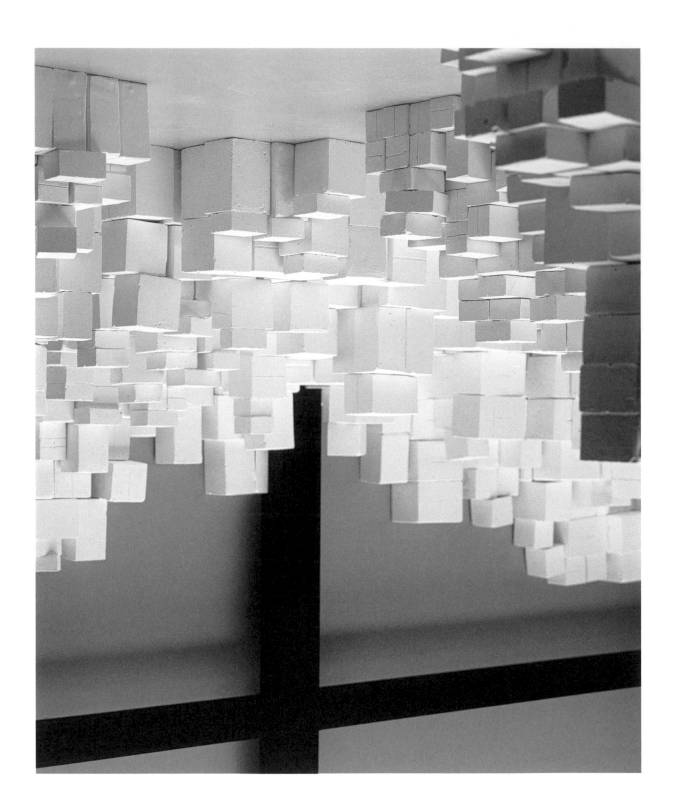

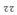

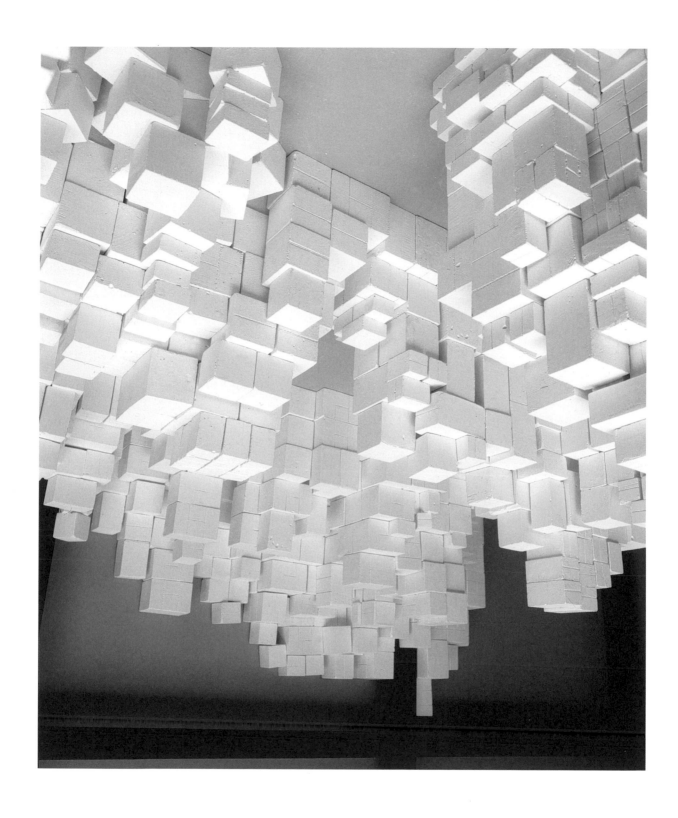

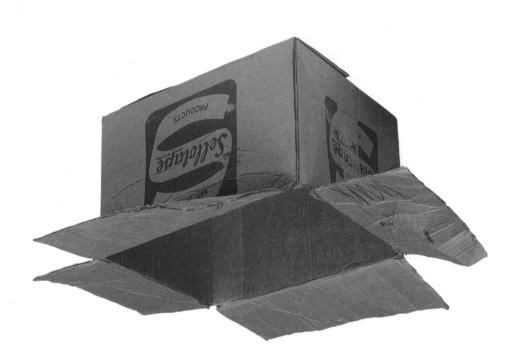

EMBANKMENT

Catherine Wood

BOX

A small cardboard box, once used to pack rolls of Sellotape, was the modest starting point for Rachel Whiteread's Turbine Hall project. The box, recently rediscovered by the artist when she was sorting through the contents of her late mother's house, had been part of her domestic environment since she was a child. Whiteread remembers it from as long ago as when she was five years old. It had been used to store her things, and its small size makes it charmingly perfect for such a function. It was kept in her toy cupboard next to piles of other boxes full of jigsaw puzzles, Cluedo and Monopoly. Through time, its printed blue logo, designed with a tape-like 'S', has become dulled and dated; its once rigid sides have collapsed slightly, dented and softened by a lifetime of being filled and emptied and moved around. It bears scars from the application and removal of packing tape used to seal in its contents. Traces of its particular history are visible in other ways too: the name 'Ivy' is written in pencil on one flap, while a child's drawing – Whiteread's own? – has been made in yellow felt-tip pen on another. For Whiteread, it was especially poignant to regain possession of this ephemeral object after more than thirty-five years, and she has spoken of how, when opening it after so long, it contained inside it the smell of her family home.

Whiteread began to think in sculptural terms about this box, and the other boxes that she was using to pack her things as she moved house. At the same time, she was preoccupied with an image from a film: the final scene in Stephen Spielberg's blockbuster *Raiders of the Lost Ark* (1981), when the elusive Ark is lowered into a crate, which is sealed, first with nails, then with a padlock, and stamped 'Top Secret'. A workman pushes the crate on a trolley into a warehouse. As the camera pans back, the vast extent of the space, full of identical crates, becomes visible. It is panoramically wide and infinitely receding. Whiteread was fascinated by the way in which the arrangement of crates gave the impression of a cubic division of the huge interior space, created using a cleverly edited segue from real scenery to a painted image. The spectacular scene conjures an image not simply of breathtaking physical scale, but of infinite mystery. Packed up, the ornate gold container appears anonymous amongst so many other identical crates, leading the viewer to wonder about all the latent secrets locked away in the rest of the boxes, hinting at an infinity of untold narratives.

The scene's significance, and the film's narrative, hinge upon the potency of the spiritual force contained inside the Ark. The concept of the box, to which both the Ark and its wooden crate refer, is rich in such mythological and cultural associations. As a shape, it is equivalent to one of Plato's 'Solids', the hexahedron or cube that might serve as an essential unit of form with which to build volume in space. In terms of its function, the Greek legend of Pandora's Box tells of its capacity to contain malevolent power, and boxes of all shapes and sizes feature in literature and film to represent the keeping of a secret, of storing or hiding personal possessions, from the rude surprise of the jack-in-the-box to the 'box of delights' or the chest of hidden treasure. At the same time, the box is familiar to most people as a temporary container for transporting or storing things, from groceries brought home from the supermarket to personal items hoarded in the loft or packed up and hastily labelled when moving house.

Whiteread began to create the foundation of her project by simply making plaster casts of the inside of found cardboard boxes. As her vision for the Turbine Hall project grew, she selected a number of differently sized examples with which to work, each having a different 'character' in the form of dents or functional marks. With these boxes she discovered the equivalent of a set of building blocks, each differentiated by its unique sculptural qualities, and at the same time a set of loaded objects that speak of narrative and personal history. By filling each box with plaster and peeling away its exterior shell to reveal a solid impression of its empty interior, Whiteread connects up sculpture's two essential features: form and content. So successful is the box in balancing these characteristics that the individual cast becomes a kind of materially mani-fested pun, and yet the cast form exists as a piece of sculpture anchored to a real referent. In order to realise the production of these units on a scale that would inhabit the Turbine Hall, approximately 14,000 boxes have been mass-produced in polyethylene by a manu-facturer of bottles and plastic goods. The resulting cubic shapes are in fact repeatable 'skins' taken from the solid cast interiors. The industrial material renders the shape frostily translucent instead of giving it the dense solidity of the original plaster. In these hollow reiterations of the cast object, the artist pushes beyond the idea of the box as a container, representing it instead as a solid membrane on a contained space; an object that captures a pure state of primary and semi-visible emptiness.

MORE BOXES

In 1980, the sculptor Edward Allington, made a series of plaster casts titled *Ideal Standard Forms*, after Plato's Solids. First he smeared plaster over clay models shaped into a cone, a ball, a cube, a half-round; then he dug the clay out so that only the crude plaster moulds were left. By destroying the original clay shapes but keeping the moulds, he raised questions regarding

'pure shape' and complicated the differentiation between the authentic and the copy.[1] It was Allington who taught Whiteread how to make plaster casts when he was her tutor at Brighton Polytechnic. Whiteread pushes this idea of the contingent nature of the 'platonic' shape further by using the found cardboard boxes as 'readymade' cubic shapes. They have a different kind of generic quality from the mathematical cube, but an almost universally understood function and form nevertheless. Her box suggests interior and exterior simultaneously, but unlike, say, Donald Judd's *Untitled* 1965, a red fluorescent Plexiglas box, it is not concerned with flaunting the process of its construction. The history of Whiteread's readymade form is revealed in the variety of indexical indenta-tions in its shape. Petrified as protrusions into the surfaces of her boxes are the circular indentations made by the beer bottles they once contained, the crumpling of a bashed corner join or the raised impression of oval carrying handles cut into the toughened, thickly grooved sides.

Alongside works by Judd like the Plexiglas box mentioned above, there are many iconic examples of artworks using the box or cube as a sculptural form or container, including Marcel Duchamp's editions such as *Green Box* 1935, containing an un-ordered array of personal notes and images relating to his sculptural objects. Boxes were the basis of the rectangular, grey-painted plywood constructions of Robert Morris from the 1960s, like *Column* 1961 or *Mirror Cubes* 1965–71. Such was the importance of the cubic form for Minimalism that Carl Andre wrote of his peers:

> It is curious that of the group, I'm . . . the only person who's never done boxes. My work has always been solid . . . You see a box is fundamentally structural and it just turned me entirely away from the structural. In a sense I suppose that Bob Morris's boxy things are the quintessence of the structural. They're the perfect platonic polyhedra.[2]

In this observation, Andre touches upon an impor-tant defining principle of Whiteread's work, as it is

distinguished from Minimalist sculpture. For Whiteread invests the shape with much more significance than simply being a structural foundation. In making each box from a real cardboard original, she treats every unit as a linguistic sign capable of poetic evocation, bringing with it a great deal of narrative or personal content, which Minimalism repressed. Three other art-historical works have particular resonance in to Whiteread's use of the box form. With *Corner of Fat in a Cardboard Box* 1963, Joseph Beuys lent the cardboard box an uncanny, anthropomorphic quality as a kind of 'skin' by placing a lump of fat in one internal corner, creating the suggestion of a soft and animal interior – a deposit that does not fill, but rather, changes the nature of the container. Andy Warhol's *Brillo Boxes* 1964, conversely, distract us from any sense of interior content, and even from their square shape, by being made of screen-printed plywood, which renders them unopenable and flaunts their surface as images equivalent to his screenprints. Paul Thek brought these two ideas into tension in his collaboration with Warhol titled *Meat Piece with Warhol Brillo Box* 1965: a waxy, graphic simulation of a piece of flesh placed inside a signature Brillo box that becomes a kind of vitrine. The grotesque meat slab appears very much at odds with the box's shiny, brightly logo-ed surface. Mike Kelley wrote of this piece that the unlikely pairing of these artists was the result of 'the strange parasitic relationship both of them have to the hard-edge aesthetic prevalent at the time'. 'Thek's Plexiglas boxes', he continued, 'reduce the minimalist aesthetic to display cases, while Warhol's boxes reduce it to commodities'.[3] In making an impression of the *inside* surface information of the original on the white, internal cast, Whiteread's choice and treatment of the box form differs from Warhol's treatment of his *Brillo Boxes* as external surface images. Though Whiteread's boxes convey an uncanny sense of disquiet about what might have been in them, she pulls back from the implicit anthropomorphism of Beuys, and further back still from the explicit horror of Thek's lump of flesh. Her cast boxes

transcend the deliberate crudeness of Thek's collision between artistic perspectives, but they do have something in common with it in terms of the way in which her translucent casts set form and unknown content in dynamic tension. Combining Minimalist structure with Pop specificity,[4] Whiteread treats the cast cardboard box as a unit that drags individualistic inflection and specific history with it. Yet as multiple forms stacked together, the sharpness of the blocks' edges melts into an impression of structured white mass more akin to hewn hunks of ice. The whiteness of these units of captured space – the empty interior of the box and all that it connotes – have an otherworldly quality. Through these straightforwardly and synthetically made objects, the installation somehow manifests on a grand scale the secret nature of the box's insides.

WAREHOUSE

Whiteread has always been fascinated by making in-between spaces visible. She has taken casts from pieces of furniture, such as the undersides of chairs or the interiors of baths, as well as from architecture, in the form of plaster 'ghosts', solid impressions of the space contained in rooms, fireplaces and staircases. These casts represent an investigation into how ordinary objects occupy space in relation to their surroundings, the way in which they capture or contain space and render it inert. As positive impressions of these negative spaces, or perhaps negative (i.e. impenetrable) actualisations of positive (i.e. clear) space, Whiteread's works – her casts of baths, mattresses and mortuary slabs, for example – have often obliquely referenced or created abstract equivalents for the human body. In the materials and serial repetitions of her objects, she references the 'primary structures' of Minimalist sculpture such as Judd's boxes, the bricks and floor works of Carl Andre or the serial grid structures of Sol LeWitt. But she has complicated Minimalism's investigation of blank

forms derived from mathematical systems by also drawing on the sensibility of the post-Minimalist sculptor Eva Hesse, whose open forms made in latex and resin often appear translucent and on the brink of collapse. Hesse's works such as *Accession II* 1967, for example, a steel cube containing a writhing mass of rubber tubing, make reference to the relationship between the inside and outside of the body.

Primary Structures of 1966 was the first exhibition to present artists including Andre, Judd, LeWitt and Morris as a coherent movement.[5] Writing on the work of the American Minimalist sculptor Walter de Maria, whose work was also included in this show, the avant-garde filmmaker Jack Smith attributed his enjoyment of the formal qualities of the work to the fact that the artist had based it on the simple shape of the box: 'What is this work of Walter de Maria's that places him so firmly on the side of structure? The principle is as simple as the box, in fact it is the box. His first sculptures were just that – bafflingly simple boxes.'[6] De Maria's sculpture was successful, he believed, because there is an almost universal human relationship to the pleasing form of the box. Smith continues: 'I would make a guess of intuition that he has been building his principles since about the age of six. I remember there was a time in my boyhood when boxes – at first wooden, then cardboard, meant all to me. I lived to crawl into boxes – very large clean cardboard boxes being the most glorious.'[7]

The work of these Minimalist artists is now on permanent display inside the vast reclaimed spaces of the Dia:Beacon in New York State. Reporting on the museum's inauguration in 2002, Suzaan Boettger described the institution as 'the conversion of a voluminous 1929 factory along the Hudson River ... (where Nabisco's cardboard cracker boxes were once printed and assembled) into vast exhibition spaces for its collection of large, abstract works from the 1960s (a return of the box, this time crafted of durable, industrial materials and called Minimalist sculpture).'[8] In this description, she makes passing allusion to the relationship between the building's industrial past

and its suitability as a space within which to show this kind of sculpture. Considered from a formal point of view, the example of Dia:Beacon, and the history of Minimalist artists making and exhibiting work in reclaimed industrial spaces, underwrites Whiteread's use of the box and her approach to the Turbine Hall. Industrial spaces were intimately connected to the work of artists shown at Dia – from their studio spaces, to the kinds of materials that built the city of New York and which featured in their work: steel, brick, slate, concrete. Similarly, Whiteread was familiar with an art scene in the UK that paralleled this practice, showing early on at the raw, reclaimed Chisenhale Gallery, for example.[9]

Minimalist and post-Minimalist forms existed conceptually in an abstracted phenomenological space that suited the abstracted nature of spectatorship inside the 'white cube' gallery. Whiteread's works, by contrast, carry their originating context with them, transposing the spectator's memory of the scale and nature of domestic objects and spaces into the gallery in a defamiliarised state. They mine what has been seen by Jack Smith and others as an implicit figurative subtext to Minimalism, in a sense restoring a representational or personal history to its generic forms. With the box, Whiteread finds a formal unit that represents a transfer of her own history into the museum, as well as referring back obliquely to the generic history of Tate Modern's past life, its original industrial function.

In her critical appraisal 'The Cultural Logic of the Late Capitalist Museum',[10] Rosalind Krauss points out what she sees as an internal contradiction within the field of Minimalist sculpture. On the one hand, artists labelled as Minimalist were concerned with the idea of prioritising the primary encounter with the object, drawing on the phenomenological theory – which described the contingency of body-centred perception – of Maurice Merleau-Ponty.[11] According to Krauss, the Minimalists believed that such a concentration on primary experience could become a 'form of resistance to mass culture',[12] in terms of its opposition to a

concentration on pure opticality and image. But, she argues, Minimalism's principles of seriality, of deadpan refabrication, 'let the world of late capitalist production right back in'.[13] For, she continues, 'the serial principle seals the object away from any condition that could possibly be thought to be original and consigns it to a world of simulation, of multiples without originals', so that in the end, 'Minimalism carries the codes of that which it wishes to attack'.[14] She sets this observation in the context of the increasingly 'generalised universal industrialisation' that 'now penetrate[s] all sectors of social life', a 'mechanisation, standardisation, over-specialisation and parcellation of labour' that even extends as far as leisure activities and aesthetic experience.[15] The new art museums being born in the high capitalist era of the 1980s, for example, which reclaim vast industrial interiors and in her eyes demand spectacular art, are taking on the 'simulacral experience' characteristic of Disneyland. For Krauss, Minimalism's mass-produced seriality becomes problematically convenient in this sense.

In the past, Whiteread has worked on projects both of very large and very small scale – from her casts of light switches shown at Anthony D'Offay gallery in 1999 to the full-size resin cast of a water tower on the skyline of New York, or the Holocaust memorial in Vienna's Judenplatz. The Turbine Hall space is unique, however, in being an indoor venue that has the physical properties and vastness of an outdoor one. In making this piece, Whiteread wanted to forge some kind of co-existence between the spectacular experience of its huge interior and the intimacy and simplicity of her very earliest attempts at casting, the fundamentals of her practice: the wardrobe or the chair.

Her previous sculptures literally carried the authentic traces of the objects or spaces from which they were cast. Striations and cracks in the smooth plaster surface of *Ghost* 1990, for example, seem to carry dusty fragments of the original room, while splinters can be imagined to remain in the grooves of wood grain in *Untitled (Amber Floor)* 1993. As casts of casts, the thousands of Turbine Hall pieces appear as an excess of phantom replicas, repetitions of the solid, cast originals that were taken from individual boxes. Here, the object is transformed into a double after-image of itself, impossibly multiplied, hovering between materiality and immateriality in its partial translucence. Going one step beyond the literal relationship between an object and its cast, the mass-produced proliferation of boxes manifests itself as a juddering repetition, like a dream or nightmare of overproduction, where a ghostly presence is suddenly impossibly multiplied to surround the dreamer. The installation does not have the restrained logic of mathematically derived seriality; it has an almost out-of-control quality, with masses of objects stacked, piled, loaded up in the space in different ways. Appearing as a spectral apparition, the installation is given its emotional weight, its power, by the fact that – unlike the generically fabricated Minimalist sculpture that Krauss describes – it is nevertheless anchored back to the specific, local fact of the real box from which each prototype cast was made.

Krauss's criticism of the idea that expanding work to a vast scale is necessarily complicit with 'capitalist spectacle' is both countered and provocatively exaggerated by Whiteread's project. In Albert Camus's *The Plague* (1946), the narrator invites us to imagine in some detail a cinema full of people – how they file into their seats, smoke, talk and so on. He then asks us to multiply this impression by ten, then by one hundred, and so on, in order to give a true sense of the thousands of victims of the plague. Whiteread's approach is similar. Her installation manifests a simple ambition to connect vast spectacle with individual scale, making what we might read as a piece-by-piece, built representation of collectivity. She chooses an object to which we can all easily relate, and whose scale and weight is easy to judge, since the cardboard box is an object that inhabits our personal domestic spaces, and of which we all have physical experience. Through this formal unit, she finds a way of making sense of a space that is beyond human scale, originally designed to house huge machines. At stake is a desire not simply for

spectacle, but for the viewer to comprehend the physical scale of the space in a way that is graspable, both in terms of its quantifiable cubic metres and as it relates to ideas of memory and personal possessions. In view of this vast assemblage of stacked boxes, our own belongings, packed to move house, seem pathetically inconsequential and small-scale, yet they can represent the accumulated possessions and memories of a life-time. As the massing of what might be many lifetimes, many sets of possessions, the installation is excessive and disorientating. The notion of spectacle is very much complicated by the immersive experience of the work, which sets up an intricate play between its impact as image and the primary encounter with its form in the physical and conceptual space of the museum.

LABYRINTH

Writing on the ritualistic experience of the contempo-rary art museum in *The Museum of Modern Art as Late Capitalist Ritual*, Carol Duncan and Alan Wallach describe the museum as a 'modern ceremonial monument' that 'belongs to the same architectural class as temples, churches, shrines and certain kinds of palaces'.[16] They discuss the fact that 'historians of pre-modern and non-western art usually acknowledge ritual contexts, but conventional art historians ignore the meanings works of art acquire in the museum and insist that the viewer's experience of art is – or should be – shaped by the artist's intention as embodied in the object.'[17] The blank exterior walls of New York's Museum of Modern Art, they claim, 'dramatize the moment of passage from exterior to interior, from the everyday world to a space dedicated to the contempla-tion of higher values', which is an essential part of the 'ritual of spectatorship'.[18] These values embody 'the ideology of later capitalism', they argue, seeing MOMA as 'a monument to individualism understood as subjective freedom'.[19]

Tate Modern's main (west) entrance, likewise, is marked by a reflective stretch of toughened glass facade containing sliding doors and sheer brick wall above, leading into the vast space of the Turbine Hall, which has often been called cathedral-like. Whiteread theatricalises this passage, bringing old-fashioned ideas of ritual together with the specific site and function of the museum. Situated in the east end of the Turbine Hall, beginning just under the over-arching 'bridge' space halfway down, her installation cannot be comprehended fully as an image at floor level. As the visitor enters, in a smooth transition from the street to outdoor walkway to interior space, and descends the ramp, the piece is apprehended gradually. It is only partially visible until one finds oneself physically immersed within it.

In creating this substantial pause between one's entrance into the building and the moment at which the work is experienced, Whiteread shifts the terms of encounter in the sense of one's perception of outside (ordinary) and inside (high art). Rather than being hit with an immediate and spectacular work of art, the viewer is pulled down into a physical experience of the piece, which begins at floor level and reaches up on a dramatic scale. With the hiatus in the passage between outside and inside, Whiteread interrupts the transition, and links what might have been seen in the city outside – boxes stacked in lorries, carrying shopping, flattened in the street – with its transformation into pure, white, sculptural form inside.

Duncan and Wallach liken the 'rational cover wrapped around an irrational core'[20] of MOMA's ritual experience to the archetypal labyrinth experience:

> The labyrinth, a basic image in world cultures, appears in literature and drama as well as in ceremonial architecture and other ritual settings . . . it is always to do with death and re-birth, relating either to a life after death or to the mysteries of initiation . . . the presiding personage, either mythical or actual, is always a woman.[21]

This discussion of the labyrinth is used as a structural metaphor for the experience of the museum and the way in which meaning is 'plotted' as a specialised

dialogue between artworks, and the individual language of the artist is in communion with the viewer as a private individual rather than as a member of a community. This can be related to discussions of how the 'grid' form has been used in modernism, where the 'formal logic' of the transcendent realm of high art does not need any referent outside of itself. Sol LeWitt's *Serial Project No. 1 (ABCD)* 1966, for example, comprised a three-dimensional realisation of a grid marked out on the floor, 'based on a set of permutations or step-by-step modifications of open and closed cubes, following a series of four variations (ABCD), beginning with a flat grid and open cubes and ending with three-dimensional closed volumes'.[22] On a preparatory drawing for this piece LeWitt wrote, 'the cube, square and variants on them are used as grammatical devices'[23] and 'The grid system is a convenience, it stabilizes the measurements and neutralises space by treating it equally.'[24]

In preparing her project, Whiteread was at first assisted by the production team, who created computer-generated impressions of how potential volumes of cubic shapes might occupy the space. But this did not help her to imagine the piece as she wanted to see it. Instead, she built a small-scale model with which to test out a physical equivalent of how the pieces might be stacked, arranged, built up in a variety of configurations. This was both more tangible and more genuinely manipulable than the computer program's idea of a 'random' generation of patterns, based on the same kind of numerical sequencing to which LeWitt refers. As the piece developed in her mind, she came to an arrangement of blocks that resembles a labyrinthine formation – what might be described as a multicursal labyrinth, which is a kind of maze with many branches and dead ends and no 'centre' or goal. To achieve this she used generative principles that have more in common with the open-endedness of Mel Bochner's *Untitled (Child's Play: Study for Seven-Part Progression)* 1966 in which a series of blocks were arranged as the basis for a form of intellectual play. Bochner wrote of his piece, 'Like a child's game, the work is a temporary arrangement of building blocks that may be constructed and taken apart (and then rearranged once again). It is not a well-made Specific Object, a finished work of art, but a plan for a "work" that need not be made an idea.'[25] Bochner's piece was distinct from LeWitt's approach, which he saw as 'a rigid system of logic that excludes individual personality factors as much as possible. As a system it serves to enforce the boundaries of this work as "things in the world" separate from both maker and observer.'[26] Whiteread's work, which drew partly on observation of her son playing with a set of wooden blocks, is derived from the very principles that Bochner describes as absent in LeWitt's work. It effects a bridge of understanding at a very basic human level between maker and observer, via a relationship to the universals of the box and the cubic unit. Although the installation will not literally be reconfigured during the course of the exhibition, as individual 'modular' units the boxes contain the latent possibility of play, of endless permutation. Indeed, from the artist's point of view, the discrete nature of each box was an essential element of the integrity of the piece. It was also important that the density of the boxes should be genuine, rather than building them on top of some kind of internally supporting structural frame.

Situated inside the museum, Whiteread's project complicates the opposition set up by Duncan and Wallach between rationality and irrationality. Her immersive structure occupies a space in between these definitions, in common with Briony Fer's problematisation of the opposition set up between Minimalism and Post-minimalism in the work of Eva Hesse. Querying the distinction that had previously been made between 'rational' and 'irrational' or 'eccentric'[27] formal composition, Fer finds elements of obsessiveness and of blank formal logic – the 'look of the void' – in both kinds of work.[28] Whiteread's cubic structures and their stacked formation bear a relationship to the scale and structure of the given space in terms not only of its horizontal and vertical

co-ordinates but also of its potential for diagonal axes or interruptions, such as gaps that appear as 'blips' in the system, as spatial 'eddies' or black holes. The immersive form built from single units holds true to the essence of Whiteread's ongoing project – the individual cast object – and yet its total mass recalls the maze-like passages of ancient rock-cut tombs. The memorial has always been a point of reference for Whiteread in an abstracted sense, and here the boxes might appear not only as monuments to individual lives and people's things but also as a reflection of the museum's status as keeper of collective memory, or as a lament on the obsolescence of industrial production. Much has been made of the association between the 'petrification' of Whiteread's casting process and ideas of death. But the translucency of this work, the formation and distribution of white surfaces whose arrangement and material qualities seem to shift in the light, bring to mind art-historian Herbert Read's description of ancient stone works, whose forms make 'spirit imagine itself in an exclusively material medium'.[29] For all their immediate dialogue with Minimalist sculpture of the 1960s and 1970s, Whiteread's rhomboids of empty space – like giant sugar cubes or blocks of ice – might equally be seen as a contemporary version of such ancient structures. Made from chemically produced industrial materials, they nevertheless share what Read describes as the 'crystalline integrity of geometrical constructions'[30] characteristic of works made long before the advent of modernism.

The essential criticism at stake in Duncan and Wallach's essay, in common with the view of Rosalind Krauss, is that the modern art museum belongs to an age of 'corporate capitalism' and addresses us not as a community but as private individuals. They took MOMA as their example, but the discussion might equally be applied to Tate Modern. What is curious and unique about Tate Modern's reclaimed architecture, though, is the decision that was taken to leave the central core of the building – the Turbine Hall – empty. The very heart of the museum is, then, a huge container that holds nothing: a void. And yet it also functions as a kind of public space. Visitors often come to Tate Modern specifically to experience it, regardless of whether there is art on display. The space has been used for informal film screenings, with people sitting on the ramp, and as a Mexican wrestling arena in Carlos Amorales's performance in 2003, whilst visitors to Olafur Eliasson's *Weather Project* in 2003–4 grouped together in formation or lay on the floor so that they could see themselves reflected in the mirrored ceiling. For all the discussion of the logic of visitor experience within the modern art museum, this area remains unusually open as a space – an experience – that defies straightforward interpretation.

Whiteread's project draws upon the essential difference between this space and the 'light-filled' MOMA lobby, understanding its combination of awe-inducing transcendence with very public terrain. Her installation introduces a different order of 'labyrinthine' experience from that of the 'late capitalist ritual' described by Duncan and Wallach, and is also different from the spectacular 'ecstasy' of large-scale artwork decried by Krauss. The box form divides this giant void into a proliferation of manageable pockets of 'voided' space[31] and somehow turns it inside out, drawing out its internal geometry as striated or divided units. Essentially, though, Whiteread mines the space for its address to collectivity, parcelling the vastness and inviting a sense of intimacy with its individual containers. Read individually, each box cast might be interpreted according to the conventional terms of engagement with modern art, but massed together they represent a different kind of 'journey' that is liminal, formally beautiful and disorientating; one that does not rest on a singular moment of private engagement to reveal its meaning. *EMBANKMENT* is Whiteread's largest project to date, but it manifests her long-held desire to make sculpture that does not depend on a highly specialised private language, but upon object-references that we share in common. At the same time, there is a poetry to the boxes' sealed interiors that speaks of how unknowable that common ground ultimately remains.

1 As a teenager, Allington was interested in the Greek philosopher Plato (429–347 BC), who claimed that all objects in the physical world are degraded copies of an authentic ideal, which humans cannot perceive.

2 Carl Andre, *Cuts: Texts 1959–2004*, ed. and introduction by James Meyer, Cambridge, Mass. 2005, p.47.

3 Mike Kelley, *Foul Perfection: Essays and Criticism*, ed. John C. Welchman, Cambridge, Mass. 2003, p.142.

4 Rosalind Krauss has written of the important difference in attitudes towards the cultural readymade of Minimal and Pop artists: 'The pop artists worked with images that were already highly inflected, such as photographs of movie stars or frames from comic books while the minimalists used elements into which content of a specific kind had not been built. Because of this they were able to deal with the readymde as an abstract unit and to focus attention on the more general questions of the way it could be deployed. What they were doing was exploiting the idea of the readymade in a far less anecdotal way than the pop artists, considering its structural rather than thematic implications.' Rosalind E. Krauss, 'The Double Negative: A New Syntax for Sculpture', in *Passages in Modern Sculpture*, Cambridge, Mass. 1981, p.250.

5 This exhibition was presented at the Jewish Museum in New York, from 27 April to 12 June 1966.

6 Jack Smith, *Wait for Me at the Bottom of the Pool: The Writings of Jack Smith*, ed. J. Hoberman and Edward Leffingwell, London 1997, p.99.

7 Ibid., p.100.

8 Suzaan Boettger, 'Inside the Box Factory', featured on *Artnet Magazine*, http://www.artnet.com/magazine/features/boettger/boettger6-3-03.asp. See also Suzaan Boettger's *Earthworks: Art and the Landscape of the Sixties*, Berkeley 2002.

9 Research conducted with artists for the development of Tate Modern found that raw and large-scale industrial spaces were the preferred choice of the majority: 'the choice of the power station was never an exercise in industrial archaeology. It was driven by the view, ascertained by Tate Modern through its discussions with artists and curators, that adapted industrial spaces made more sympathetic and inspiring spaces for exhibiting art than purpose-built ones.' Raymond Ryan, 'Transformation', in Rowan Moore and Raymond Ryan, *Building Tate Modern: Herzog & De Meuron Transforming Giles Gilbert Scott*, London 2000, p.17.

10 Published in *October: The 2nd Decade, 1986–1996*, Cambridge, Mass. 1997.

11 Maurice Merleau-Ponty, *The Phenomenology of Perception*, new ed., London 1970.

12 Krauss 1981, p.434.

13 Ibid.

14 Ibid.

15 Ibid., p.438.

16 Carol Duncan and Alan Wallach, 'Grasping the World', in Donald Preziosi and Clare Farago (eds.), *Grasping the World: The Idea of the Museum*, Aldershot 2004, p.483.

17 Ibid. p.484.

18 Ibid, p.485.

19 Ibid. p.488.

20 Ibid. p.492.

21 Ibid p.490. Quoted by John Layard, *The Stone Men of the Malekula, Vao*, London 1942, p.652.

22 James Meyer, *Minimalism*, London 2000, p.109.

23 Sol LeWitt drawing for invitation card for Dwan Gallery, Los Angeles 1967: see ibid., p.108.

24 Ibid.

25 Ibid, p.113.

26 Mel Bochner, 'Serial Art, Systems, Solipsism' (1967), reproduced in Johanna Burton, 'Mystics Rather than Rationalists', in Donna De Salvo (ed.), *Open Systems*, exh. cat., Tate Modern, London 2005, pp.64–80.

27 Lucy Lippard's *Eccentric Abstraction* exhibition was held at the Fischbach Gallery, New York, in 1966.

28 Briony Fer, *On Abstract Art*, New Haven 1999, p.109.

29 Herbert Read, *The Art of Sculpture*, London 1954, p.4.

30 Ibid., p.11.

31 Fer 1999. In her essay about rationality and irrationality in the work of Eva Hesse, she goes on to discuss the way in which the gallery space is not 'filled' or 'occupied' by the sculpture, but transformed and changed. Like Malevich's white on white paintings Hesse's sculptures and drawings such as the 'Woodstock' series of 1969 capture an empty space. Fer terms this the 'look of the void'.

Note that ABCD does not appear as a true square

Eye Level Station Point (Side View)

Note that vp_1 and vp_2 occur above the eye level

Station Point (Top View) (a)

Note that vp_1 and vp_2 occur below the eye level

Eye Level Station Point (Side View) Station Point (Top View) (b)

Fig. 10.

Comparison with the instrumentally drawn Figs. 6 and 7 will help in realizing the necessary relationships.

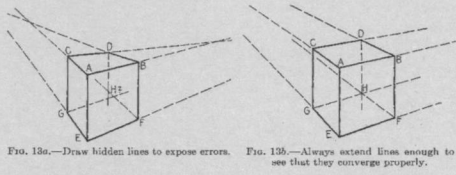

Fig. 13a.—Draw hidden lines to expose errors. Fig. 13b.—Always extend lines enough to see that they converge properly.

71. Another stumbling block in freehand drawing is failure to realize that *both* vanishing points must lie on the horizon, even if the vanishing points and the horizon are not actually drawn. Figure 14a shows the appearance of a drawing in which this has been disregarded; Fig. 14b shows the correction. The cube in Fig. 14a appears to be sliding downhill toward the reader. In Fig. 14b the lines AC, BD, and GE have been made to con-

Fig. 14a.—Vanishing points on different levels. Fig. 14b.—Vanishing points on same level.

verge more sharply, thereby bringing vp_1 down, while the slope of AB, CD, and EF has been increased slightly, thereby raising vp_2 to the same level as vp_1. Students often fall into this trap when they begin drawing without the aid of actual vanishing points located on the drawing board with pins; and, although they may recognize that the drawing seems distorted, they are usually unable to do anything about it. This is because the source of the trouble, being less obvious than that of Fig. 13, is more difficult to to recognize. Whenever a drawing, despite having correctly vertical sides, appears to be climbing up or downhill, look for vanishing points on different levels. This very error, committed deliberately and intelligently, can be the basis of amusing cartoons in which a car or wagon can be made to appear almost alive and straining on a hilly road.

72. There are two drawbacks to the tracing-paper method. For one, if the final picture is to appear on an opaque paper, the tracing must be rubbed on the back with pencil, and the drawing must be transferred by tedious retracing of every line with a hard pencil or stylus. The lines thus transferred are smudgy and must be cleared up by going over them directly with pencil or pen. Consequently we find that, even after the drawing is

Eye Level

(a) (b) (c) (d)

(e) (f)

Fig. 15.

fully corrected, the work must be done twice more, an operation that can only be tiresome. Moreover, the process of tracing inevitably loses some accuracy, for lines frequently shift quite badly in the steps of tracing, rubbing, transferring, and redrawing. The principal advantage of working on tracing paper is that it preserves the delicate surfaces of some drawing papers, such as cameo, which cannot stand erasures.

73. Commercial illustrators, pressed for both speed and accuracy, usually use a method that gives the results of tracing without the tedious reworking and litter of paper. The work is done from first to last on the paper it is to be finished on. This naturally requires a rather tough surfaced drawing paper, such as the best grade of Bristol board, or a fine water-color paper. Such paper is relatively expensive but is worth many times its cost in time saved. The preliminary work is done lightly with a

should be spared many feeble drawings if it were fully realized that each visible line or plane implies much unseen structure. The habit of drawing only what can be seen leads to drawings of such objects as chairs with three feet off the floor, tables with legs sunk six inches into the floor, cylinders open in the back, and similar miracles. If your figure of a man floats a foot above the ground, you should be illustrating H. G. Wells on purpose, not because you can't help it. Draw the invisible lines while constructing

Horizon or Eye Level vp_1

(a)

Fig. 18.

(b)

your drawing, and take them out later. Then you can keep miracles in their place.

94. The direct use of diagonals just discussed shows how areas may be *divided* into halves, quarters, eighths, etc. Diagonals may also be used for the *multiplication* of areas. Figure 18 shows two ways to do this. Either of them, or a combination of both, might be used to solve a similar problem.

95. Suppose we are required to draw a box 2 in. high, 4 in. wide, and 6 in. long. Since we already know how to draw a cube (which we may consider as having sides of 2 in.) it is merely necessary for us to reproduce it three times in one direction and twice in another. Since this presents an opportunity for multiplying small errors, the original cube should be laid out with care. We must also be careful to see that the figure, when completed, does not cover too wide an angle of view.

Use of Isometric Scale

If an isometric drawing be made of a cube, using the two lengths of the sides the drawing will show a component larger than it actually is. In order to obtain a true view, use must be made of the isometric scale.

Consider a cube drawn in isometric projection (see Fig. 3). If the top face ABCD is rotated about the diagonal BD until it is in a vertical position, a true view of the top face EBFD is obtained. The angle EBF is 90°, therefore the angle DBF is 45° and the length BF is a true length. The amount of foreshortening in isometric projection is the difference between the true length BF and the isometric length BC. An isometric scale can be produced (see Fig. 4) using this fact.

Little use is made of an isometric scale in practice. It is customary to take the true or natural lengths as it is more important to show the shape of a component than its size when using pictorial representation.

A view drawn using the isometric scale, strictly speaking, is an isometric projection, and one using the natural scale is an isometric drawing. In practice this distinction is often ignored.

FIG. 3.

FIG. 4.

143

35

outer surface. Printing is also demanded on those portions of the outer surface arrowed, the direction of the print being that of the arrows in every case.

Fig. 70 shows a single-piece model in which pats of soap are sold. Box makers know, of course, that soap manufacturers are selling soaps merely paper wrapped, but it is

FIG. 70.—MUCH USED SINGLE-PIECE MODEL FOR SALE OF POPULAR PRICED PATS OF SOAP.

far better to interest them in the sale of soap in these thin cardboard cartons, which can be offered at competitive prices. In the example before me, which is a horizontal and not an upright model, A is the top and B is the base, C and D are the sides, and E is the attachment flap, which is heavily covered with adhesive, and attached to the back of C so that it corresponds with the shaded portion of that side.

NS, and OU. Print is required on the outer portions only in the direction of the arrows, and only on those portions bearing arrows.

The dimensions of this model are as follows :

Total height, 7 inches ; width of side, $3\frac{1}{2}$ inches ; width of front, $3\frac{1}{2}$ inches, *i.e.*, the base is a square ; total weight uncharged, $1\frac{1}{2}$ ozs. Cheap buff card can be used for its

FIG. 31.—SINGLE-PIECE ELECTRIC LAMP PACKET.

production, as the model is usually paper covered on the outside.

Fig. 32 shows a horizontal single-piece carton, in which packets of cigarettes are sold by tobacco firms to retailers. In this drawing A is the top and B is the bottom, C and C being the two sides, and D the junction flap, which is heavily glued and attached to the back of the lower side C so that its inner margin LL corresponds with the outer margin of C indicated by PP. While the base is extended to the right by an end G, and an end flap H, the top is extended to the left by an end E, and an end flap F. The sides are extended

FIG. 1.

FIG. 2(a)

FIG. 2(b)

39

EMBANKMENT

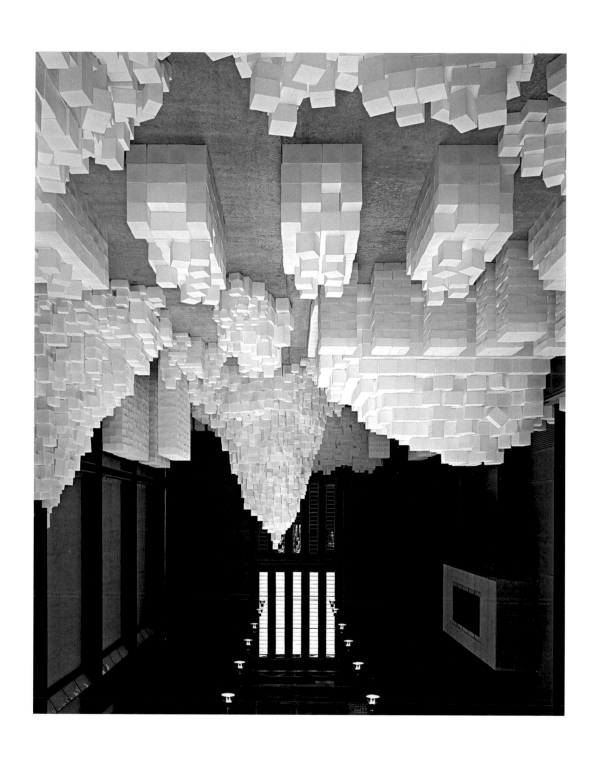

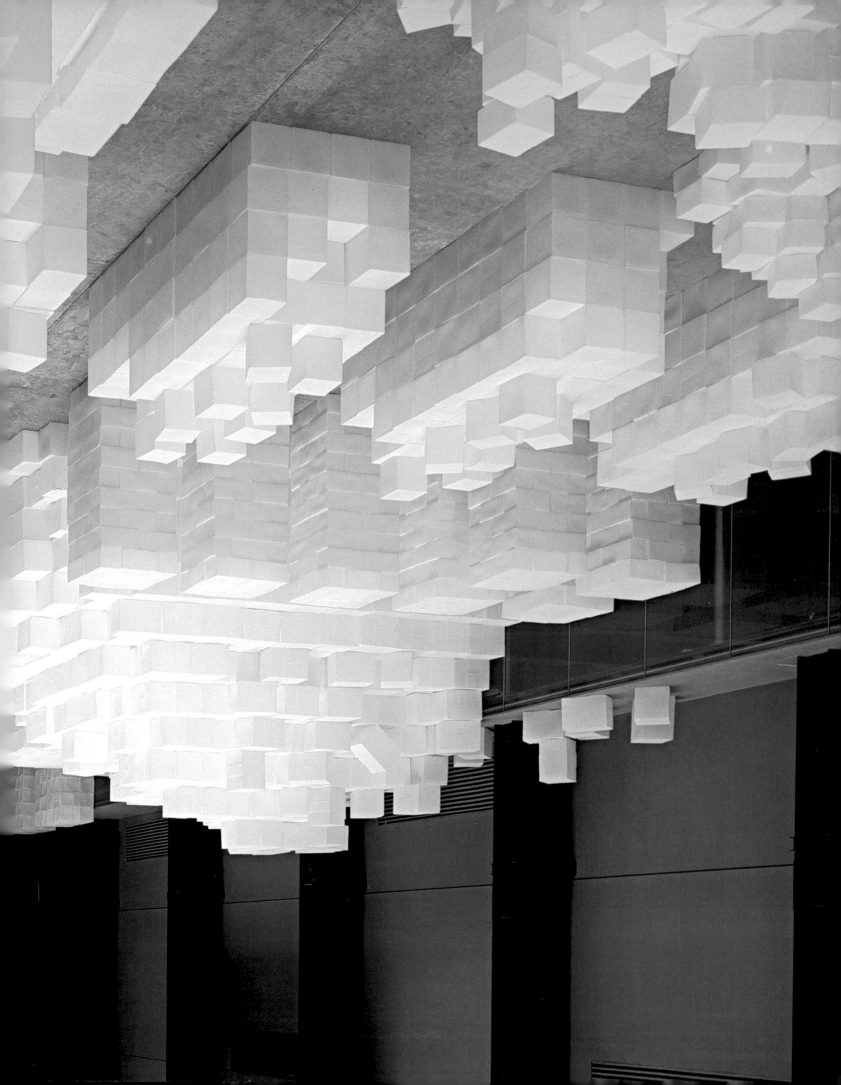

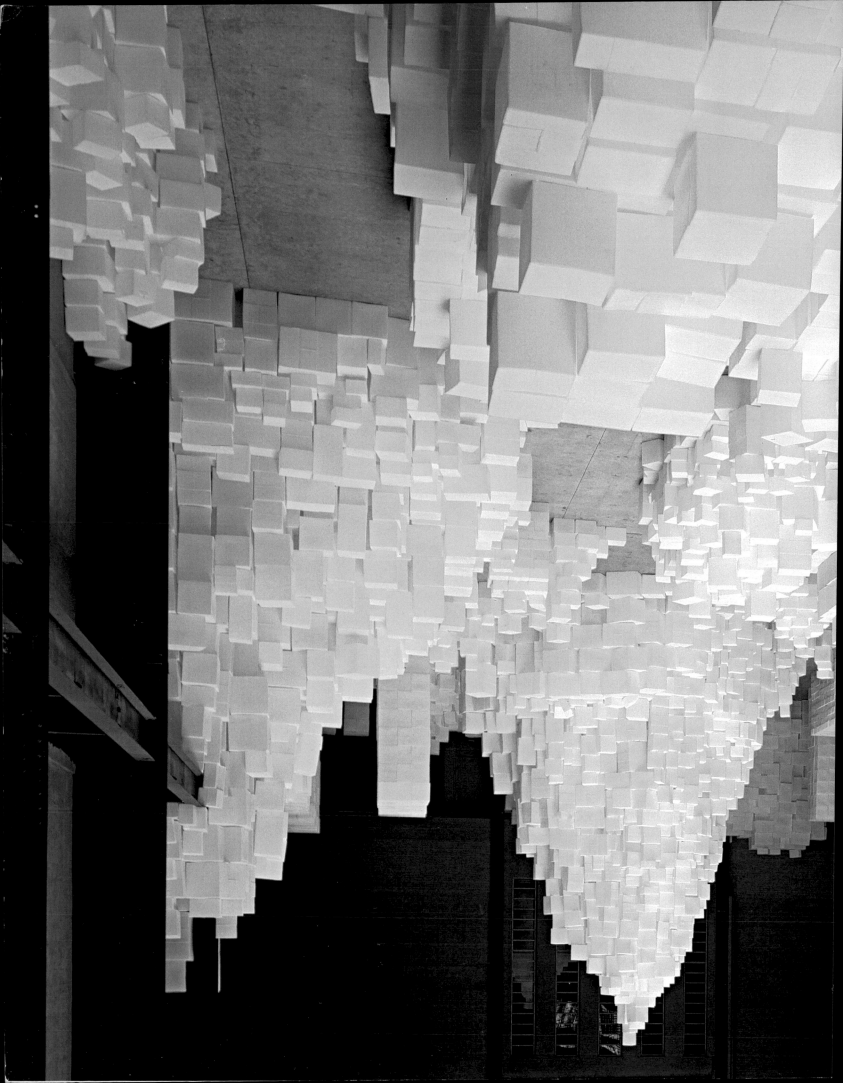

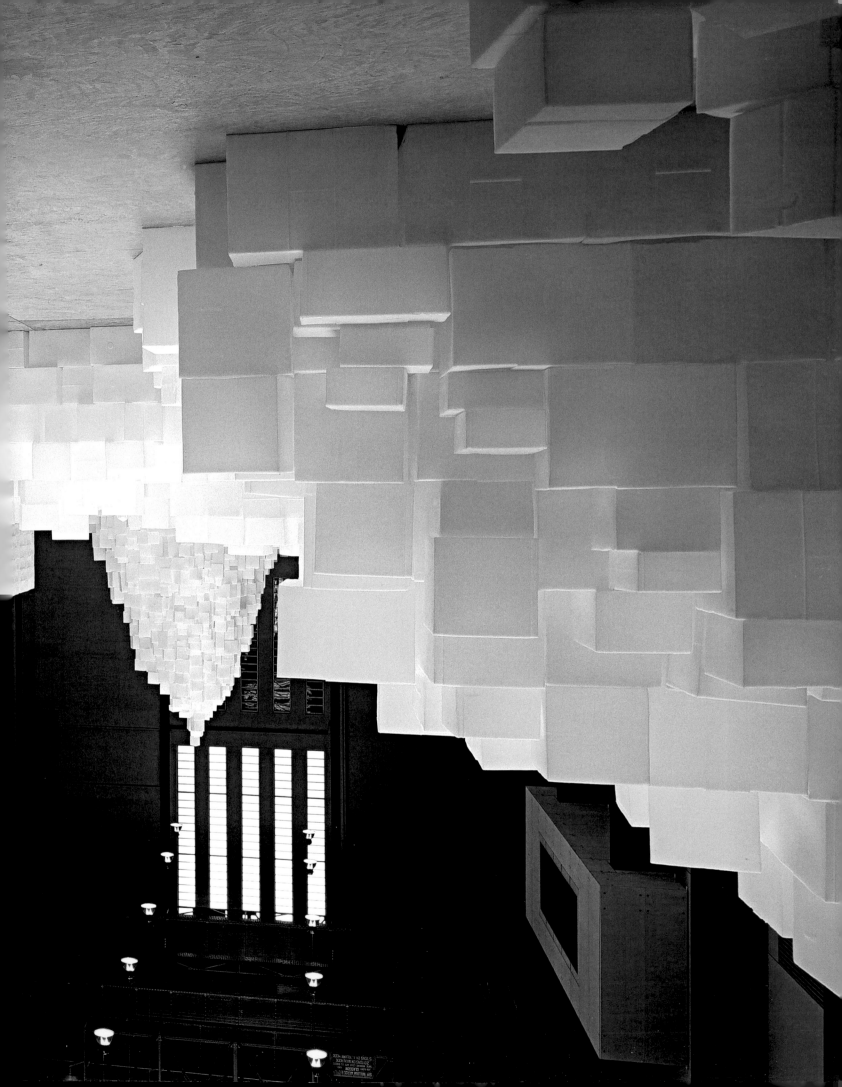

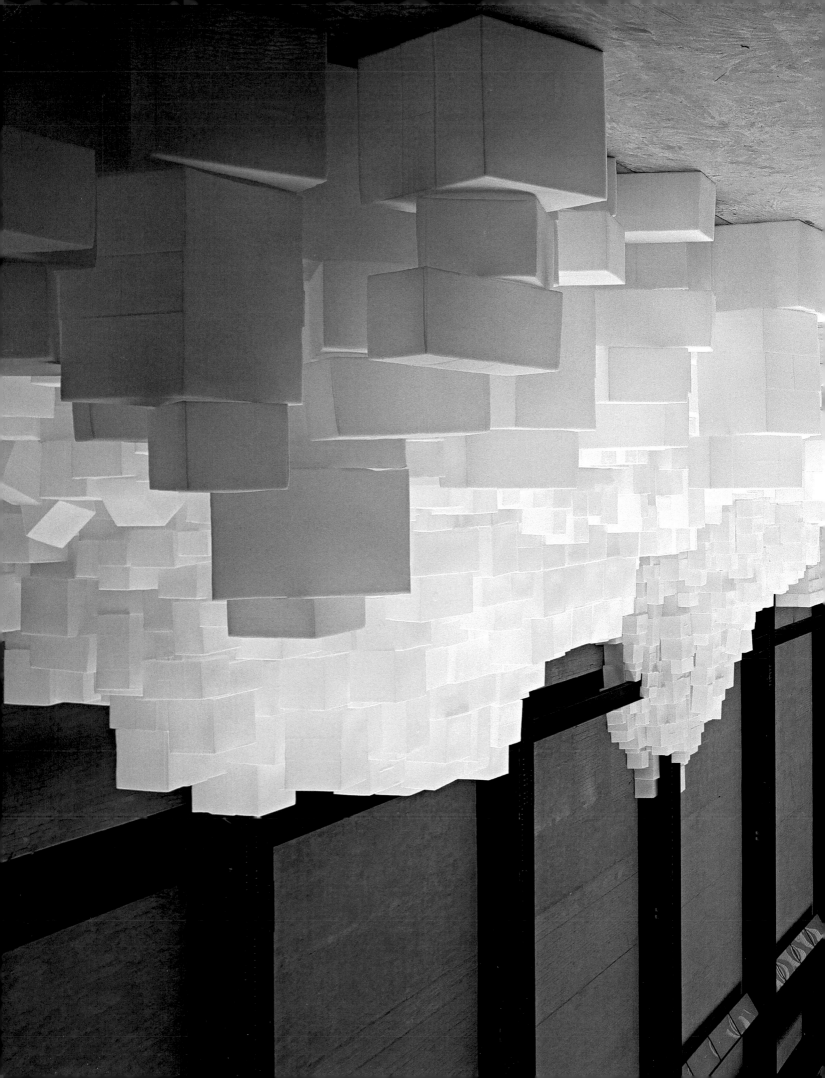

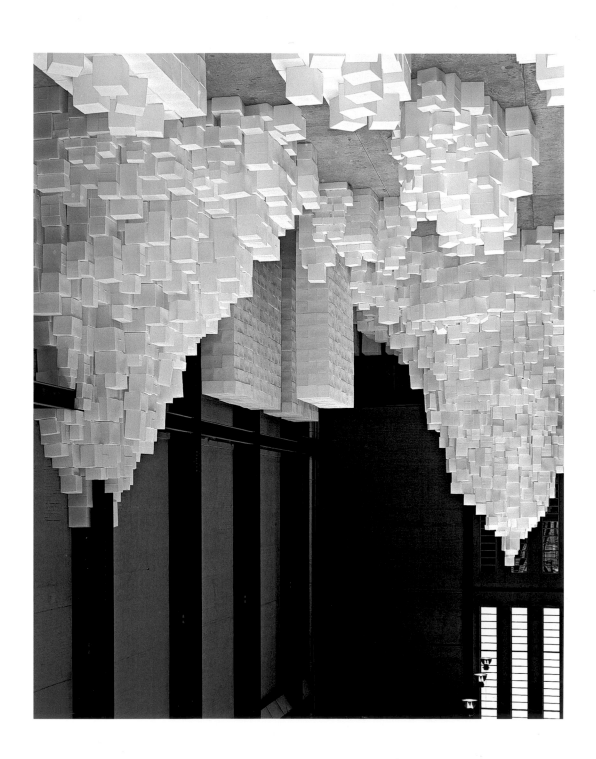

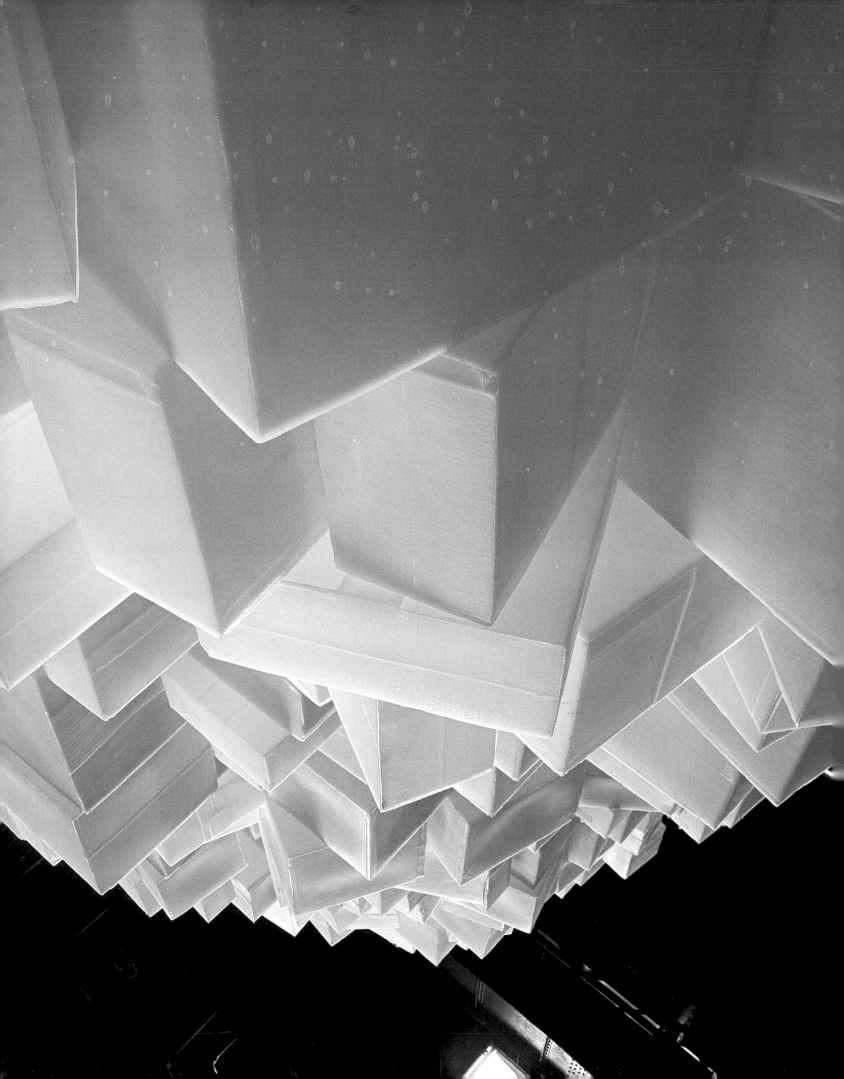

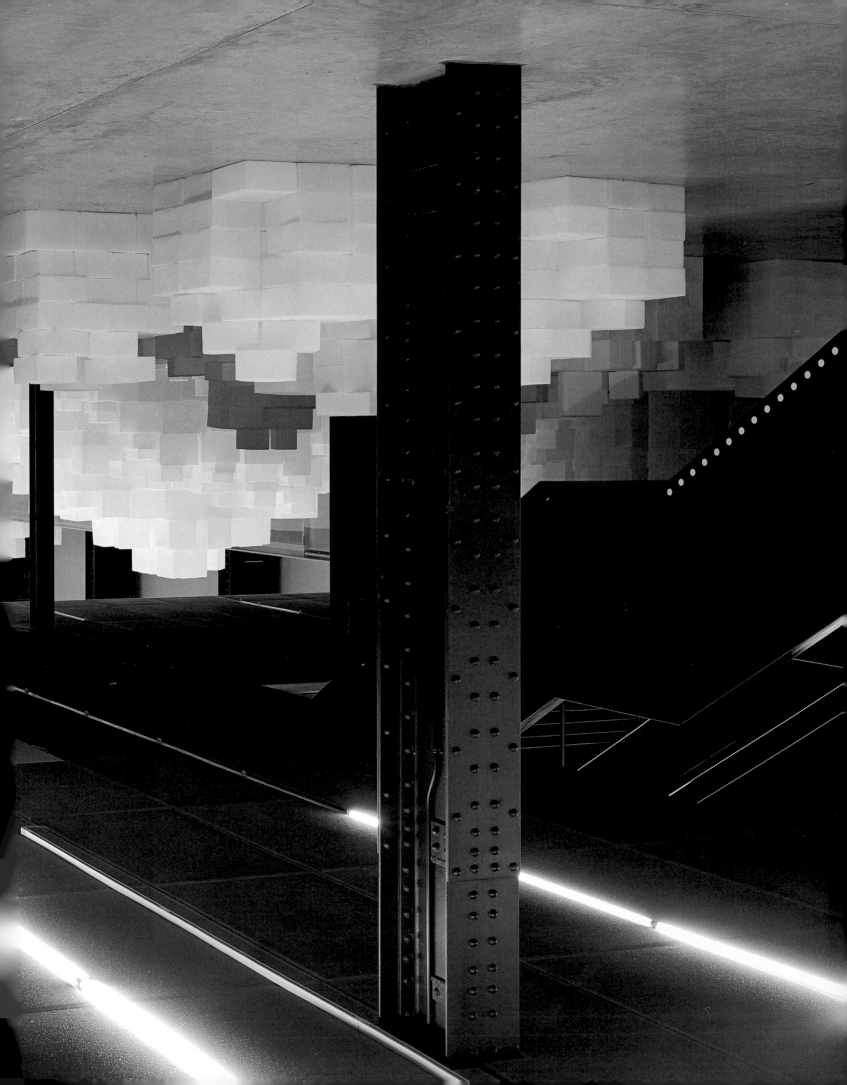

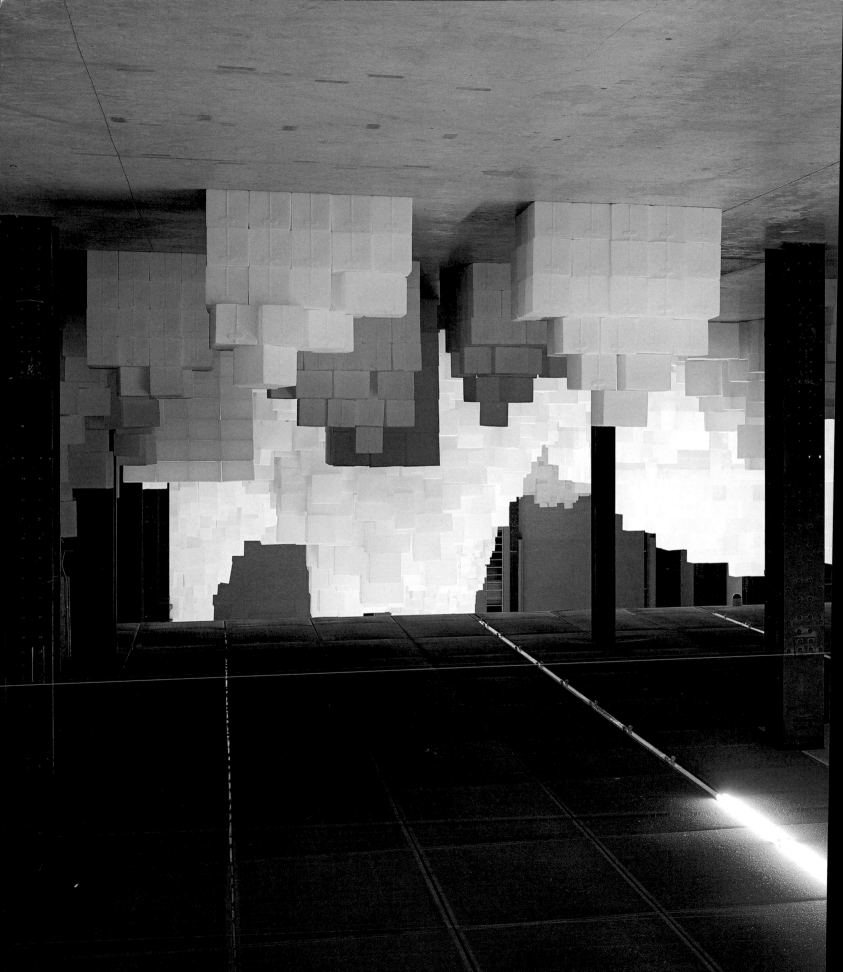

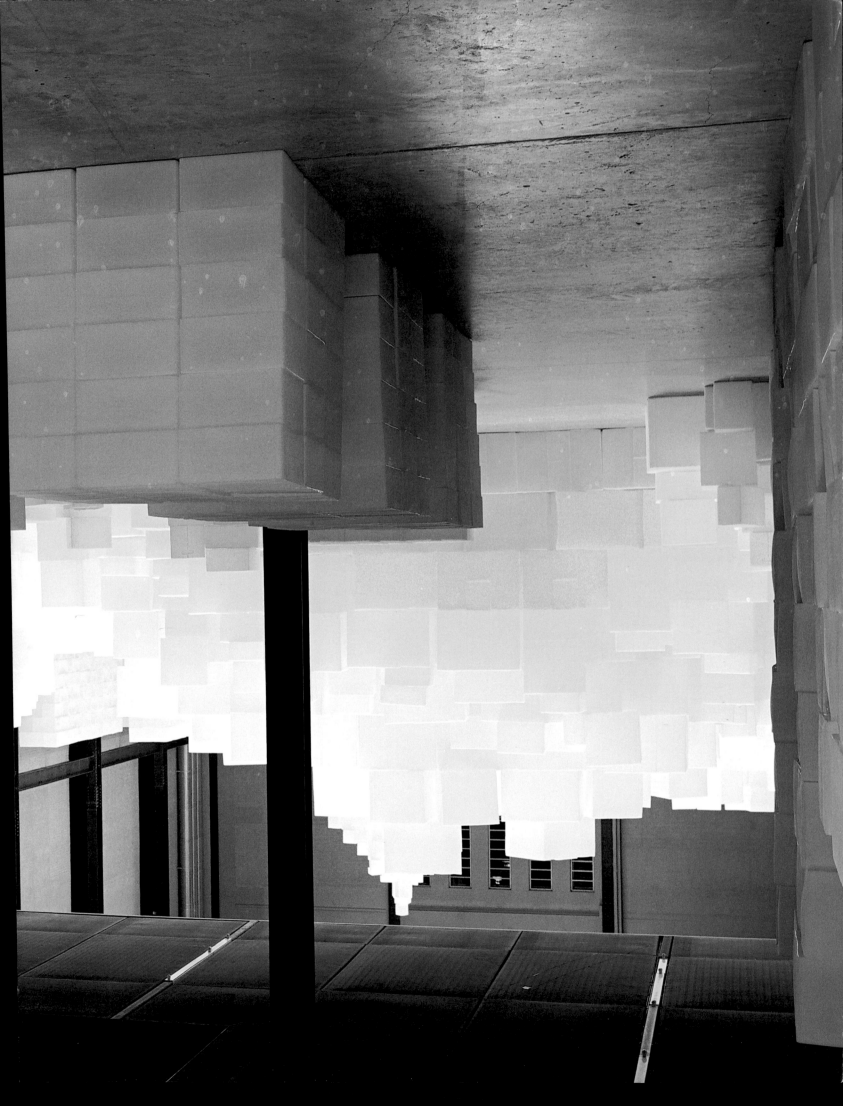

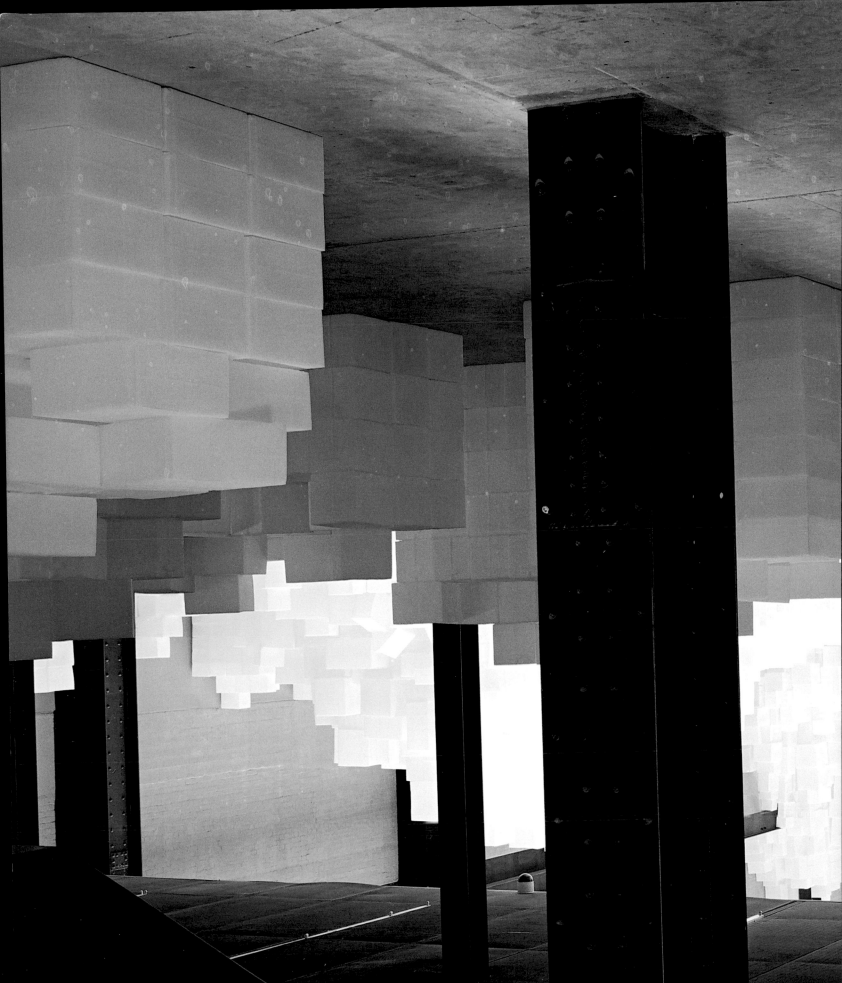

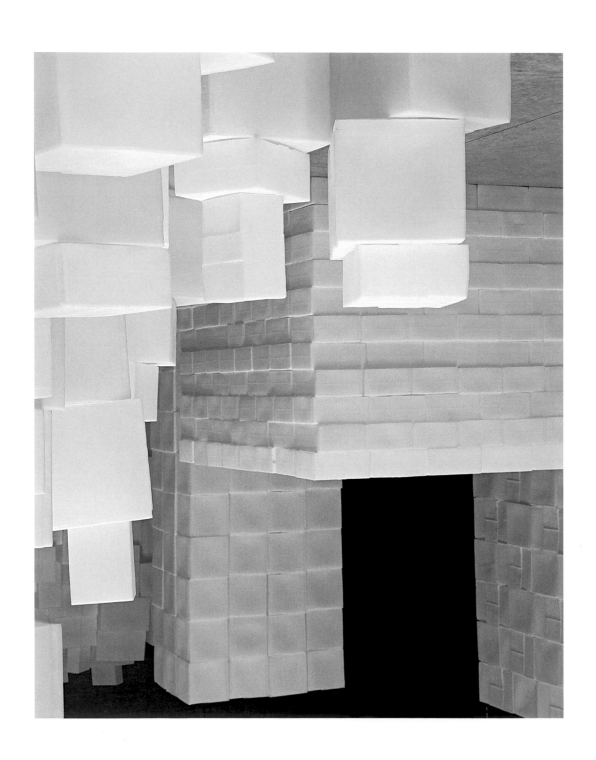

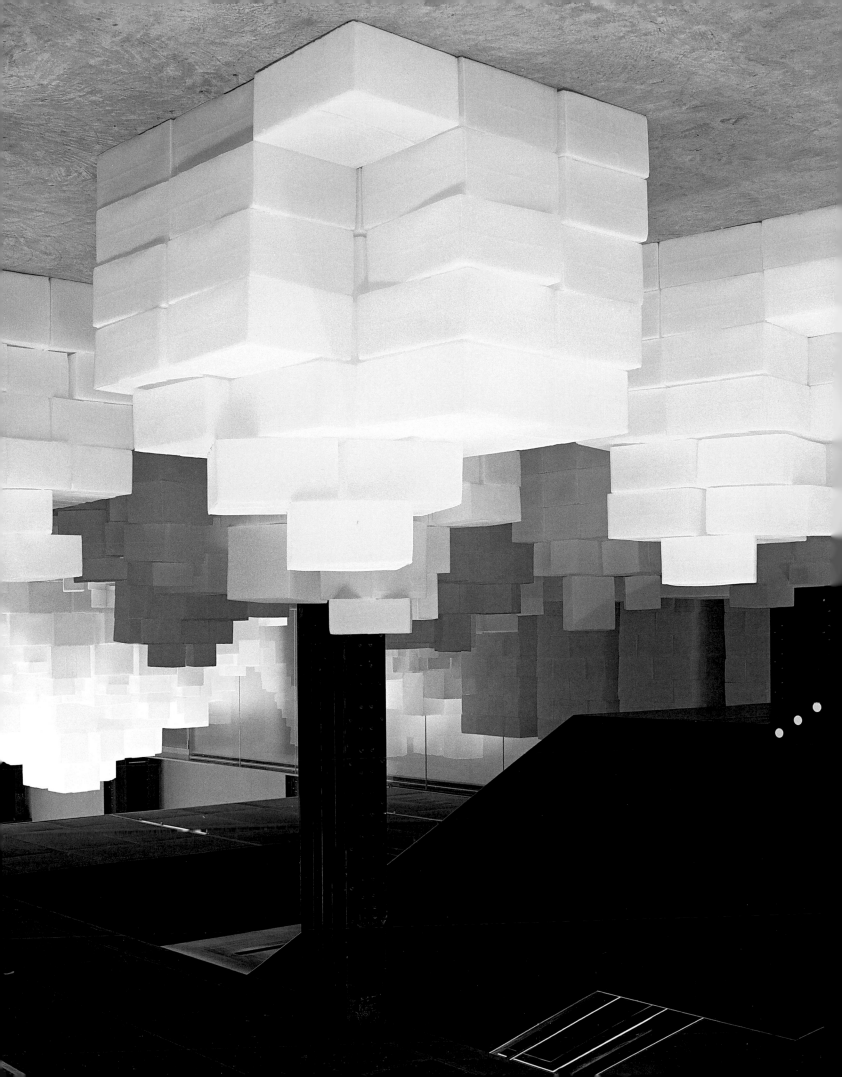

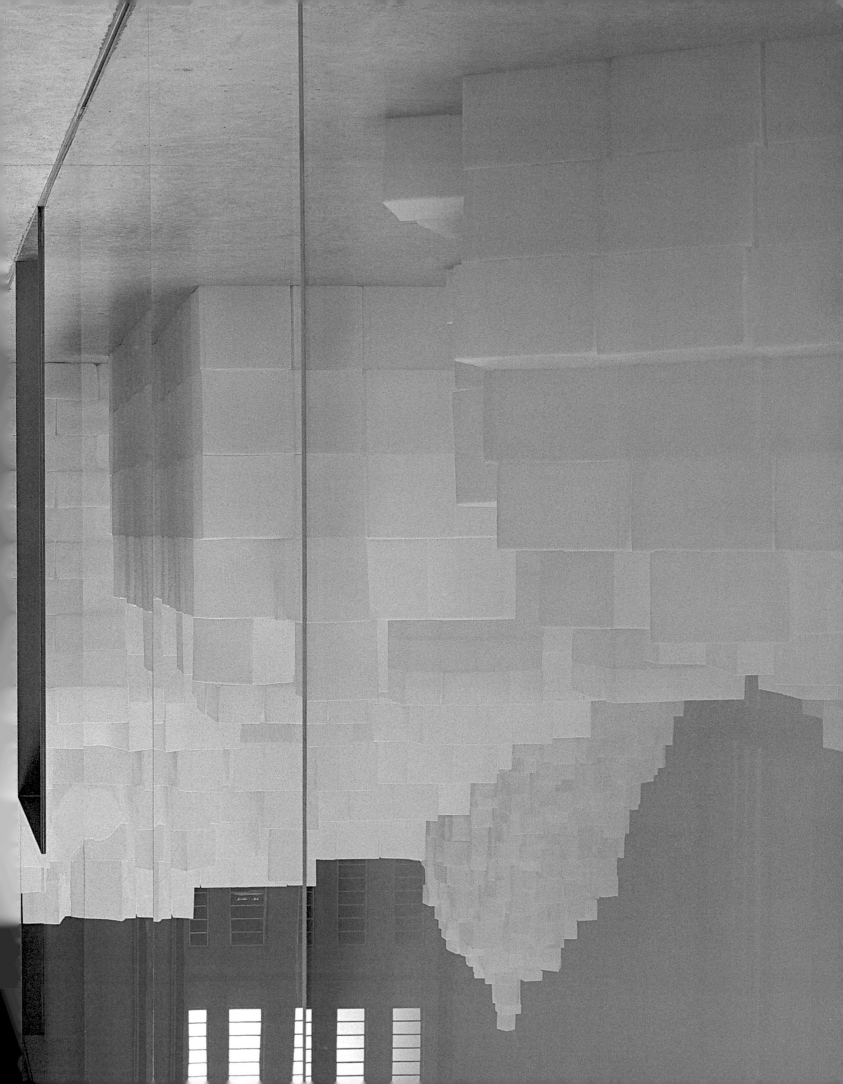

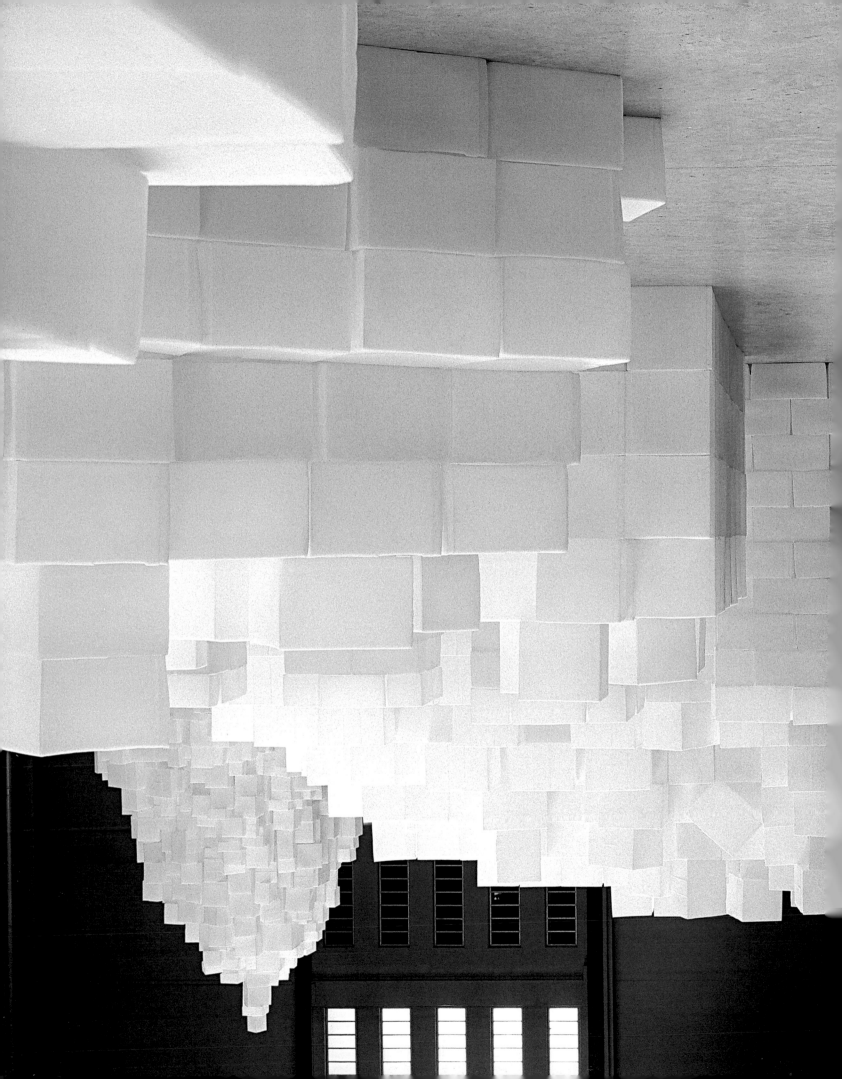

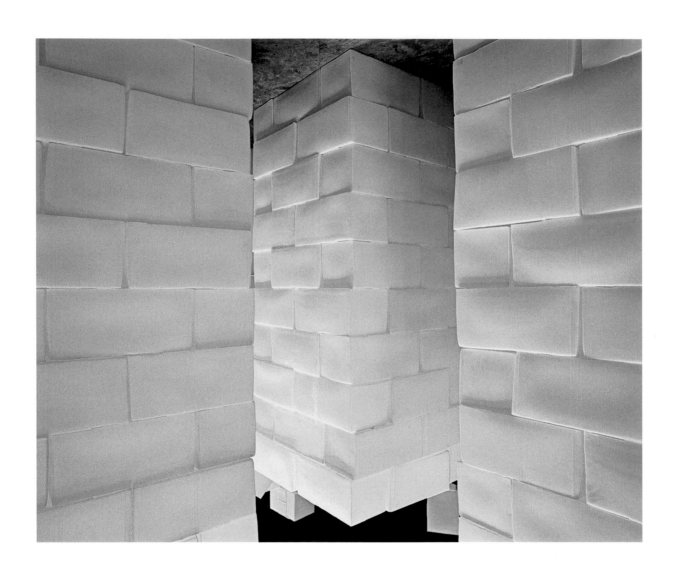

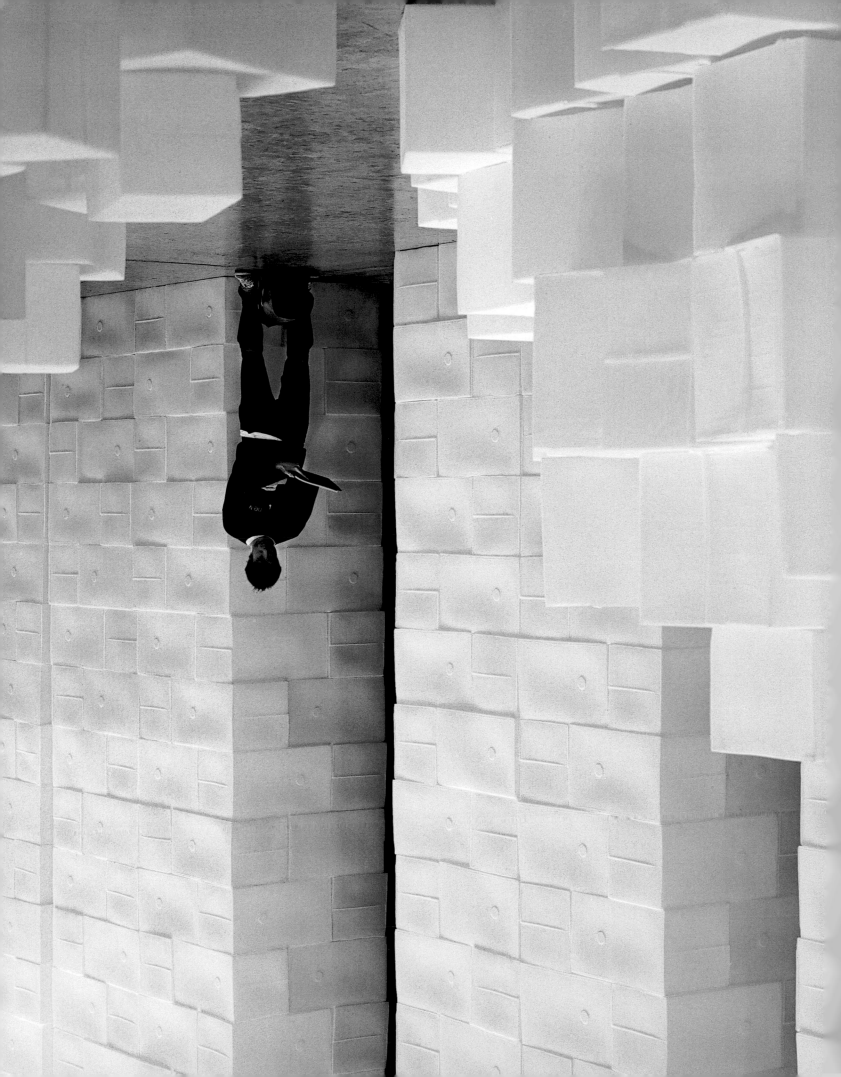

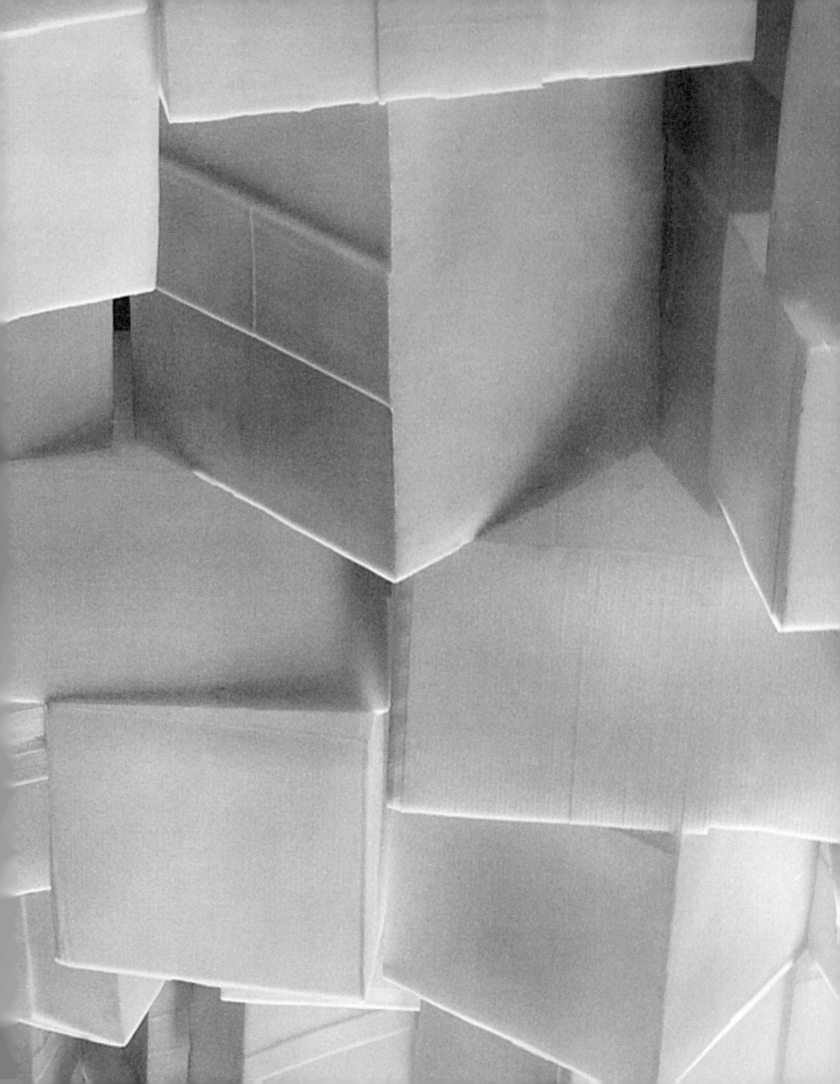

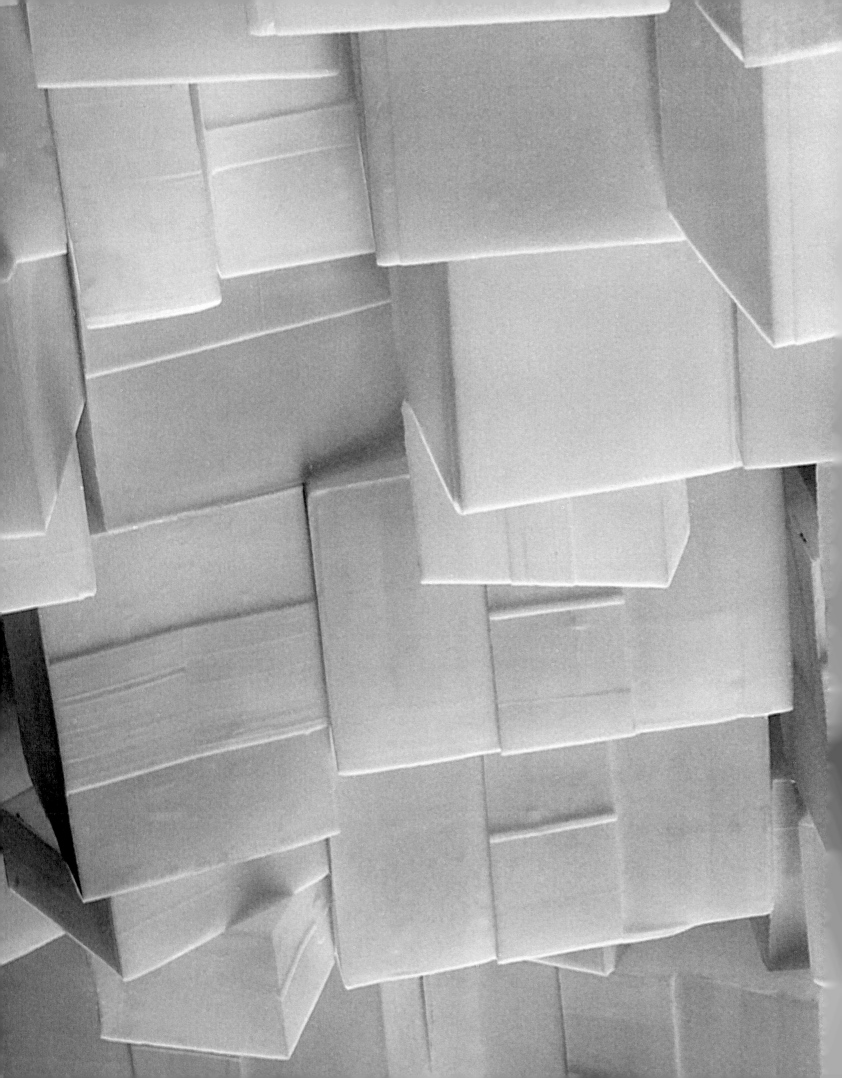

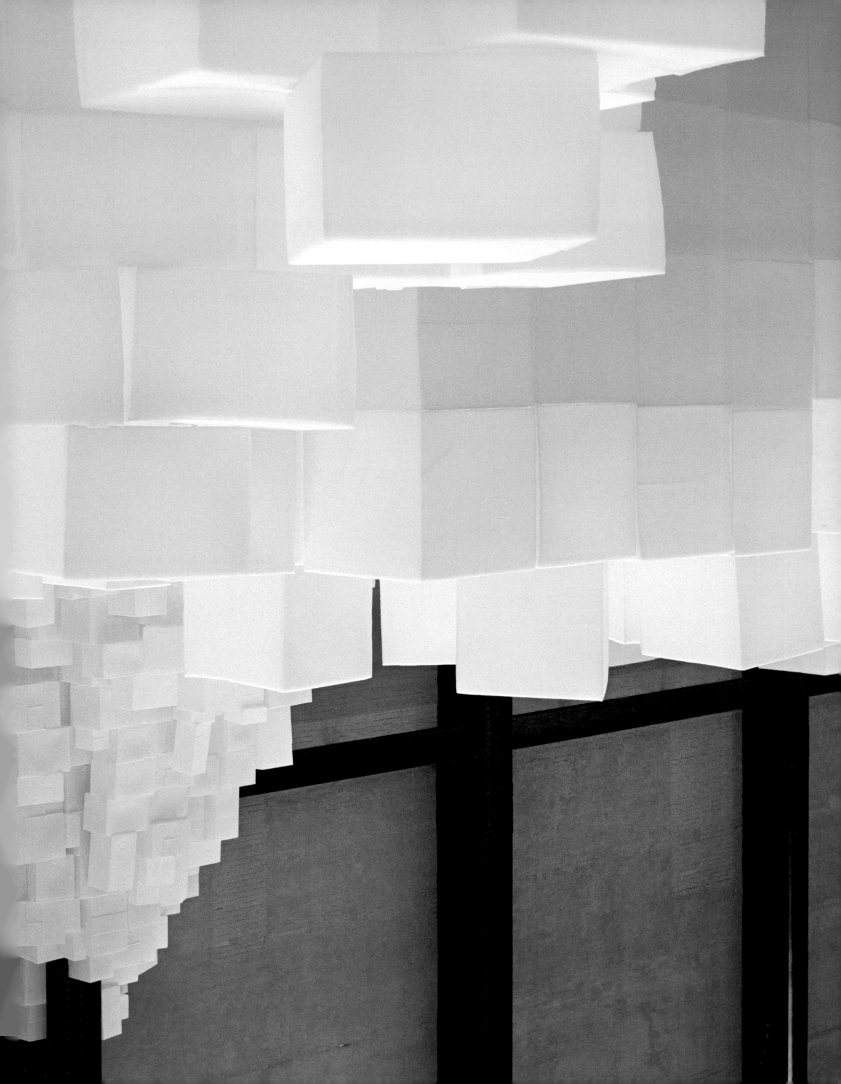

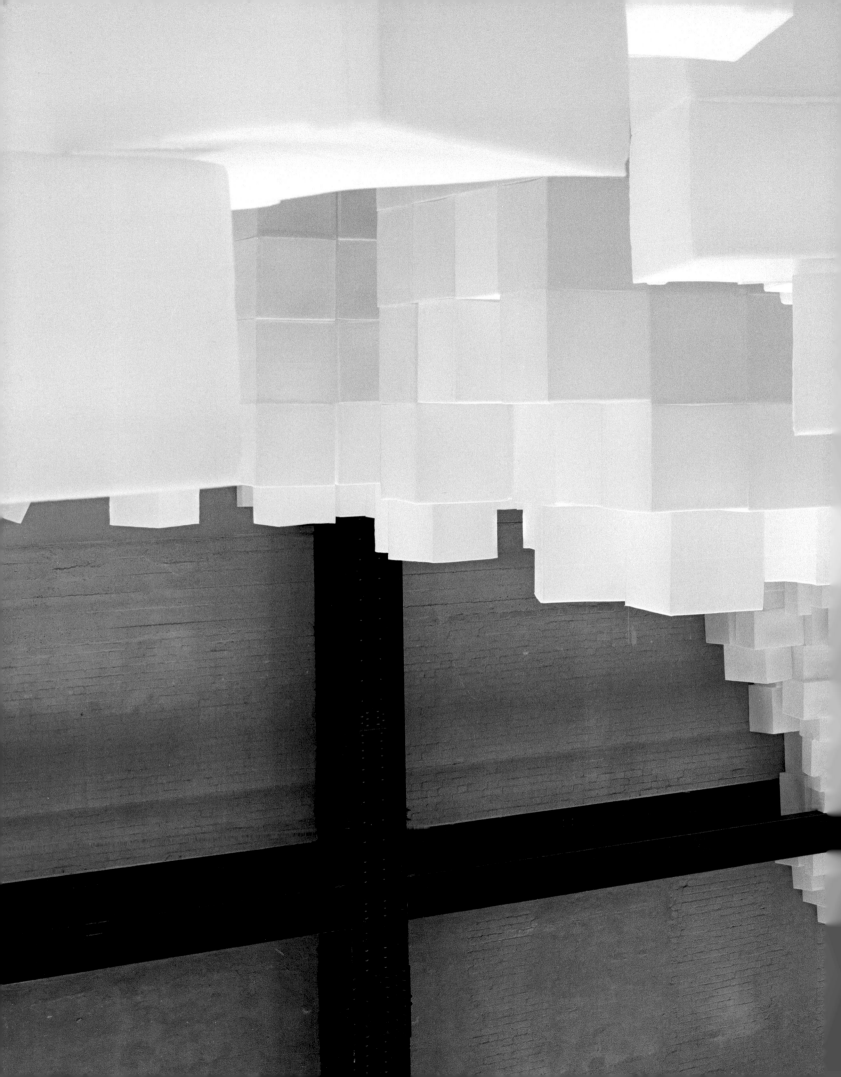

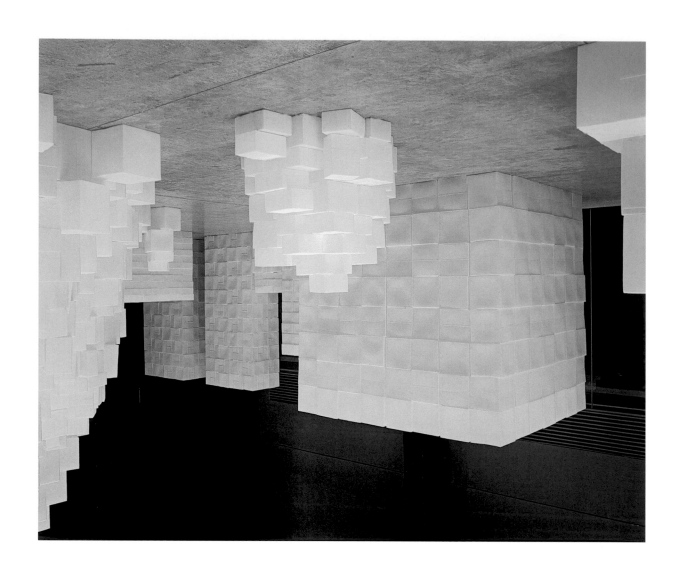

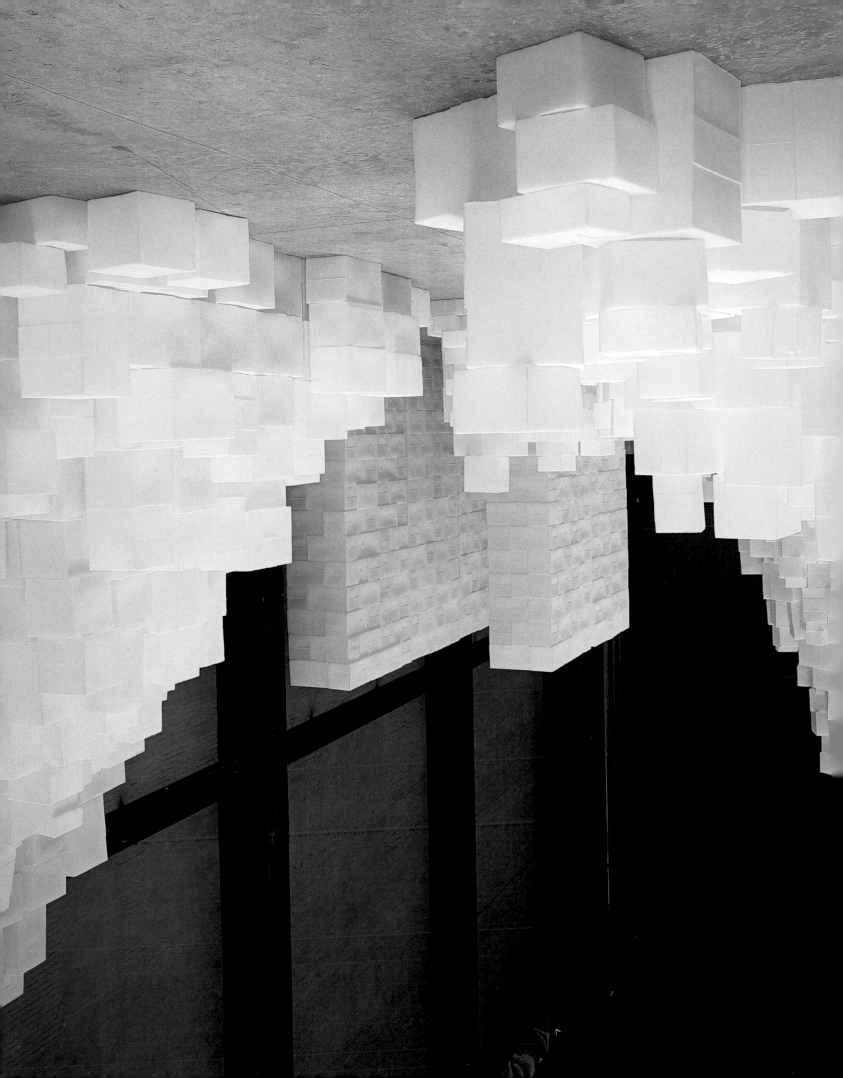

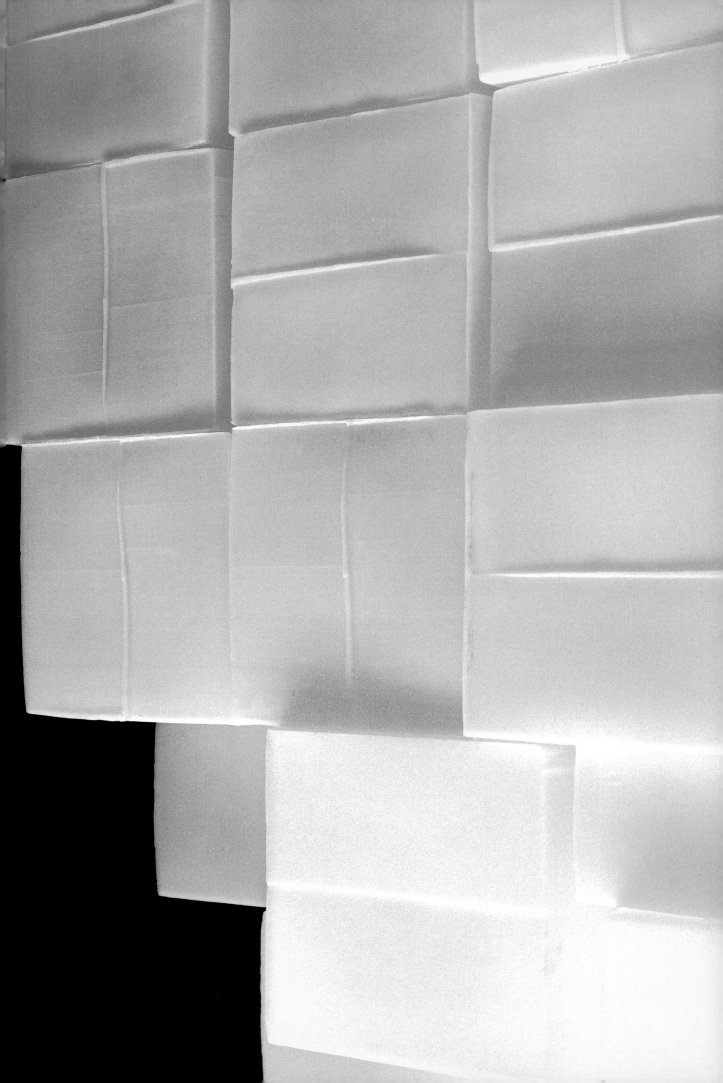

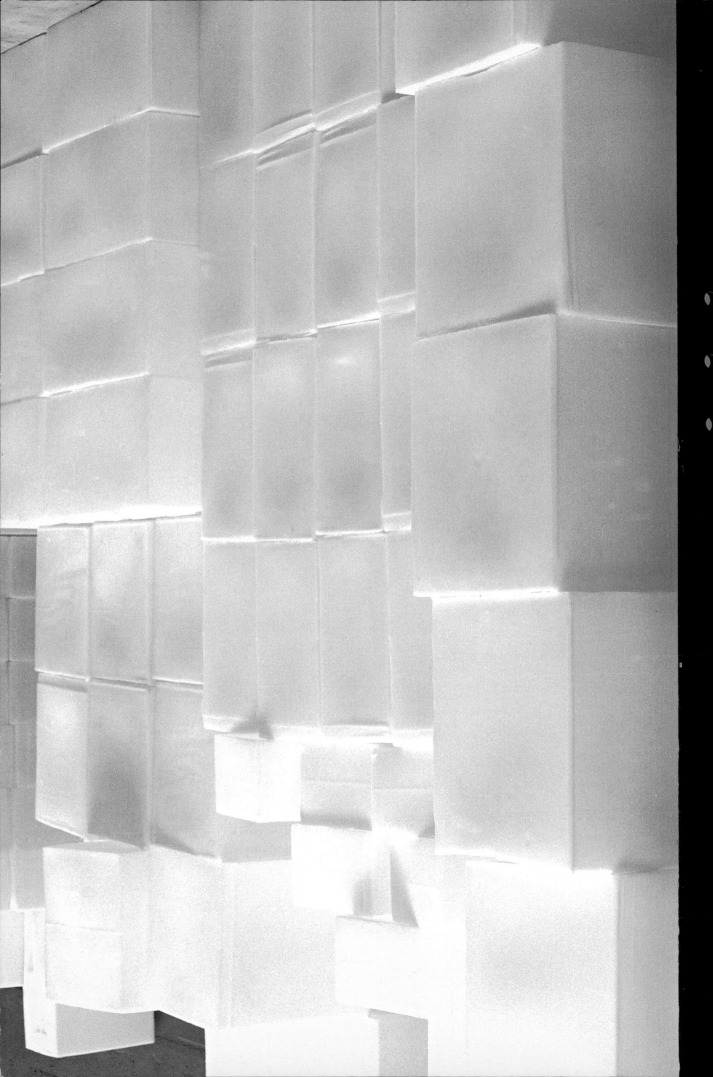

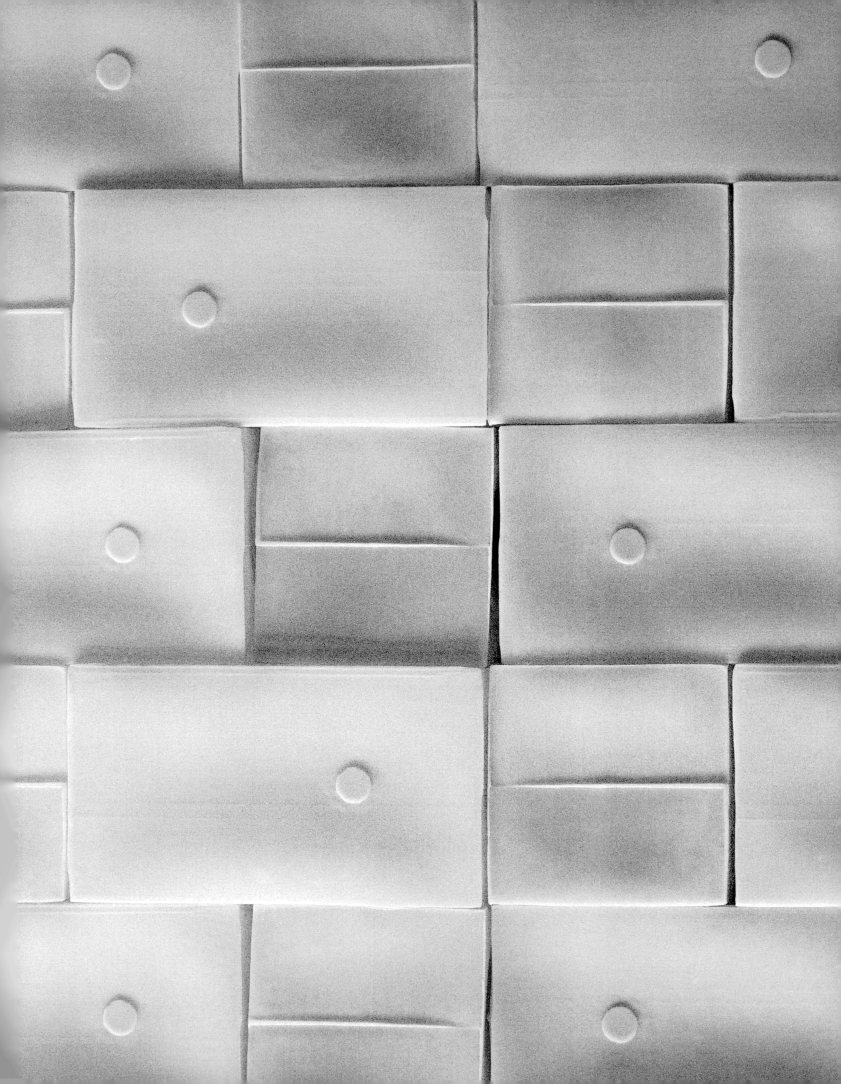

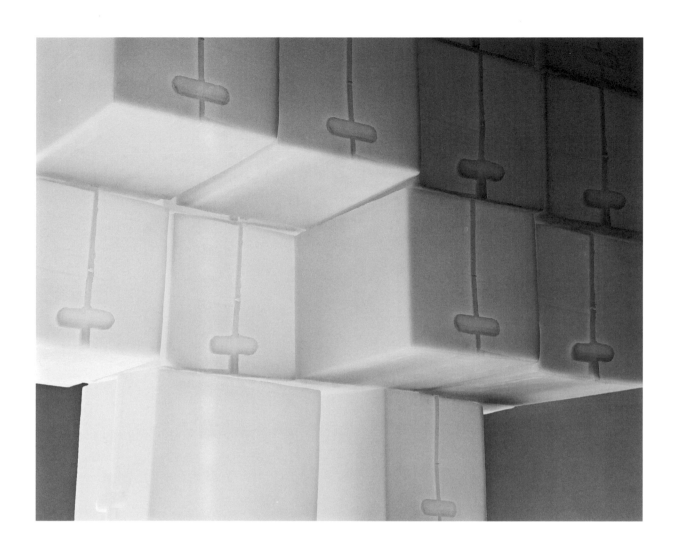

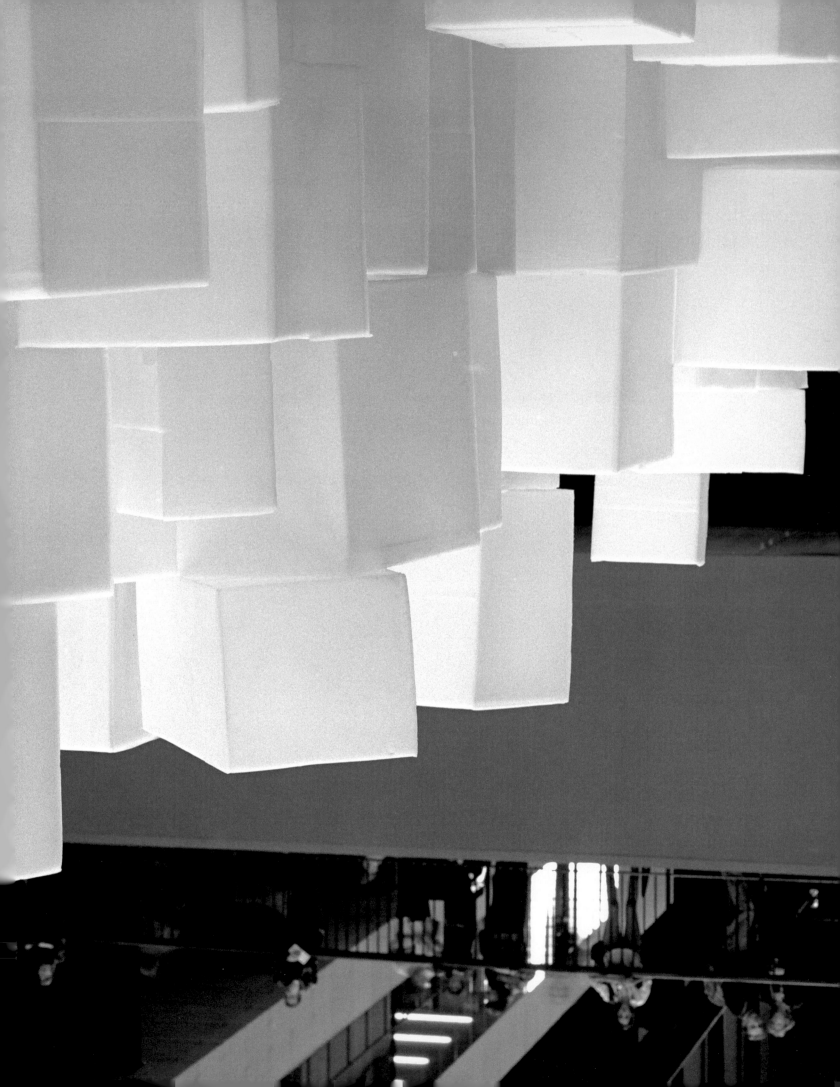

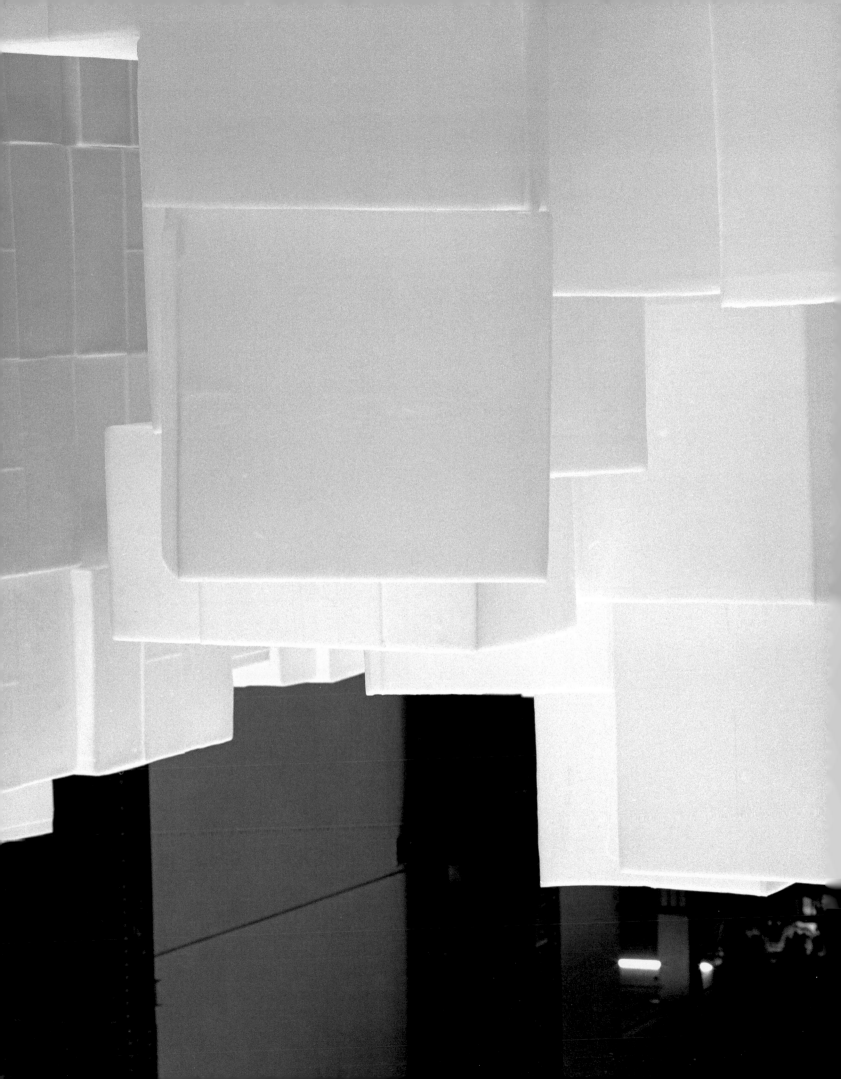

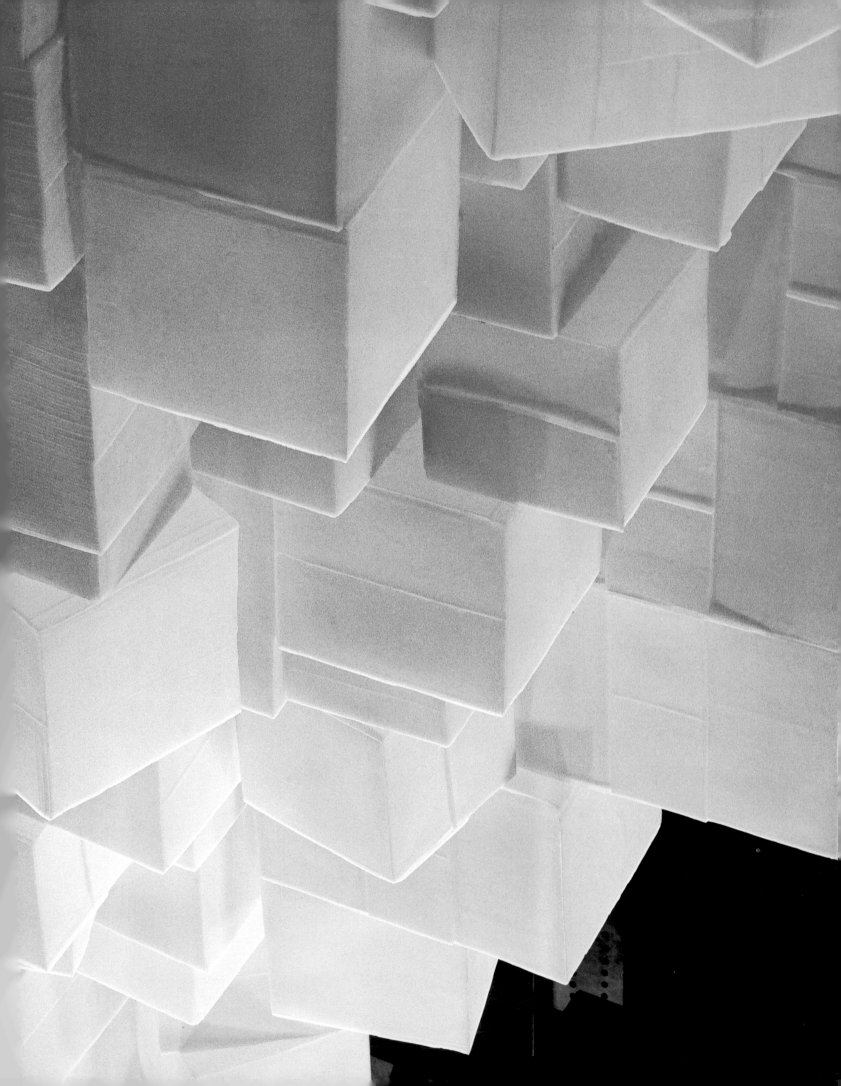

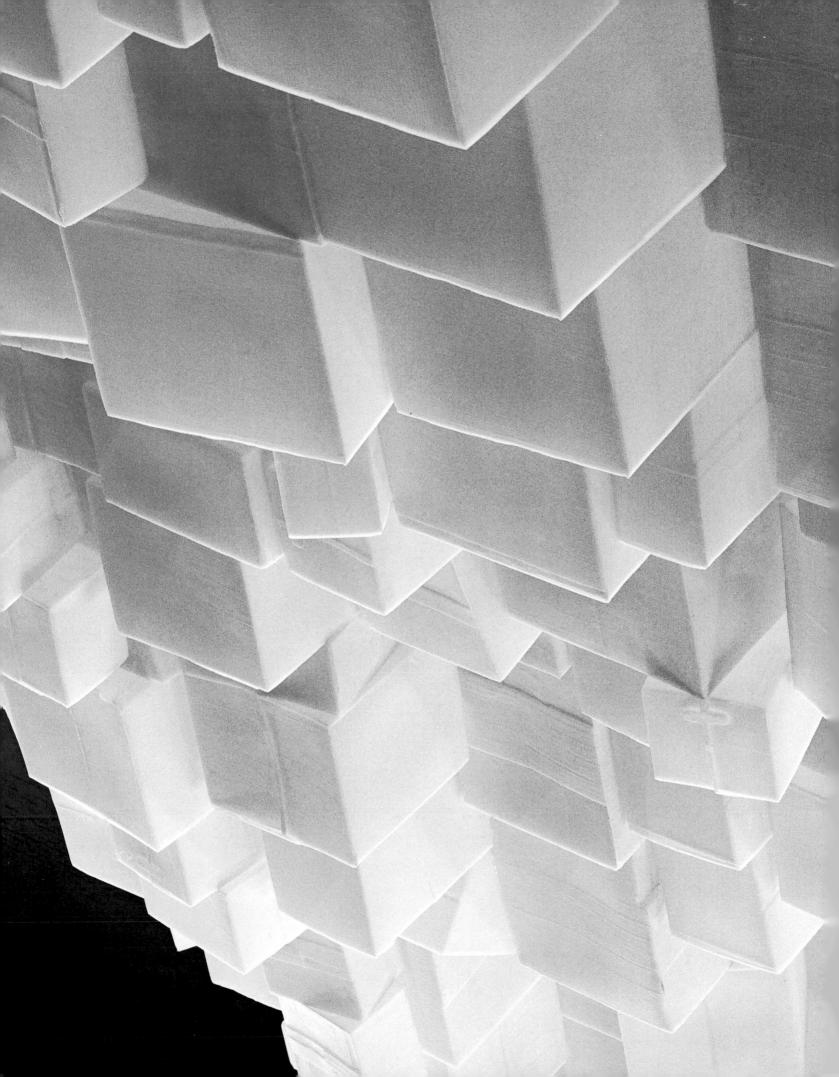

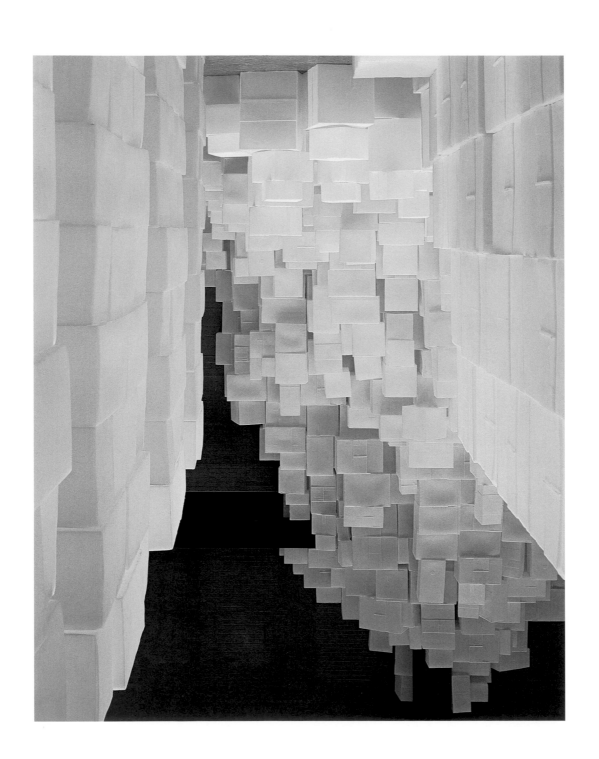

Rachel Whiteread in conversation with Gordon Burn

16 June 2005 – East London

GORDON BURN
Perhaps a good place to start would be for you to explain the thinking that took you from doing a big, monumental, politically highly charged piece – the Holocaust memorial in Vienna – to about as far away from that as you can get, which is a cardboard box, basically.

RACHEL WHITEREAD
I've been making sculpture for about twenty years, and, from having a very quiet start in the studio, and doing the painting and decorating and everything else you have to do to earn money just to *be* in the studio, and organising my life in a certain way, I then had the luxury of being able to be in the studio full-time. I had the money, I was selling work, and along with that comes assistants, and big international shows, and your career just takes on a whole different kind of scope. I've always resisted working with lots of assistants and having a massive production in the studio. But, you know, these things without a doubt change the way in which you work.

You've always been hands-on yourself? I don't just mean in the period pre-dating studio assistants, but in the day-to-day making of the bigger work.

I've always been completely hands-on. *Ghost* I made. *House* I made. But some of the more recent larger architectural works, I actually *haven't* physically made. The people that I've worked with for a long time make them, and I come in. The works that were actually cast in this building, those two *Apartment* pieces, and the small staircase pieces, I didn't physically make any of those, but I was totally around. So I became like a 'producer' of the larger works. Which is great in

some ways. But I was feeling, not that my *touch* had necessarily gone, but that it was all a bit out of control and I just wanted to go back into the studio.

Was it the complex political and other wrangles that dogged Holocaust Memorial *that finally influenced you in your decision? Because before that you'd had the uproar and unlooked-for controversy surrounding* House.

House really was a very different thing.

But it was collaborating with an organisation like Artangel, and Bow Council, and then the media picking it up and feeding it and keeping it on the boil as a story – art splashed across the front pages. It was extraordinary at the time.

I was a baby artist then. I think if you can go through things naively it's much easier – even though it was incredibly stressful. But I didn't really have the responsibility: Artangel had the responsibility of managing the situation, as it were, although I was personally in the firing line.
 Holocaust Memorial was the beginning of trying to get people to make things completely somewhere else, but also trying to work with components, and trying to think about spaces as components rather than as one piece, which is where the books came in. *Holocaust Memorial* is, essentially, a cast library. It's something I'm incredibly proud to have made. But it was the most hands-off thing I've ever been involved with, and I remember having hours of arguments about wanting more bubbles in the concrete and I wasn't allowed to because of frost erosion, and so on

and so on. There were all sorts of frustrations with that. But essentially I was quite happily working away.

Then I was moving house and studio and starting a family, all at the same time. So life was just in chaos. I was determined when I moved studios that I wanted to work in the way that I used to work. I've got a large space now, but I wanted to be intimately involved with what I was making. Like in the way that I've always drawn, or – from very early pieces like *Yellow Leaf* – completely made them myself.

So you felt that a new studio meant a new start; that as well as making a change in your life, you had to make a change in your work?

Yes, I think I did. I think I wanted this studio to be *my* studio, rather than a studio for me and my assistants. I didn't want all the chaos of the last place. I wanted to take ownership of it, and in order to do that I had to physically make the work in it, and so it was a case of trying to work out what that was. I decided I wanted to find a way of making an object that was something that I could repeat, that I could build with, that I could use as a sort of building block, that was *abject*. There was something about finding cardboard boxes; I was just sort of looking at them in the studio, and some were empty, some were full, some had loads of precious things in, some had rubbish in them …

Why was the abjectness of the boxes important?

I wanted to start with something that was as dumb and inert as I could find, that wasn't a brick.

You told me the last time I came to the studio that the old Sellotape box that you've flattened and fixed to what you call the 'collage wall' used to have your family's Christmas decorations stored in it all the time you were growing up.

The other great change in my life is that my mum died very suddenly. She went into hospital for a standard investigative procedure, but she died. It was a year before we could face starting to clear her house. I was doing it with my two sisters, and it was a really incredibly emotional thing to do – I don't think any of us had realised *how* emotional it was going to be, going through the house, and the basement. She'd lived there for about ten years; not really a long time, but a lot of stuff that she'd never unpacked from before just stayed in the basement. So there were layers of stuff down there that were very peculiar to go through. The things I'm talking about now were *their* belongings; things they'd had before my dad died. But then there were our toys, all very mouldy. I've still got black plastic bags and cardboard boxes.

After gradually sorting through stuff, we chucked away as much as we could, but we stored a lot as well. But it then became … everything looked like a still from a film; a film of my life. And I felt I was going mad. Because every single thing had a significance – connections and associations that you couldn't stop. And I really thought 'I'm going to go insane here if this carries on.' It did subside. But you know in movies when they do a flashback of memories, like in *Terminator*? If that had gone on for a long period I think I would have ended up in therapy. Because I really was thinking 'I can't live the rest of my life having to repeat these memories.' I really couldn't do that.

You told me you had tugs-of-war with your sisters over small, common-or-garden, apparently insignificant household things, things that you felt meant more to you than the others.

No, I think we all had equal memories of baking cakes with my mum, or separating eggs … I've got this funny red plastic, fried-eggy object. Just totally silly. But I felt: 'No, I need to have that.' Why I needed to have it, I've no idea. I'm actually using it in the kitchen. But I think those things are … Obviously it's incredibly painful, but also it's quite cathartic when you do go through all of this stuff.

But there is one other thing, actually, here in the studio, in addition to the Sellotape box. You see these three boxes [photographs of the interiors of three cardboard boxes, ascending in size, each box containing a broken Pyrex bowl]. That was actually an artwork of my mum's.

You told me she used to have them up the staircase in her house, like plaster ducks.

I *love* having in them in here, actually. Because it's absolutely to do with what I'm making. I will put them up in our flat, but at the moment they're on the collage wall.

But to go back to the period immediately before I started on this new work: my mother's house was still full of stuff. And my house was still full of stuff from having moved and still having the builders in. So I was in this place of literally not being able to unpack my life, my mum's life – my parents' lives. We were having a disaster, because we'd moved into a building that wasn't finished; I couldn't get in my studio. So I was *thinking*, but I wasn't physically making anything, for probably eight or nine months. And I kind of stumbled across it in a way. And once I fixated on the cardboard boxes, it just sort of became … my world!

And at this stage it involved taking cardboard boxes and doing what with them, exactly?

As I say, I became fixated: looking for boxes, finding very specific ones, working with them, crunching them up more; or just looking for ones that had had particular objects in them that left an impression on the surface – cans, or bottles, or sharp objects, or whatever.

That's on the interior surface?

Yes. All the casts are made from the inside of the cardboard box; not from the outside, from the inside. Which sounds simple and straightforward, but … I

love it when there's been a circular object, whatever it is, inside, and it's been moved around a lot in transit, so you get these beautiful drawings, circular shapes.

Although your work practice is very well established by now and, in theory, we've all got used to the idea of 'negative space', in practice it's something I still often find difficult to get my mind around. It's still a big leap between knowing that you cast the insides or undersides of objects, and recognising what you're looking at.

You can't figure it out. But it's the place where all the flaps are shut. It's inside there. It's … oh, you know!

The casts that you're using in the Turbine Hall aren't going to be solid, are they?

Initially I thought I could do it all in plaster. Then I realised you needed about fourteen thousand of them [laughter]. That physically wasn't possible. And it just wasn't right, actually. I'd started making objects in the studio, with the boxes. That was becoming very much the studio activity: combining the boxes with other elements, furniture and whatever.

Had you tried casting other objects before you settled on the boxes?

Actually, yes. I was trying impressions of objects, and pushing one thing into another and casting round them. But that's always been the way I work: I actually spend a lot of time figuring out what it is I'm going to make before I start making the finished pieces.

You've grown to trust some instinctive gut reaction to what you're doing?

I'm like some old rag-and-bone woman. I'll go out and get loads of stuff, bring it all back to the studio and just start playing around with it. And a lot of it gets chucked before it's cast.

That's something that your generation of British artists has in common: reclaiming disregarded, everyday urban detritus for use in their work. It's also what connects you to the previous generation of Lisson Gallery sculptors like Bill Woodrow and Richard Wentworth and Tony Cragg, who also picked over the rubbish tips and skips looking to find use for the things that people had thrown away.

Well I suppose so much more stuff gets chucked away now, doesn't it? I remember my partner Marcus's grandfather in Ireland. He never threw anything away. *Everything* had a use. He once gave me a walking stick made out of a Christmas tree. And he'd put a little rubber stopper on the end of it: 'You'll go a long way on that.' The fantastic creativity of never letting anything go. As you can see from my studio, not much gets thrown away. But, as a whole, for our generation, the iPod generation, everything has to be clean and technical and perfect. When it breaks down, you don't mend it; you just get another one. But I'm a hoarder – always have been.

But in the art-historical sense, what do you feel is the significance of the fact that, for twenty-five or thirty years, many of the most prominent British sculptors have been scavenging and recycling scrap?

It's not just British sculpture, it's an international phenomenon. But I think for our generation, the Bill Woodrows and Richard Wentworths and people like that were incredibly influential. They were all teachers, and they all taught my generation of artists.

There was minimum intervention, in a way. The found objects were always more or less left as they were.

Bill Woodrow changed everything, didn't he? Everything was cut up and turned into something else: a washing-machine into a guitar or whatever. And mine's a total intervention. The things don't exist any more. They're just used as moulds.

Perhaps a better way to look at it is as a shared aesthetic of the fundamental rejection of monumentality.

I know what you're saying, but it's very much just using the detritus and the stuff that's around. For me, it was very much fixed in memory. That's where it came from initially. And now it's become – with the boxes especially – a vehicle for building something. I think some of the plaster box works are going to be very intimate and pathetic.

What was the first one you made?

It's basically two plaster boxes that I stood – completely accidentally, in a way – I just stood them both on their ends, and they were sort of looking at each other. They're the same height, and they've got quite big ridges on the front of them. And I looked at them and I thought: 'I think I've just made a version of another sculpture.' I said to Marcus: 'Marcus, come and have a look at this; what does it look like?' And he said: 'Brancusi's *Kiss.*' And I'd just made the same thing, but out of two cardboard boxes. Obviously it wasn't the same thing, but it had exactly the same sort of presence. And that was a kind of extraordinary moment, in the way that when I made *Ghost* there was a moment when I first saw the light-switch inside-out and I suddenly realised that I'd made this work, and that I was the wall. Even though I'd been making the work for three of four months, I was inside it, and could never get any sense of what it was, and it was only when I put it up in the studio that it was like [sharp intake of breath]. It was really like that. And it felt the same with these boxes.

I think very often you can make work and you *sort of* know where you're going. But it's obviously nice *not* to know where you're going all the time and to lose your-self in a way of making – that's the really good creative part – and then to be able to assess it, and I think that's where the art comes in, because you can work out if it's good or not … [laughs], if it's worth keeping.

And I think with this piece ... Well, we'll see, but I like the work, and we'll see what other people think about it. But for that moment I thought: 'To transform a cardboard box totally unintentionally into a twentieth-century sculptural icon is quite a bizarre step.' Not that I'm trying to do that now.

Can you remember what prompted you to place the boxes in that relation to each other?

Just by using the boxes as building blocks. That was the beauty of making them: you could just make these things; some of them were really creased, some of them were perfect, and you try to work out a very formal relationship between things. In the studio now I have lots of plaster boxes and I have the problem of trying to make them into sculptures. That's the bit that's really taking the most time. It really is quite tricky. Someone came and saw something the other day and said: 'That hasn't worked yet, has it?' Then two days later they came back and said: 'Oh look, it's cooked now, isn't it? Looks perfect'. It's like making drawings.

I thought at first when you said you'd put these two boxes on end next to each other you were going to say the first image that came to mind was the Twin Towers. I suppose it's not such a huge leap from them to Brancusi's Kiss. They had a sort of anthropomorphic relationship to each other standing at the tip of Manhattan.

I actually had a picture of the Twin Towers that I was going to put up there on the collage wall. But I've resisted having any imagery of the Twin Towers since they got blown up. I feel I'd rather respect them in memory.

So after your eureka moment, you did what?

So then I went into a cardboard-box-casting frenzy [laughter]. The two that I first cast were off the street. They were just two particularly grotty boxes.

Soggy?

Not soggy. Soggy I've avoided. Actually I had one soggy one that I dried in the studio. But around here soggy is not generally to be recommended.

Would you be put off by what had once been in the box, or by the wording on the outside, or a logo? In other words, no to tampons, say, but yes to soup? [laughter]

Maybe. Maybe subconsciously. I've tried not to select things in that way. It's just more to do with either the shape, or with the personality inside it – what's actually happened to the interior; the traces left by what it once contained.

You obviously haven't, and can't, use the Sellotape box from your mother's house that was used to store your childhood Christmas decorations because the process of making the cast would physically destroy it.

Maybe one day I will.

I collect dolls' houses, as you might see. And not dinky dolls' houses, but old used ones, and mainly handmade, or at least ones that have been decorated in some way. I've been collecting them for years, and normally I just get them from junk shops. But eBay is a great source for this sort of thing, and the average eBayer is quite odd, I think – the eBay seller – especially for objects like this, with awkward shapes. They come in the most *fantastic* boxes, like a TV box that may have been totally reconfigured. They'll cut a bit, and then they'll stick a bit down ... They're people who don't have any idea about three-dimensional things and practicalities, and they do it in such a bodgy way. It's always a completely weird package. And I realised: 'this is what people *do* to them.' It was a totally practical thing; part of the transaction was to stuff them in this box. So I actually used a lot of those; they had all that history around them. So it just became a whole other world.

You said once you used to buy secondhand furniture from Loot *but you came to be unnerved by the interaction with the people you were buying from and the closeness with the personal histories that were imprinted on their beds and tables and chairs.*

Absolutely. With eBay it's a bit more impersonal. In fact my assistant does most of the eBaying transactions for me [laughter]. But nevertheless the interaction with the seller is on average quite peculiar. Recently, for example, someone turned up with a dolls' house in a Rolls Royce and they had another little box with the family in it and, because they were late delivering, they also presented us with a box of Matchmakers. I mean it really is quite peculiar… It's just some weird world.

The cardboard box has multiple associations, especially in the context of city living. Like with a flattened one you think of people lying in shop doorways or on park benches, or homeless people sleeping in the bigger ones at night, packed in with their few possessions.

For this Tate book I've been collecting lots of images, and I wanted to include some images of cardboard cities, and how people use them as shelters, essentially. I don't know if you remember under Waterloo when there used to be this whole cardboard city there? It was a completely extraordinary place. As a student I used to walk through it all the time and it didn't ever feel threatening; it was where people lived. But I realised there's a real problem with photographing people who live in these places, because there are issues about privacy; but it's not something that should be forgotten about. In fact somebody told me the other day – not that I've been watching – that on 'Big Brother' one of their tasks was to see how long the people in there could last living in cardboard boxes. Which to me seems just so totally insensitive. Completely extraordinary. But then it is 'Big Brother' [laughter].

Can we talk a bit about the connection between the work you've been making in the studio for your next

London gallery show and the piece you're doing for the Turbine Hall?

The Tate initially approached me about eighteen months ago, and I was just beginning with this work in the studio, and I was feeling unsure as to which direction it was going to go in. So I spent about three months mulling it over and then I thought that if I could find a way of totally mass-producing these boxes, then I could make it work. So that you could make the inside of the Turbine Hall almost like landscape, as well as like this massive storage area.

Last time I came you said you had the idea of 'warehousing' Tate Modern. I wasn't really sure what you meant by that.

Well, the only spaces that I ever see that are enormous and gargantuan like the Tate Turbine Hall are warehouses. Whether it's Ikea or B&Q or an image from *Raiders of the Lost Ark* or *Citizen Kane*, they're the only kind of places that are just *massive* on that scale. And it struck me that, by using these boxes – there are basically ten different boxes, which have six different sides – there should be a way to do this repetition thing with them. And by using some very small ones and some quite large ones, I'd really be able to play with one's sense of scale.

I did also think of finding *something* that was just vast – that was so spectacular that it would be just that one thing in that enormous space. I've no idea what that is. I think if someone could do that, it might be a masterpiece. But I've definitely gone for more of the theatrical version. The Tate thing undoubtedly is going to be a spectacle, and theatrical, and it has to be. It's the only way to deal with that space. And I have to make that jump. That's what I've done. And that's how it has to be done.

Do you find you spend your time mentally building stacks of boxes?

I often put on very loud music in here and just play with that model like a kid's toy. It's actually really good fun, just stacking these things up and unstacking them and getting little figures walking round them.

Are these physically the most lightweight things you've ever made?

Yes they are. I mean, they're skins.

In fact they're both aren't they? They're both the interiors of objects with the outside protective skin removed, and at the same time concrete entities in themselves. Solid air. It's going to be like seeing a load of space piled up. And you can push it over.

Well, I think we're going to try and make sure that doesn't happen [laughter].

It's become almost a cliché about your work that it has always referenced the human body and it's always anthropomorphic. You once said: 'All the sculptures I make refer to objects that we've designed for our bodies: beds, tables, chairs, bathtubs, etcetera.' I was going to say the cardboard box doesn't have that obvious human connection, except now that I hear you describing them as 'skins' there's a temptation to let the mind wander in the direction of flayings, or even the emergency coffins you see in newsreels after an atrocity.

I hadn't made that connection. You're very sinister [laughter].

You've said you've always been interested in the macabre. The evidence is there: stained mattresses; plughole hair; mortuary slabs.

I have always been interested in the macabre. I thought I was getting away from it though, but obviously not [laughter]. No, I think it'll have a very different feel to anything else I've made, actually.

And you feel at this point that it's both exciting and scary?

Absolutely. Exactly. Which is why I'm doing it. I've had to push myself into another direction, to keep myself interested, and also to deal with that kind of scale, on the kind of budget you get to work with. I've often thought it would be great to cast a street. You know, it's actually known as 'the street' – the Turbine Hall is classified as a street, architecturally. And I thought: 'You could cast an entire street inside.' And then I thought: 'Actually I don't want to do that. I really *don't* want to do that. I made *House* ...'

It's a strange irony that, after going though Holocaust Memorial *and all that that involved, moving here, scaling down, working by yourself, you then turn the thing you made into the building block, literally, for another monumental thing that involves money, meetings, manufacturers, government agencies ...*

It wasn't something I took on lightly. It took me four or five months to say yes. It was a case of: do I really need to do this right now?

Is this the way the art world, and the world in general, now pushes artists? Towards bigger, grander, sometimes grandiose work, needed to fill the vast, more imposing spaces that have been built to hold it?

I think there is that pressure. But when I started working with Gagosian Gallery in London I said that I needed to spend a year and a half just sorting myself out. And they were very good about just completely leaving me alone to get on with it. And, you know, I've got a reputation as an artist who's not an arse. I do just get on with it, and I'm very steady and pragmatic.

You found it very stressful at one point, flying around the world installing shows, repairing pieces?

Very. All of that stuff. It can really get on top of you. And it gets to a point where you just actually need to shut the studio door.

Is this a new kind of pressure for artists?

A few years ago I went to Henry Moore's studio, and it was fascinating going there, because there are a few sheds and outbuildings that have fake skies painted on the walls on the inside. And I was asking: 'What's that about?' And they said: 'Oh that's for the maquettes.' They used to make the maquettes, then photograph them from a very low angle, like Albert Speer did when he wanted to persuade Hitler to build whatever. Then Moore would go over to Canada, America, Australia with the photograph and say: 'I've got one of these, one of these, or one of these. Which one d'you like?' So he was the first British artist, I would say, that ... you know: hustlers – people who really know how to get it all working for them. It's why there's a Henry Moore on every street corner in every city.

If you want to do that, you can do that. There was a great pressure on me to become a memorial-maker after I made *Holocaust Memorial*. I don't do that. I don't work like that. I've made four public sculptures, and people think you're producing products. But a lot of the time, making good pieces of work is a completely cathartic process. It's about the whole life; it's about all experience; it's about everything that happens. And if you can channel it out somehow – great.

In addition to being cool and minimal, your work has always had social and human resonances that the work of, say, Sol LeWitt and Donald Judd never had. Is that going to continue to hold true with the boxes?

Someone came to the studio and sent me an email afterwards saying the work was somewhere between Brancusi and Donald Judd ... I can do things in quite a formal way, but there's always emotion in there. It's just how I am. I walk round with my heart on my sleeve, and it obviously is in the work. And, you know, I wouldn't want it to be any different. I wouldn't know how to make anything else. It's simply how I do it.

I think there will be touches in the Turbine Hall installation that are very intimate; maybe very sad little piles. I've been trying to work that out over here ... I mean, these are almost like Sol LeWitt pieces. Does that belong to a family? Is that one person's thing? Is that Ikea? I think until you start walking through it, you won't have a sense – and I won't have a sense, until I've actually made it – whether something is going to look like a building or a landscape, or chaos, as if someone has been trying to find something and hasn't been able to and it's been kicked around a bit; just a mess. We'll see.

And you're conscious as well of it being looked down on from above, from the bridge.

So there might be some very formal areas, some very high areas ... To be honest, I'm not *sure* how it's going to work. All I can do is play around with these blocks. It's a bit of an unforeseeable thing. I'm hoping it will work [laughter]. If it doesn't, I'll just throw them all in there in a great big pile [laughter].

Was that a decision arrived at very quickly, that it would be clean and white and translucent?

I wanted to use a natural material. I didn't want to start dyeing things. It's not something I normally do – play around with colour and stuff. I normally use the colour that the actual material is. I didn't want to have something that was black and totally oppressive. I wanted it to be something lighter than that. The Turbine Hall's actually quite a dark place, but I think that by having so much white in there it will really feel illuminated.

They do look like what they are, which is the product of an industrial process. You haven't done that before.

It was a sort of leap of faith, really. It's very exciting, because everything else I've ever made, I've been able to sort of visualise as I made it. And this is like, this could be ... Wow!

Are you a control-freak kind of person?

No! [laughter]. Not at all … I think, inevitably, to dream up something like this, you've got to be a control freak, haven't you? Or at least have a large ego.

I sense that you're sort of braced for people to go: 'A cardboard box! Is that all she could come up with, a cardboard box?'

I am completely braced for it. And in the early stages, when I was still making collages and just working all this stuff through, I had to try to figure out whether or not it was really *dumb*, actually – just too stupid to do. But it's funny, a friend of mine the other day who's seen some of the work said: 'I can't go anywhere now without thinking, "Oh that's a good one!"' – just about the shit that you see in the street, and making aesthetic decisions about whether or not you like a cardboard box. It's nice to affect people's lives in that way, I suppose. But I've no idea how it will go down. What I'm hoping is that a lot of people who go to the Tate will also go to Gagosian. I'm making a series of works with the plaster boxes, small-scale, and I think that will be a completely other version. That will have a very, very different feel. The pieces have a very different feel. They're filled in. They're essentially lumps of plaster.

If you look at the components of Ghost *and some of the other pieces, they're basically blocks, aren't they, piled on top of each other? You see the seams, so you get the feeling of similar-sized units making up a construction. There's that link.*

There is. Not so much *Ghost*; that was like a skin that was then put on a metal framework. That was the only way I could work out how to make it. But there was another piece I made called *Room*, which was actually solid blocks that stacked on top of each other, and it was freestanding. The wardrobe piece I made, that was basically rectangular elements. So, definitely, the

thing I was looking for was to find a component – a sort of component part that I could fiddle around with. I just couldn't work out what it was.

When I made the chair pieces, I made a number of those in resin. And that was the same thing: I was trying to find something that I could use as a repeat, that could be like an absent audience.

Do you still get the trace on these boxes for the Tate show, the kind of evidence of a previous life that you've always been interested in?

Not really. Some of the ones in plaster, yes. These plastic ones, no. The trace is totally gone. These are actually three-times removed. I gave them the originals, which were plastic. They then made moulds from them, and then made an aluminium skin as the outside, and that's what's being cast at the factory now. So these are third-generation. That's what happens when you do this kind of casting, it gets removed and removed.

Are you sad about that?

No. It's just the process. So no, not at all. I can't get sentimental about fourteen thousand plastic boxes [laughter].

What are we supposed to feel, looking at them?

I don't know. I would imagine there will be a sense that you'd be over-awed by them. I imagine that that's what will happen. And the way it's going to be installed is that it will be beyond the bridge in the Turbine Hall. With some of the artists who've showed there, you know what's coming, entering from the ramp. With this, you might see a little bit of it as you walk down, but I want you to approach it slowly and walk into it and gradually be overtaken by it. But who knows? It's so difficult to tell. I could spend a couple of months making some computer model and spinning the view around, looking at it every which way. But I think it's actually much more interesting to wait.

81

You've called it EMBANKMENT. *Why?*

An embankment is something that is built to hold back water, or to support a road or railway over low ground. I thought of it as something that was built up, and built up out of other materials, something that was completely connected to London and, specifically, resonated with the river location of Tate Modern, which I thought was important. As a word, it's associated with the moving of cargo – the boxes can be seen as cargo – it isn't too poetic, and it suggests scale.

There were so many other titles that I had, and that was the one that felt right in the end. We'll see when I've made the piece. I don't normally title things until they're made.

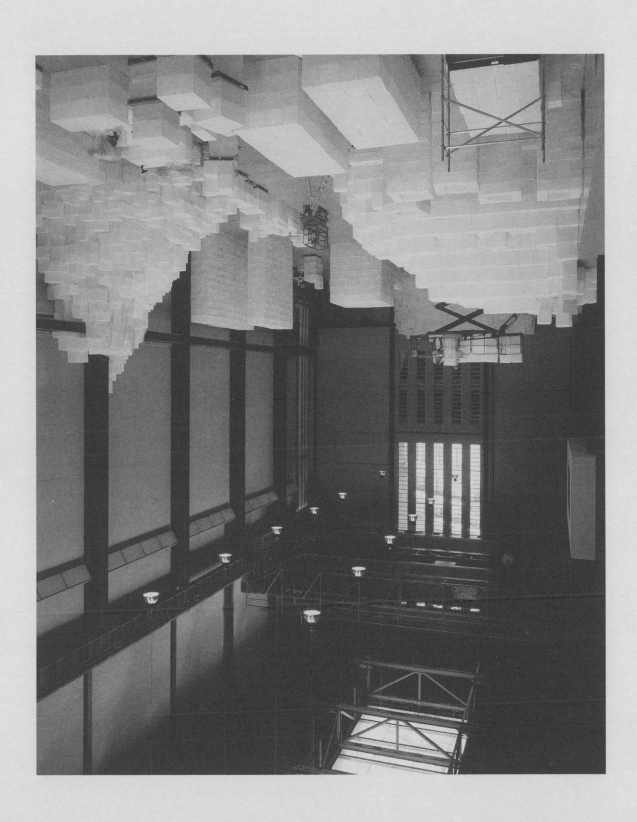

ELEPHANT AND OTHER STORIES

not to mention property-damage insurance. Jill had to borrow money to bury him, and then – can you beat it? – she was presented with a bill for the bridge repair. Plus, she had her own medical bills. She can tell this story now. She's bounced back. But she has run out of patience with my mother. I've run out of patience, too. But I don't see my options.

"She's leaving day after tomorrow," I say. "Hey, Jill, don't do any favours. Do you want to come with me or not?" I tell her it doesn't matter to me one way or the other. I'll say she has a migraine. It's not like I've never told a lie before.

"I'm coming," she says. And like that she gets up and goes into the bathroom, where she likes to pout.

We've been together since last August, about the time my mother picked up and moved up here to Longview from California. Jill tried to make the best of it. But my mother pulling into town just when we were trying to get our act together was nothing either of us had bargained for. Jill said it reminded her of the situation with her first husband's mother. "She was a clinger," Jill said. "You know what I mean? I thought I was going to suffocate."

It's fair to say that my mother sees Jill as an intruder. As far as she's concerned, Jill is just another girl in a series of girls who have appeared in my life since my wife left me. Someone, to her mind, likely to take away affection, attention, maybe even some money that might otherwise come to her. But someone deserving of respect? No way. I remember – how can I forget it? – she called my wife a whore before we were married, and then called her a whore fifteen years later, after she left me for someone else.

Jill and my mother act friendly enough when they find themselves together. They hug each other when they say hello or goodbye. They talk about shopping specials. But Jill still dreads the time she has to spend in my mother's company. She claims my mother bums her out. She says my mother is negative about everything and everybody and ought to find

BOXES

an outlet, like other people in her age bracket. Crocheting, maybe, or card games at the Senior Citizens Centre, or else going to church. Something, anyway, so that she'll leave us in peace. But my mother had her own way of solving things. She announced she was moving back to California. The hell with everything and everybody in this town. What a place to live! She wouldn't continue to live in this town if they gave her the place and six more like it.

Within a day or two of deciding to move, she'd packed her things into boxes. That was last January. Or maybe it was February. Anyway, last winter sometime. Now it's the end of June. Boxes have been sitting around inside her house for months. You have to walk around them or step over them to get from one room to another. This is no way for anyone's mother to live.

After a while, ten minutes or so, Jill comes out of the bathroom. I've found a roach and am trying to smoke that and drink a bottle of ginger ale while I watch one of the neighbours change the oil in his car. Jill doesn't look at me. Instead, she goes into the kitchen and puts some plates and utensils into a paper sack. But when she comes back through the living room I stand up, and we hug each other. Jill says, "It's OK." What's OK, I wonder. As far as I can see, nothing's OK. But she holds me and keeps patting my shoulder. I can smell the pet shampoo on her. She comes home from work wearing the stuff. It's everywhere. Even when we're in bed together. She gives me a final pat. Then we go out to the car and drive across town to my mother's.

I like where I live. I didn't when I first moved here. There was nothing to do at night and I was lonely. Then I met Jill. Pretty soon, after a few weeks, she brought her things over and started living with me. We didn't set any long-term goals. We were happy and we had a life together. We told each other

Tom said: 'Ma, what stuff we gonna take from here?'

She looked quickly about the kitchen. 'The bucket,' she said. 'All the stuff to eat with; plates an' the cups, the spoons an' knives an' forks. Put all them in that drawer, an' take the drawer. The big fry pan an' the big stew kettle, the coffee pot. When it gets cool, take the rack outa the oven. That's good over a fire, I'd like to take the wash tub, but I guess there ain't room. I'll wash clothes in the bucket. Don't do no good to take little stuff. You can cook little stuff in a big kettle, but you can't cook big stuff in a little pot. Take the bread pans, all of 'em. They fit down inside each other.' She stood and looked about the kitchen. 'You jus' take that stuff I tol' you, Tom. I'll fix up the rest, the big can a pepper an' the salt an' the nutmeg an' the grater. I'll take all that stuff jus' at the last.' She picked up a lantern and walked heavily into the bedroom, and her bare feet made no sound on the floor.

The preacher said: 'She looks tar'd.'

'Women always tar'd,' said Tom. 'That's just the way women is, 'cept at meetin' once an' again.'

'Yeah, but tar'der'n that, Real tar'd, like she's sick-tar'd.'

Ma was just through the door, and she heard his words. Slowly her relaxed face tightened, and the lines disappeared from the taut muscular face. Her eyes sharpened and her shoulders straightened. She glanced about the stripped room. Nothing was left in it except trash. The mattresses which had been on the floor were gone. The bureaus were sold. On the floor lay a broken comb, an empty talcum powder can, and a few dust mice. Ma set her lantern on the floor. She reached behind one of the boxes that had served as chairs and brought out a stationery box, old and soiled and cracked at the corners. She sat down and opened the box. Inside were letters, clippings, photographs, a pair of ear-rings, a little gold signet ring, and a watch chain braided of hair and tipped with gold swivels. She touched the letters with her fingers, touched them lightly, and she smoothed a newspaper clipping on which there was an account of Tom's trial. For a long time she held the box, looking over it, and her fingers disturbed the letters and then lined them up again. She bit her lower lip, thinking, remembering. And at last she made up her mind. She picked out the ring, the watch chain, the earrings, dug under the pile and found one gold cuff link. She took a letter from an envelope and dropped the trinkets in the envelope. Then she folded the envelope over and put it in her dress pocket. Then gently and tenderly she closed the box and smoothed the top carefully with her fingers. Her lips parted. And then she stood up, took her lantern, and went back into the

kitchen. She lifted the stove lid and laid the box gently among the coals. Quickly the heat browned the paper. A flame licked up and over the box. She replaced the stove lid and instantly the fire sighed up and breathed over the box.

Out in the dark yard, working in the lantern light, Pa and Al loaded the truck. Tools on the bottom, but handy to reach in case of a breakdown. Boxes of clothes next, and kitchen utensils in a gunny sack; cutlery and dishes in their box. Then the gallon bucket tied on behind. They made the bottom of the load as even as possible, and filled the spaces between boxes with rolled blankets. Then over the top they laid the mattresses, filling the truck in level. And last they spread the big tarpaulin over the load and Al made holes in the edge, two feet apart, and inserted little ropes, and tied it down to the side-bars of the truck.

'Now, if it rains,' he said, 'we'll tie it to the bar above, an' the folks can get underneath, out of the wet. Up front we'll be dry enough.'

And Pa applauded. 'That's a good idear.'

'That ain't all,' Al said. 'First chan[...]
plank an' make a ridge pole, an[...]
it'll be covered in, an' the folks[...]

And Pa agreed: 'That's a goo[...]

'I ain't had time,' said Al. [...]
before?'

'Stuff a fella got to do when he [...]
country. God knows where you b[...]

'Ain't had time? Why, Al, you [...]
to be goin', Pa?'

And then he lost some of his assura[...]

'Huh? Well — sure. Leastwise — yeah. We had hard times here. 'Course it'll be all different out there – plenty work, an' ever'thing nice an' green, an' little white houses an' oranges growin' aroun'.'

'Is it all oranges ever'where?'

'Well, maybe not ever'where, but plenty places.'

The first grey of daylight began in the sky. And the work was done – the kegs of pork ready, the chicken coop ready to go on top. Ma opened the oven and took out the pile of roasted bones, crisp and brown, with plenty of gnawing meat left. Ruthie half awakened, and slipped down from the box, and slept again. But the adults stood around the door, shivering a little and gnawing at the crisp pork.

WORLD POVERTY DAY SPELL OUT THE TRUE COST IN HUMAN MISERY OF DESPERATE LIVES

Population rise 'eating up all our resources'

BY ROB LYONS

THE world population boom is making it impossible for rich nations to tackle poverty and hunger, a top academic warned yesterday.

Too many people are using up the planet's natural resources leaving little for future generations, said Prof Anthony Young of the University of East Anglia.

He also warned that unless action was taken to cut population growth the UN goal of raising world living standards would not be met.

The answer, he said, was for 'ethical' ways of cutting population growth recommended by a 1993 conference in Cairo to be adopted. These included improving the education and status of women and making family planning services available to all.

Prof Young said some institutions trying to beat hunger and poverty, such as the World Bank and the UN Environment Programme, were not putting the need to cut population growth at the centre of their policies.

He added that in some developing countries, especially in Africa, advances in rural development were being wrecked by the soaring number of people. In a Royal Geographical Society report, he said the rise in the population of Malawi from 3million 40 years ago to 11million now has been accompanied by a drop in the size of farms, reduced soil fertility and lower crop yields.

'There are simply no viable development options left to its government or to the rural people themselves,' he said.

He warned that this scenario was typical of the future for many developing countries unless they acted to check population increase immediately.

A child lives in a cardboard box on a rubbish tip in Kyrgyzstan Picture: AFP

CARDBOARD BOXES
UNDER A BLOCKS
BEADY EYE

FOLDING
CREASING
V-GROOVING
CRADLE
CUBES
BOOK BOX
MEASURING
CAGE

A CLOSE LOOK

At some point when you've got a moment, it's worthwhile to take a really hard look at a scrap of heavy cardboard . . . close your eyes and feel the surfaces . . . work it apart and look at the pieces . . . notice the different textures . . . look hard at the way it's put together . . . try making a small piece by hand . . . try predicting the shapes you'll get when you take apart a small cardboard circle.

Wonder how they make it?

Tote boxes: VERY strong

Cut on solid lines.
Fold on dotted lines.

27

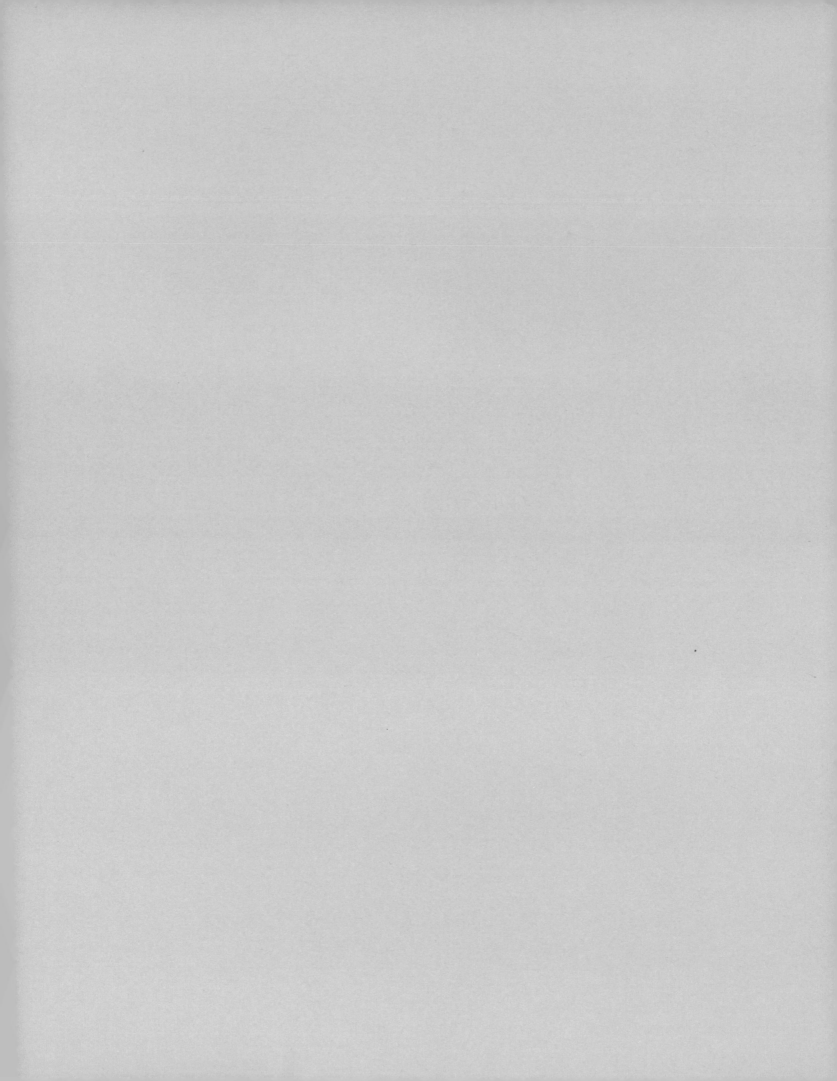

BOX ART

Assemblage and Construction

by DONA Z. MEILACH

182 Photographs and 19 Color Plates

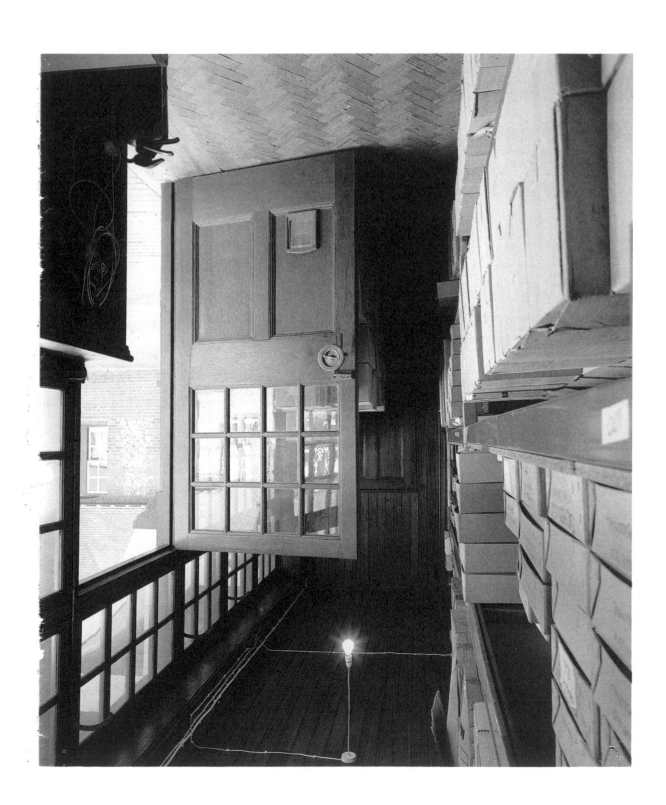

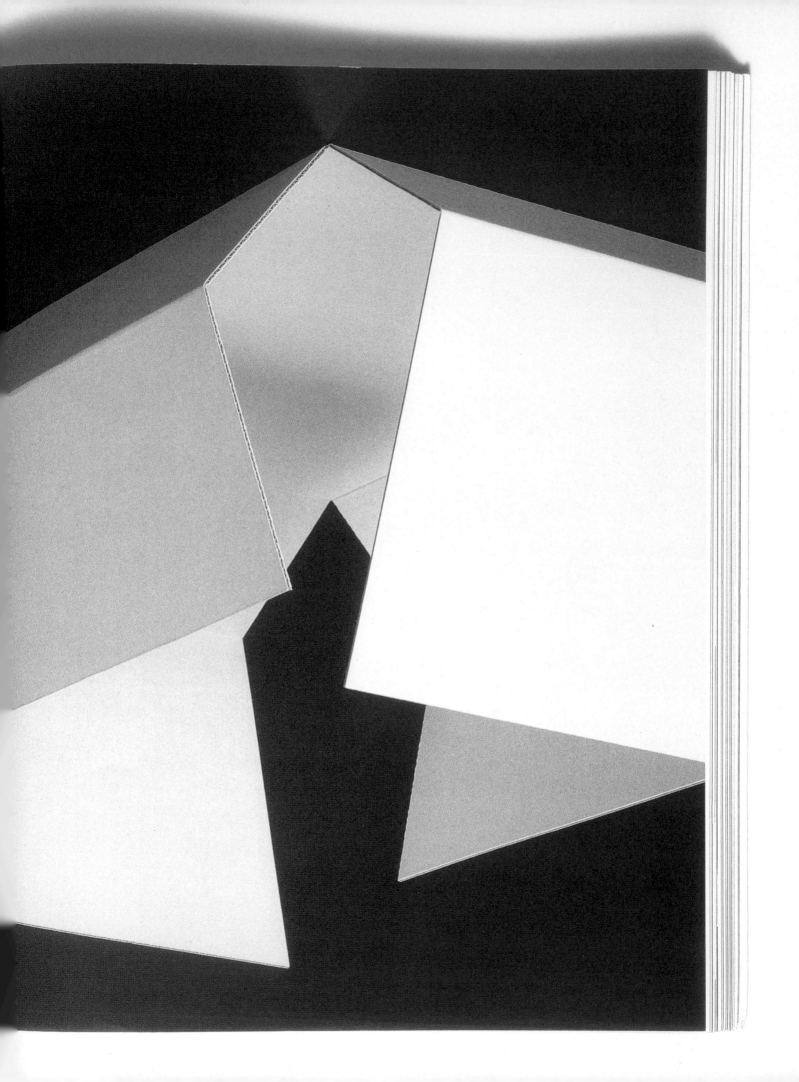

<<<

A corrugated carton used for transporting product units safely – as such, it trad-
itionally functions as a secondary package. It could be used for primary packaging
but the thickness of carton board would limit the size and scale of the container.
Corrugated board would normally be used for its shock-absorbency and strength.
This carton is typically sealed with adhesive tape/ or melt adhesive/staples.

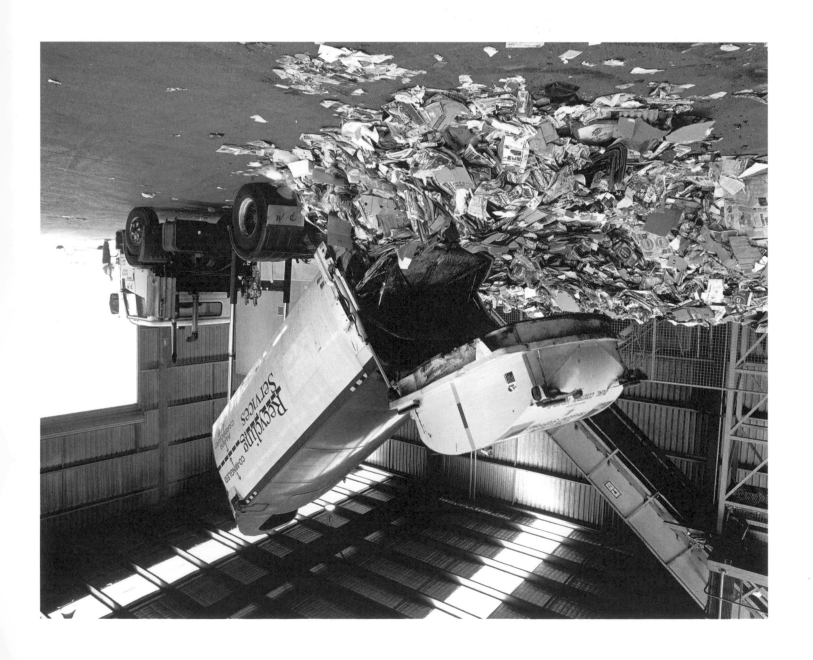

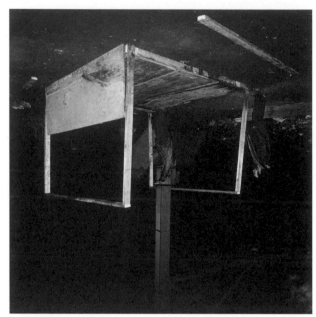
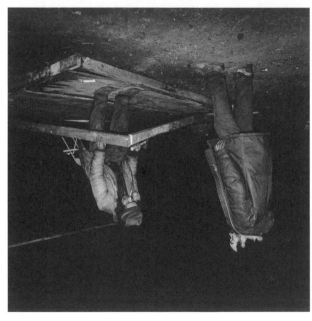
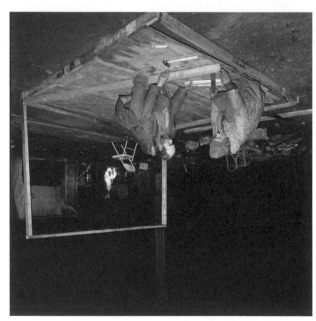

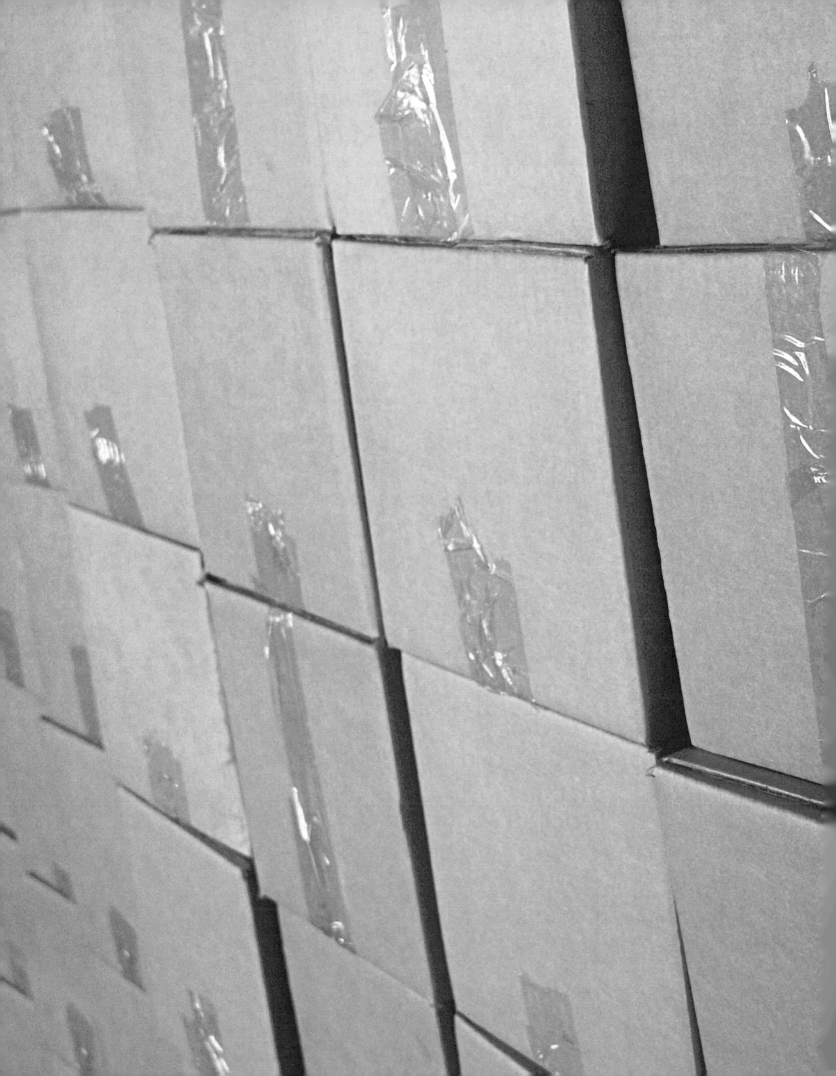

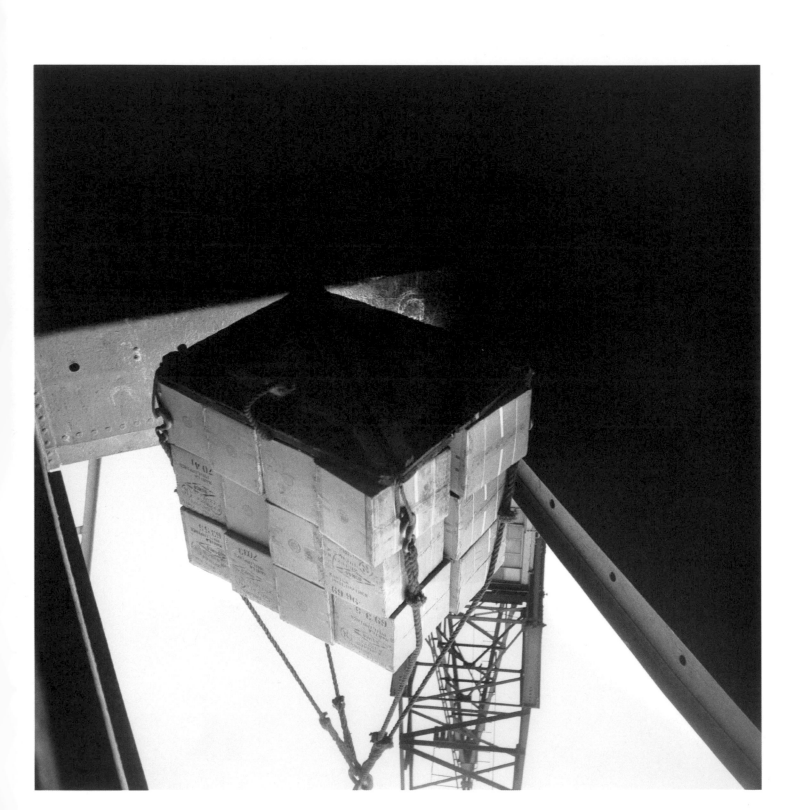

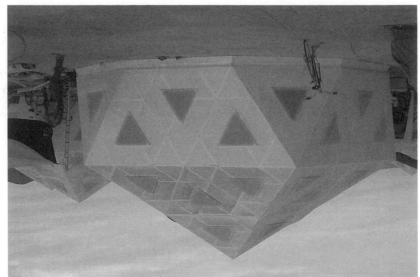

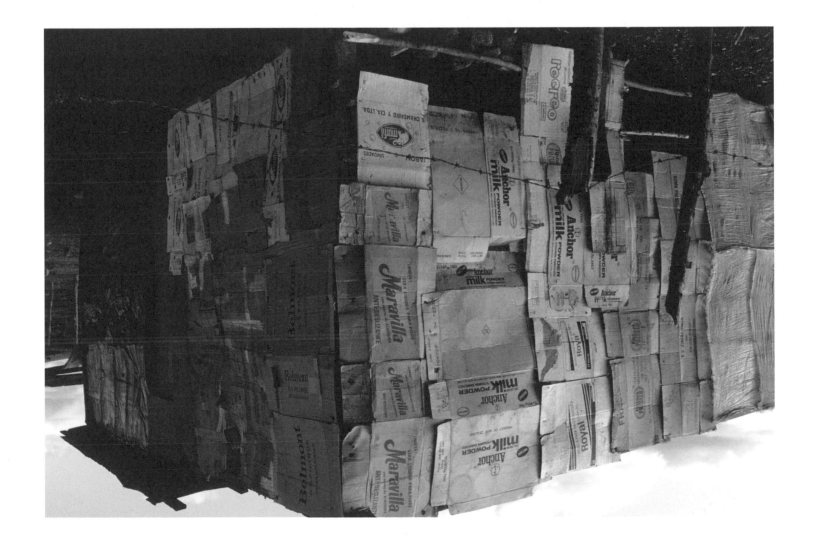

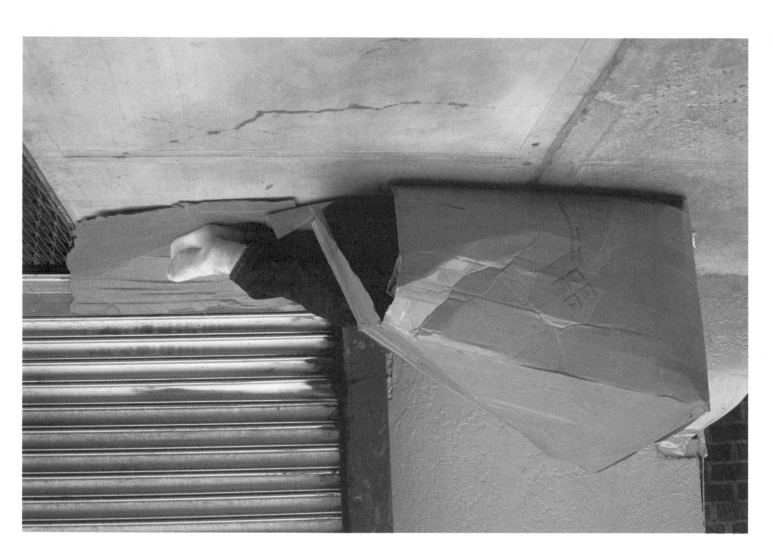

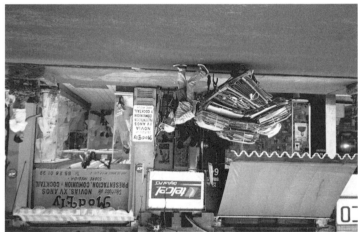

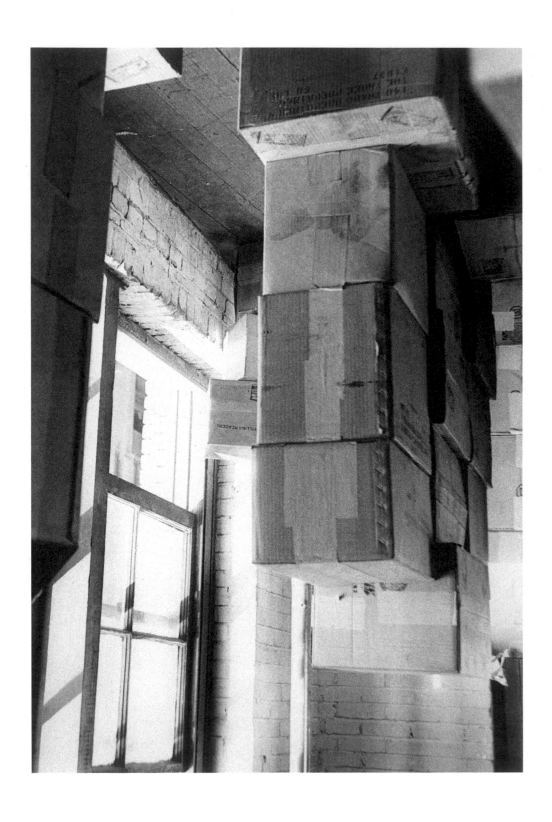

116

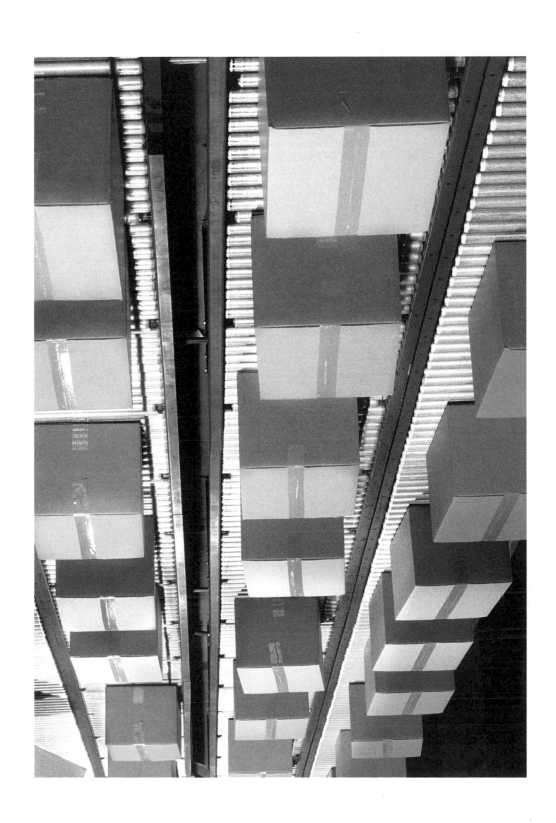

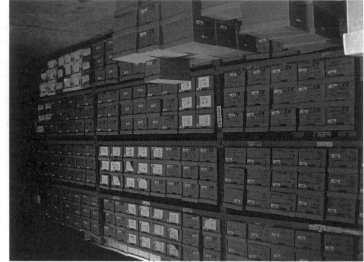
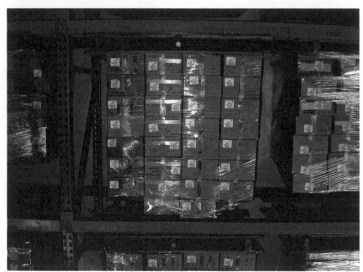

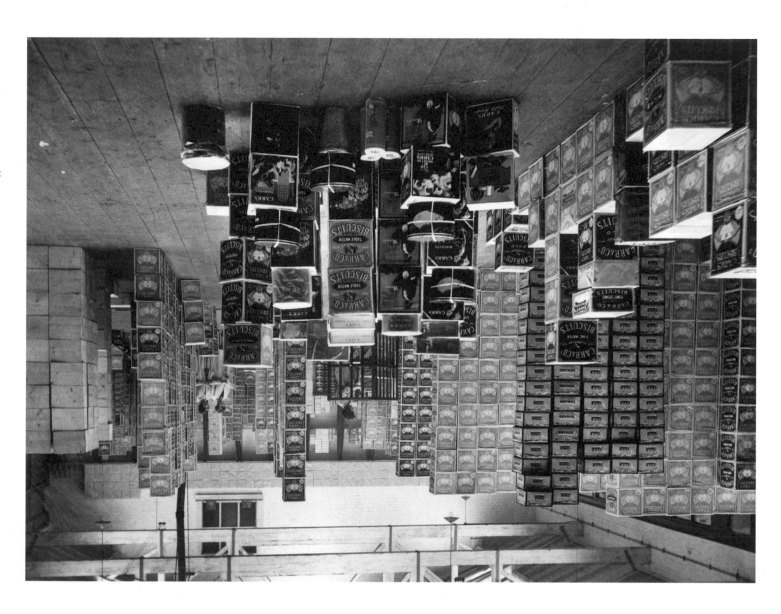

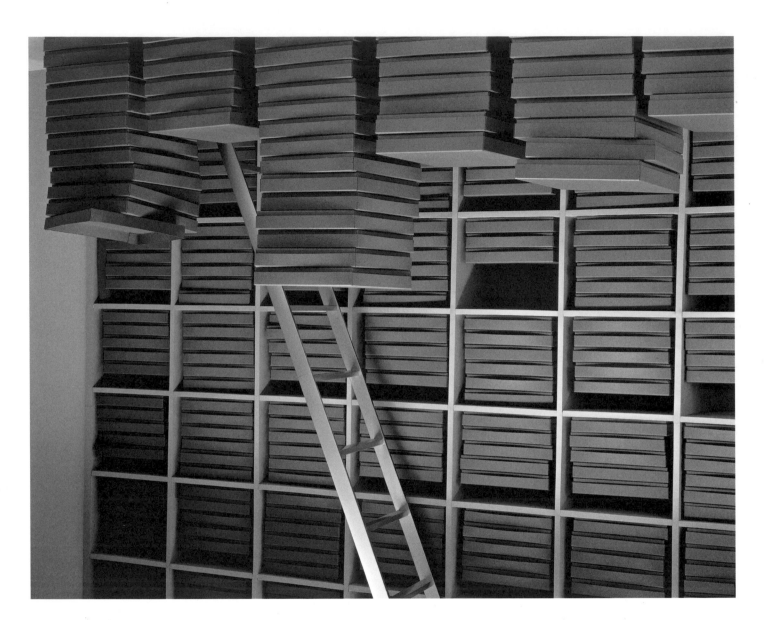

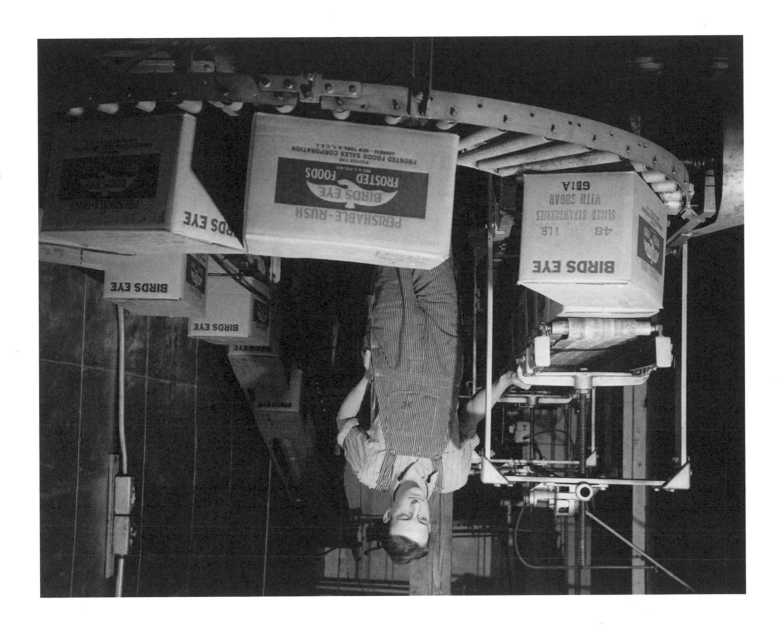

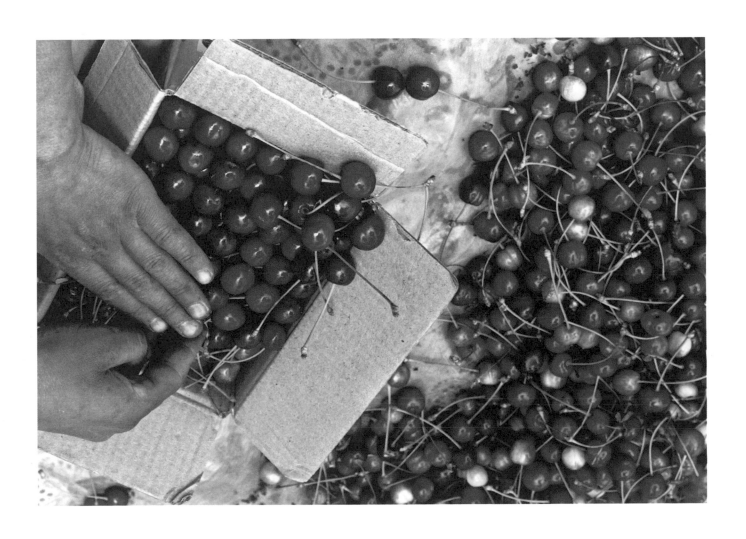

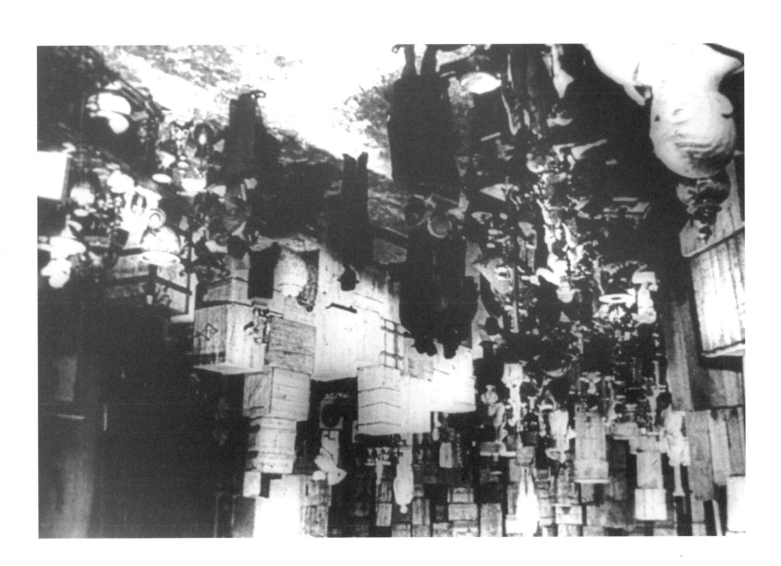

And she did at last.

Box references

Boxes and packets are now required for a great many purposes, and it may be interesting and useful to discuss a few of the large number of their more important applications. Not only shall I discuss them, but types will be illustrated, dimensions will be given, and details of the angular bends that are required will in all cases be included.

Wide variation will be noticed both as regards the size and shape of various specimens. The weight as a rule varies much less, and in the case of many small boxes or packets is under two ounces. The character of individual boxes is also subject to very considerable variation; sometimes these are paper-covered, the paper bearing the print; in others the box is printed on both sides; while in still other cases the outer side only carries printed matter.

E.T. ELLIS, *Paperboard Packet and Cardboard Box Manufacture*, London 1931

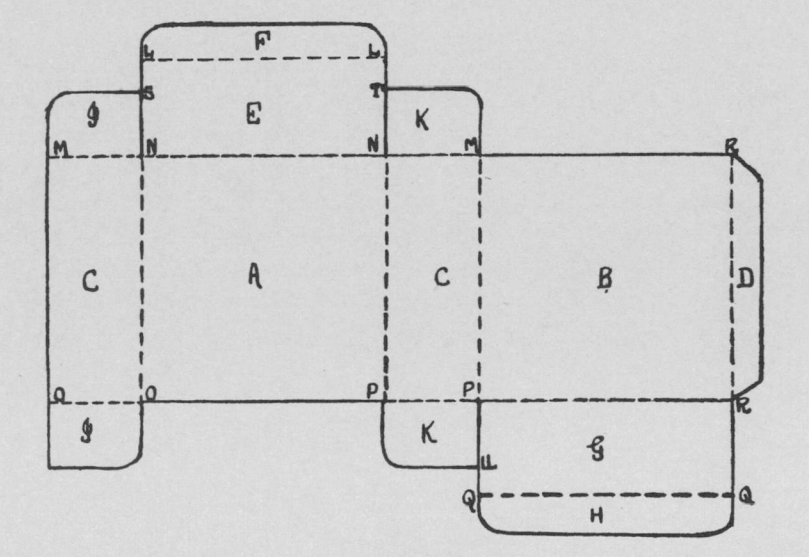

'How can one make a life of six cardboard boxes full of tailor's bills, love letters and old picture postcards?'

Virginia Woolf on beginning her biography of Roger Fry

On the eve of the conclave, the 115 cardinals are deeply divided over the prospect of Joseph Ratzinger becoming the next Pope, paving the way for the emergence of a surprise compromise candidate ... Bergoglio has consistently kept a low profile and has given just one interview since becoming Archbishop of Buenos Aries – to a parish newsletter. He lives a simple life, cooks his own meals, rides buses and works with the people in the cardboard cities of the Argentine capital.

Gerard McManus, *Herald Sun*
16 April 2005
www.heraldsun.news.com.au

The city opens a $17 million shelter Monday amid controversy that funds would have been better spent on affordable housing.

Los Angeles – The modernist concrete-and-steel structure rises in the shadow of gleaming downtown skyscrapers, looking like a new museum or corporate headquarters. Yet its identity is given away by where it stands: in the heart of a 55-square block area of aging single-room-occupancy hotels, where homeless men, women, and children crouch in cardboard boxes, push shopping carts, or lean in doorways.

Daniel B. Wood, *Christian Science Monitor*
18 April 2005
www.csmonitor.com

'We were shocked to witness an advanced country such as Japan allowing so many cardboard cities to exist.'

Rodney Hedley, a member of a British team that visited various homelessness projects in Osaka, Tokyo and Yokohama.

'Quote of the Day', *Japan Today*
6 March 2004
http://japantoday.com

But it's not enough to get young people to come to your restaurants; you have to get them to keep on coming back. McDonald's operates something like 8,000 Playlands around America ... Then there's the Happy Meal, launched in the US in 1979. It cost a buck in those days. Inside a cardboard box with a circus theme, children found a McDoodler stencil, a puzzle book, a McWrist wallet, an ID bracelet and McDonaldland character erasers.

Morgan Spurlock, *Don't Eat This Book*, Harmondsworth 2005

WSU's student chapter of Habitat for Humanity sponsored an all night sleep-out to increase the awareness of the poverty issue that surrounds the world. More than 20 students slept outside on the Quad in cardboard boxes to help simulate what a typical night is like for a homeless person. WSU's Habitat for Humanity President and biological sciences major Andy Diller said that the sleep-out was part of the Act! Speak! Build! Week, which is the worldwide student initiated week of support for Habitat for Humanity groups. 'The goal was to create awareness on the Wright State campus about the need to provide adequate housing for all human beings,' he said.

Erin Thompson, *Guardian Online*,
Wright State University
13 April 2005
www.theguardianonline.com

Since Poland joined the EU a year ago on 1 May 2004, industrious, ambitious Poles have become an integral part of the British employment landscape, arriving in their thousands to fill every and any job . . . And so graduates and non-graduates alike take their chances in the UK. But what happens when they arrive? Many are happy to take minimum-wage employment in whatever job they can get their hands on. For those who do not speak English, the move can be a traumatic experience. And even though Poles can earn much more than they would have done at home, the cost of living is correspondingly high. At the bottom end of the labour market, life can be extremely tough for the new arrivals, particularly those seeking work in London. Walk around Victoria at night and you will see Poles sleeping on what they call 'English mattresses' – cardboard boxes.

Ed Ceasar, *The Independent: Online Edition*
28 April 2005
http://news.independent.co.uk

The best arguments for the monarchy don't revolve around lofty issues of constitutionality. They concern compassion. For Britain's royal palaces are sheltered workshops to protect the woeful Windsors, amongst some of the most vacuous and vulnerable of its citizens. Far from keeping the plebs out, Buckingham's high railings and palace guards are there to keep them in, safe from the harsh realities that force similarly dysfunctional families to live in cardboard boxes on London streets, where any day or cold night of the week you'll see old ladies as worthy as Mrs Windsor wheeling their worldly goods around in supermarket trolleys.

Phillip Adams, *The Australian*
9 April 2005
www.theaustralian.news.com.au

I wanted to get a feel for the area, so I took a stroll down the block to the Volunteers of America Drop-In Center between Sixth and Seventh. This is Skid Row ground zero, lots of squats here for the low-to-no-income crowd.

Shopping carts pushed against the buildings border the sidewalk on either side of the block. Wheelchairs. Crutches. A discarded walker lies toppled in the gutter. A shirtless, skeletal 20-something man in filthy, low-hanging jeans is crawling on his hands and knees, taste-testing white specks from the street till he finds a keeper and scampers into a cardboard-box-and-blanket tent to smoke it up. Two older black men with blood clotting through last week's gauzed abscessed wounds watch from the next box as they smoke crack from a glass stem.

Sam Slovick, *LA Weekly*, 29 April–5 May 2005
www.laweekly.com

Leaving the surgery she stumbles into a corridor to be faced with a large cardboard box. From inside this box the blade of a knife appears, twisting through cardboard until a hole has been cut in both sides and in the top of the box. From the holes two arms and a head appear, a strange looking man stands up with the cardboard box now covering his torso. Yoko screams and runs away, but the man gives chase after drinking an odd red liquid from a jar in his hand.

He catches up with Yoko and the latter flails at his head with a hammer, a struggle occurs with Yoko eventually sticking the man's knife deep into the cardboard box. Blood pours out from inside the box and the man stumbles backward then oddly begins stabbing himself anyway, shouting at Yoko to watch him as he does so.

Review of *Bloody Fragments on White Walls*
(dir. Izo Hashimoto, 1989)
bizarreingredients.co.uk

The Box Man
Director: Nirvan Mullick. United States, 2002, 5min
Format: 35mm

Synopsis
In a cold empty city, a man encounters a cardboard box.
The box has a small rectangular slit that compels him
to take a closer look inside. Stop-motion animation.

Brooklyn International Film Festival 2003
http://wbff.org

'This is the record of a box man.

 I am beginning this account in a box. A cardboard
box that reaches just to my hips when I put it over
my head.

 That is to say, at this juncture the box man is me.
A box man, in his box, is recording the chronicle of
a box man.'

Kobo Abé, *The Box Man* [1974]

In *The Box Man*, Abé explores the isolation of the
individual by creating a psychological study of a
'box man,' one of the homeless who live their lives
in cardboard boxes. Abé extends the allegory into
hyperbole by making his box man not only sleep in
the box, but live in it at all times, even moving about
in it by peering through a carefully cut hole. We see
that Abé indeed intends for the box man to be an
allegory for the existential man when he writes,
'Paralysis of the heart's sense of direction is the box
man's chronic complaint.'

 The novel not only studies the internal sensations
of the box man but also examines the effects a box
man has on those in the external world. The relations
between the two are strained at best, and involve the
box man being shot at and being paid to simply get
rid of the box and, ceasing his existence as box man,
rejoin the external world.

David Keffer, *The Modern Word*
www.themodernword.com

Noxolo lifted up a large cardboard box. She showed
us a self portrait on one side and on two sides a
chronology, written in felt-tip pen: her date of birth;
when she moved to live with her grandmother; the
date her granny died; when she left school; when her
son and daughters were born; when she became
weak and ill; when she had her first HIV test; when
she disclosed her HIV status in public; when she
began to receive medicine for repeated bouts of TB.
On the fourth side of the box was written: 'Message
to the Youth: "Abstain and Condomise"'.

 Noxolo pulled a book made from bound cardboard
from inside the box. It was entitled 'My Story' and
each page described, with drawings and details, those
significant events in her life listed on the outside of
the box. The book is dedicated to her children as a
memorial, so they can read about her life after she
has gone...The idea of the Memory Box, and the
books, pictures and personal items it contains, was,
initially a means to help people face terminal illness
...Memory Box groups are also about living – not just
about dying. The process of making boxes and books
provides group therapy and establishes on-going
mutual support at a community level.

Roddy Bray, African Dawn – Insight and Tailored
Arrangements for Visitors to Southern Africa
1 December 2003, World AIDS Day
www.capetown.at

Patrice Edoh Fanou buried Marcellin, his six-year-old
son, one day last week here in the Tokoin Dogbeavou
neighborhood of Togo's capital. There was no
money for a coffin. Friends found a cardboard box
and the men gently lifted the boy into it, then taped
the flaps shut.

Michael Kamber, *New York Times*
5 May 2005
www.iht.com

Chicago (AP) – Authorities blew up a suspicious package outside the downtown federal courthouse Wednesday that turned out to contain a small refrigerator. The 3-foot-high cardboard box was discovered by a granite bench outside the John C. Kluczynski federal building and near a U.S. post office, police Sgt. David Villalobos said. Officers considered the package suspicious in part because it had no address on it. Authorities temporarily blocked off streets leading to the federal building while a small charge was set off next to the box. The incident happened several hours after the White House and the Capitol in Washington were evacuated when a small plane strayed into restricted airspace.

12 May 2005
© 2005 The Associated Press

Carrboro – For three years every other Saturday morning, the parking lot at Henry Anderson III Community Park was a depot for international trade. It started with the arrival of a white van with Texas plates towing a trailer. The driver would park, and dozens of Mexican immigrants would line up. On a recent Saturday, Maria Jauregui pushed a bulging cardboard box almost as big as herself. That box and two others were bursting with used clothing and shoes bound for Jauregui's nieces, nephews and aunts in Mexico. 'Even if my relatives don't use the clothes, I hope they get to someone else, to some other people,' she said.

The van's trip between the Triangle and Guanajuato, a central Mexican state home to many of the area's immigrants, follows a modern-day spice route between the United States and points south.

Jessica Rocha, *Chapel Hill News*
17 May 2005
www.chapelhillnews.com

Call it a mother's instinct, but Allison Grover knew something was awry when she noticed a mother duck frantically squawking over a water drain Wednesday afternoon. Her hunch proved correct, because when Grover and her daughter Ashley got out of their car and peered into the drain, she saw that the mother's ducklings had fell 2 feet down the drain squawking and swimming around. 'The mother duck was very upset,' and continued to make frenetic movements around us, Grover said. With the help of a crowbar, the mother-daughter team pried open the grate and picked each duckling out with their hands before placing them inside a cardboard box, which would turn out to be the easiest part of the rescue yesterday afternoon. 'Honestly, we didn't know what to do with them after that,' Grover said. Ashley, a self-proclaimed 'animal lover,' grabbed the box, put one of the ducklings in her hand and attempted to lure the mother to follow her to Flax Pond . . . The growing rescue team tried everything, including placing the box of ducklings on top of a fire truck to see if the mother would rather fly back to the pond.

Jill Casey, *Daily Item*
12 May 2005
www.the dailyitemoflynn.com

Global packaging group Amcor has plumped for an internal candidate as its new chief executive as it seeks to put its operations back on track after a horror year plagued by cost concerns and an investigation by regulators . . . Ken MacKenzie . . . replaces Russell Jones, who resigned last December along with the company's Australasian boss Peter Sutton amid allegations of price-fixing and anti-competitive behaviour in the $2.2 billion cardboard box market.

AFR staff, *Australian Financial Review*
12 May 2005
afr.com

Collin County Sheriff's Deputies arrested a Trenton man for allegedly drowning four kittens by dropping them in a creek from the Pilot Grove Creek bridge . . . Rutledge fit the description provided by a 50-year-old unnamed witness from Fannin County who spotted someone dropping a cardboard box over the bridge and into the creek at 12:15 p.m. Wednesday. The bridge is located on S.H. 121 just north of Westminster. When the witness looked over the bridge at the box, she could hear kittens crying, and when she could not reach the box, she dialed 911 and the Society for the Prevention of Cruelty to Animals (SPCA) of Texas. SPCA officers arrived at the scene and retrieved the box with a net. Inside they found four, dead, two week-old kittens.

Danny Gallagher, *McKinney Courier-Gazette*
18 May 2005
www.courier-gazette.com

A 58-year-old Italian man was yesterday jailed for two years for selling fake gold coins to a local goldsmith for around £100,000 . . . Audiero came to Cyprus on August 20, 2003 with 53-year-old Egyptian Sayed Abd El Hamid, an Italian passport holder. Two days later they met goldsmith Antonis Andreou from Anthoupolis and offered to sell him a quantity of 24-carat Mexican Pesos. On the same day, Andreou was given a coin and after checking it he found it to be genuine and agreed to buy 500 coins for £100,000 . . . The suspect opened a bag, which contained gold coins and gave Andreou ten pieces. Audiero put the rest in the safe, which was locked. It was then placed into a cardboard box that was sealed with tape and a paper with their signatures placed on top. The box was put in the cupboard and the suspect took the key to the safe, the court heard. The suspect and El Hamid left the island the next day after agreeing with Andreou to settle the amount in Greece where the key to the safe would be handed over to him.

George Psyllides, *Cyprus Mail*
www.cyprus-mail.com

Kerry Packer retains a clear lead as [Australia's] richest person, adding $400 million to a nest egg now worth a staggering $6.9 billion. Shopping centre magnate Frank Lowy, equal second in 2004 with cardboard box entrepreneur Richard Pratt, is alone in second spot at $4.8 billion, up $600 million. Mr Pratt is third with $4.7 billion.

Andrew Fraser and Richard Gluyas, *The Australian*
19 May 2005
www.theaustralian.news.com.au

When a suitcase full of cash falls from the sky into the cardboard-box hideout Damian has constructed beside some railroad tracks, he begins using the money for saintly deeds, doling it out to people who seem in need.

David Germain, from review of *Millions*
(dir. Danny Boyle, 2005)
© The Associated Press

Police in Argentina are hunting two men who dumped a box containing £1,000,000 worth of cocaine on a city pavement. The men reportedly dumped the cardboard box in the middle of the day after seeing police officers near Flores train station in Buenos Aires. Policemen could not believe their eyes when they opened the box and saw it contained 45kg of cocaine . . . Witnesses said the two men were carrying the box at around 1pm when they saw the police and simply dropped the box and ran. The police have organised a major operation to catch the two men but without success so far. A police spokesperson said: 'It is incredibly bold that they were carrying this amount of drug in a cardboard box in the middle of the day. We never heard of anything like that before, we are astonished.'

31 May 2005
www.ananova.com

Imagine, if you can, spending several years in the Nevada Department of Corrections. You're released, dropped off at the Greyhound bus station or the Division of Parole and Probation office, still dressed in your 'blues.' A cardboard box containing all of your possessions – letters from family and friends, a change of clothes, a stick of deodorant – rests in your arms. A $20 check hangs from your back pocket – but you don't have an updated photo ID to cash it.

Matt O'Brien, *Las Vegas CityLife*
30 May 2005
www.lasvegascitylife.com

The North American Free Trade Agreement is 'failing the people of Mexico,' by facilitating low pay and poor working conditions, says Anglican Bishop Sue Moxley. Workers, often women, are employed by Fortune 500 companies, yet still live in cardboard houses, Moxley told an April 13 news conference.

Deborah Gyapong, *Canadian Catholic News*
25 April 2005
www.wcr.ab.ca

As Sharon pushes on with his 'disengagement' plan, dozens of Israelis are flooding the doomed West Bank settlement of Sanur convinced they can thwart Israel's summer of disengagement. Swapping comfortable homes for dusty tents and two-roomed trailers, they are obsessed with preventing Israeli soldiers from evacuating all Jewish residents from Sanur, another three northern West Bank enclaves and the Gaza Strip … Children crouch in the dust. Others help their parents ferry bags, bedding and pet budgies from clapped-out old cars into their new homes. At least one flattened cardboard box masquerades as a carpet to keep out the worst of the sand.

Monday Morning
24 June 2005
www.mmorning.com

Hobbling Big Brother contestant Vanessa was shocked to arrive home from hospital on Saturday to find her housemates hanging out in cardboard boxes. Fearing that she may have received a knock on the head rather than a sprained ankle after last night's bout of bed bouncing, she was shocked to find the Big Brother house had turned into cardboard city … Unbeknown to the limping lady, today's task requires each housemate to remain inside a cardboard box for as long as possible, with whoever can take living in a box the longest declared the winner.

But for some contestants old habits seem to die hard and life in a cardboard box is continuing much the same as life in the outside world. Maxwell, determined that a piece of cardboard should not come between him and Saskia, has already made contact with her box, asking her to talk dirty to him. And being boxed up in a cardboard prison has clearly had a negative effect on Science and Kemal who have been bumping into each other's boxes and hurling abuse from inside their cardboard tanks.

11 June 2005
www.inthenews.co.uk

It's the time of the year when yard sales abound on every corner of every street and one can't help but do a little 'rubber necking.' That's what my mother used to call driving along with your head hanging out the window and looking at things. Who, who, who could possibly not be fascinated by the idea of perusing through someone else's junk? It's a compulsion – well, for me at least. I can't look at a cardboard box, an old light fixture, a scrap of wood, without thinking hmm … what could that be used for? So, needless to say, I have a basement full of junk that will someday be useful for something, if I can find it when I need it.

Bluefield Daily Telegraph
15 June 2005
www.bdtonline.com

LIST OF ILLUSTRATIONS

x

List of Illustrations reproduced from
E.T. Ellis, *Paperboard Packet and
Cardboard Box Manufacture*, London 1931

The Arrival of the Bee Box

SYLVIA PLATH

I ordered this, clean wood box
Square as a chair and almost too heavy to lift.
I would say it was the coffin of a midget
Or a square baby
Were there not such a din in it.

The box is locked, it is dangerous.
I have to live with it overnight
And I can't keep away from it.
There are no windows, so I can't see what is in there.
There is only a little grid, no exit.

I put my eye to the grid.
It is dark, dark,
With the swarmy feeling of African hands
Minute and shrunk for export,
Black on black, angrily clambering.

How can I let them out?
It is the noise that appalls me most of all,
The unintelligible syllables.
It is like a Roman mob,
Small, taken one by one, but my god, together!

I lay my ear to furious Latin.
I am not a Caesar.
I have simply ordered a box of maniacs.
They can be sent back.
They can die, I need feed them nothing, I am the owner.

I wonder how hungry they are.
I wonder if they would forget me
If I just undid the locks and stood back and turned into a tree.
There is the laburnum, its blond colonnades,
And the petticoats of the cherry.

They might ignore me immediately
In my moon suit and funeral veil.
I am no source of honey
So why should they turn on me?
Tomorrow I will be sweet God, I will set them free.

The box is only temporary.

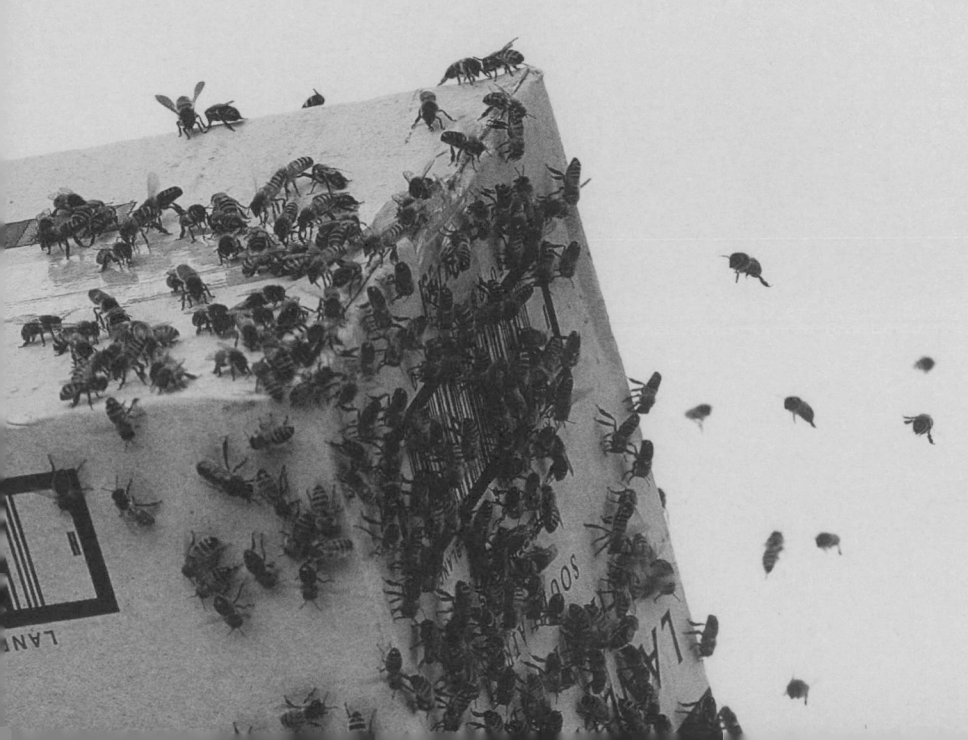

In Ebon Box, when years have flown

EMILY DICKINSON

In Ebon Box, when years have flown
To reverently peer,
Wiping away the velvet dust
Summers have sprinkled there!

To hold a letter to the light –
Grown Tawny now, with time –
To con the faded syllables
That quickened us like Wine!

Perhaps a Flower's shrivelled check
Among its stores to find –
Plucked far away, some morning –
By gallant – mouldering hand!

A curl, perhaps, from foreheads
Our Constancy forgot –
Perhaps, an Antique trinket –
In vanished fashions set!

And then to lay them quiet back –
And go about its care –
As if the little Ebon Box
Were none of our affair!

I felt a Funeral, in my Brain

EMILY DICKINSON

I felt a Funeral, in my Brain,
And Mourners to and fro
Kept treading – treading – till it seemed
That Sense was breaking through

And when they all were seated,
A Service, like a Drum –
Kept beating – beating – till I thought
My Mind was going numb –

And then I heard them lift a Box
And creak across my Soul
With those same Boots of Lead, again,
Then Space – began to toll,

As all the Heavens were a Bell,
And Being, but an Ear,
And I, and Silence, some strange Race
Wrecked, solitary, here –

And then a Plank in Reason, broke,
And I dropped down, and down –
And hit a World, at every plunge,
And Finished knowing – then –

Complete Destruction

WILLIAM CARLOS WILLIAMS

It was an icy day.
We buried the cat,
then took her box
and set fire to it
in the back yard.
Those fleas that escaped
earth and fire
died by the cold.

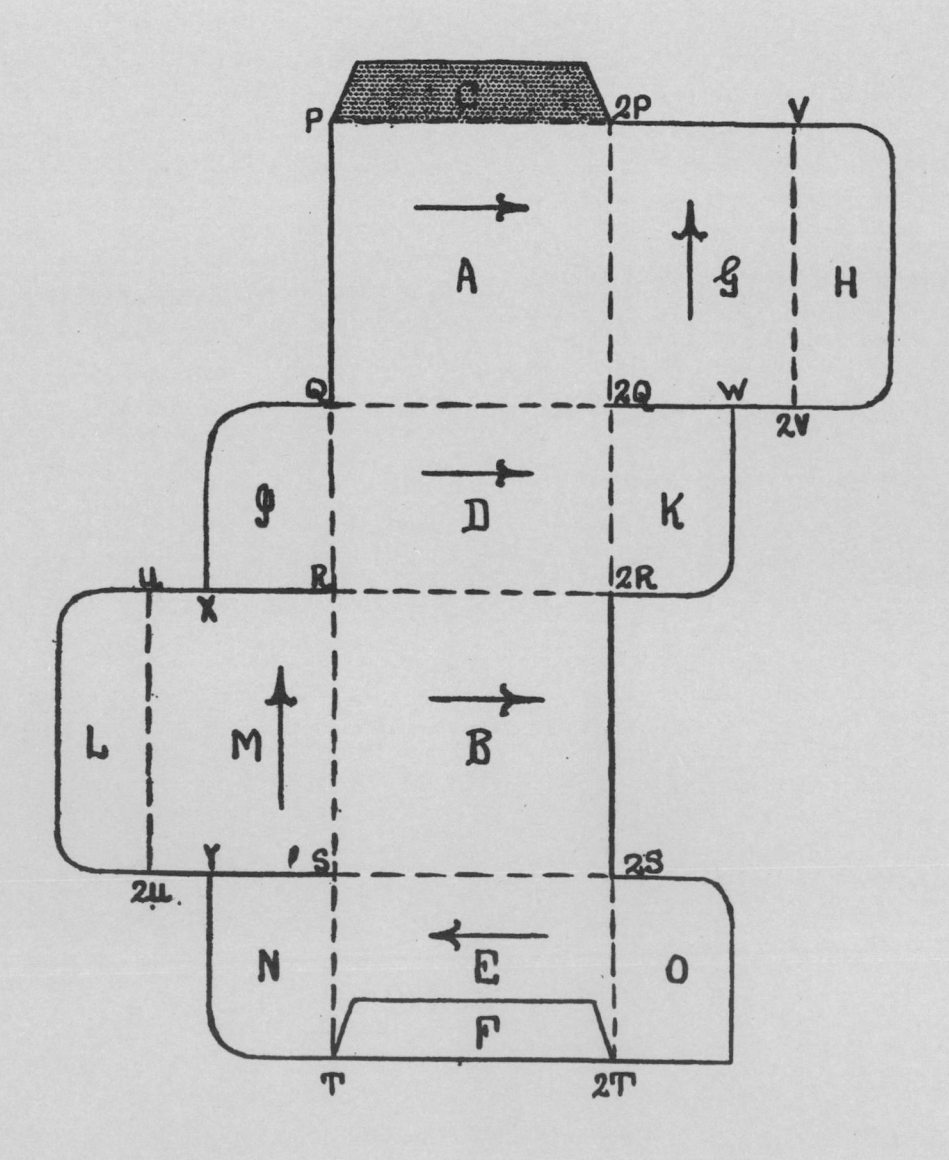

Little Boxes

MALVINA REYNOLDS

Little boxes on the hillside,
Little boxes made of ticky tacky,
Little boxes on the hillside,
Little boxes all the same.
There's a green one and a pink one
And a blue one and a yellow one,
And they're all made out of ticky tacky,
And they all look just the same.

And the people in the houses
All went to the university,
Where they were put in boxes
And they came out all the same,
And there's doctors and lawyers,
And business executives,
And they're all made out of ticky tacky,
And they all look just the same.

And they all play on the golf course
And drink their martinis dry,
And they all have pretty children
And the children go to school,
And the children go to summer camp,
And then to the university
Where they are put in boxes
And they come out all the same.

And the boys go into business
And marry and raise a family
In boxes made of ticky tacky
And they all look just the same.
There's a green one and a pink one
And a blue one and a yellow one,
And they're all made out of ticky tacky
And they all look just the same.

Little Boxes (Beatnik Version)

WOODY GUTHRIE

See the beatniks in the Village
See the beatniks on MacDougal Street
See the beatniks in the Village
And they all look just the same
There's a tall one and a short one
And a white one and a Negro one
And they all go to the Village
And they all look just the same
And the boys all wear dungarees
And the girls all wear sandals
And they're all nonconformists
And they all dress just the same
And they go to the university
And they major in philosophy
And they're all deep thinkers
And they all think just the same
And they all read their Sartre
And they all read their Kierkegard
And they all talk about it
And they all sound just the same
And they all like folk music
And they dig Woody Guthrie
And just like Bob Dylan
They all sound the same

149

Excerpt from

The Adventure of the Cardboard Box

SIR ARTHUR CONAN DOYLE

It was a small shed in the narrow garden which ran down behind the house. Lestrade went in and brought out a yellow cardboard box, with a piece of brown paper and some string. There was a bench at the edge of the path, and we all sat down while Holmes examined, one by one, the articles which Lestrade had handed to him.

* * *

'So much for the string then' said Holmes, smiling; 'now for the box wrapper. Brown paper, with a distinct smell of coffee. What, you did not observe it? I think there can be no doubt of it. Address printed in rather straggling characters: "Miss S. Cushing, Cross Street, Croydon." Done with a broad pointed pen, probably a J, and with very inferior ink. The word Croydon has been spelt originally with an i, which has been changed to a y. The parcel was directed, then, by a man – the printing is distinctly masculine – of limited education and unacquainted with the town of Croydon. So far so good! The box is a yellow, half-pound honeydew box, with nothing distinctive save two thumb marks at the left bottom corner. It is filled with rough salt of the quality used for preserving hides and other of the coarser commercial purposes. And embedded in it are these very singular inclosures.'

He took out the two ears as he spoke, and laying a board across his knees, he examined them minutely, while Lestrade and I, bending forward on each side of him, glanced alternately at these dreadful relics and at the thoughtful, eager face of our companion. Finally he returned them to the box once more, and sat for a while in deep thought.

'You have observed, of course,' said he at last, 'that the ears are not a pair.'

Excerpts from

Moon Palace

PAUL AUSTER

I lived in that apartment with over a thousand books. They had originally belonged to my Uncle Victor, and he had collected them slowly over the course of about thirty years. Just before I went off to college, he impulsively offered them to me as a going-away present. I did my best to refuse, but Uncle Victor was a sentimental and generous man, and he would not let me turn him down. 'I have no money to give you,' he said, 'and not one word of advice. Take the books to make me happy.' I took the books, but for the next year and a half I did not open any of the boxes they were stored in. My plan was to persuade my uncle to take the books back, and in the meantime I did not want anything to happen to them.

As it turned out, the boxes were quite useful to me in that state. The apartment on 112th Street was unfurnished, and rather than squander my funds on things I did not want and could not afford, I converted the boxes into several pieces of 'imaginary furniture.' It was a little like working on a puzzle: grouping the cartons into various modular configurations, lining them up in rows, stacking them one on top of another, arranging and rearranging them until they finally began to resemble household objects. One set of sixteen served as the support for my mattress, another set of twelve became a table, others of seven became chairs, another of two became a bedstand, and so on. The overall effect was rather monochromatic, what with that somber light brown everywhere you looked, but I could not help feeling proud of my resourcefulness.

* * *

My imaginary furniture remained intact for almost a year. Then in the spring of 1967, Uncle Victor died.

* * *

That was when I started reading Uncle Victor's books. Two weeks after the funeral, I picked out one of the boxes at random, slit the tape carefully with a knife, and read everything that was inside it. It proved to be a strange mixture, packed with no apparent order or purpose. There were novels and plays, history books and travel books, chess guides and detective stories, science fiction and works of philosophy – an absolute chaos of print. It made no difference to me. I read each book to the end and refused to pass judgment on it. As far as I was concerned, each book was the equal of every other book, each sentence was composed of exactly the right number of words, and each word stood exactly where it had to be. That was how I chose to mourn my Uncle Victor. One by one, I would open every box, and one by one I would read every book. That was the task I set for myself, and I stuck with it to the bitter end.

Each box contained a jumble similar to the first, a hodgepodge of high and low, heaps of ephemera scattered among the classics, ragged paperbacks sandwiched between hardbound editions, pot-boilers lying flush with Donne and Tolstoy. Uncle Victor had never organized his library in any systematic way. Each time he had bought a book, he had put it on the shelf next to the one he had bought before it, and little by little the rows had expanded, filling more and more space as the years went by. That was precisely how the books had entered the boxes. If nothing else, the chronology was intact, the sequence had been preserved by default. I considered this to be an ideal arrangement. Each time I opened a box, I was able to enter another segment of my uncle's life, a fixed period of days or weeks or months, and it consoled me to feel I was occupying the same mental space that Victor had once occupied – reading the same words, living the same stories, perhaps thinking the same thoughts. It was almost like following the route of an explorer from long ago, duplicating his steps as he thrashed out into virgin territory, moving westward with the sun, pursuing the light until it was finally extinguished. Because the boxes were not numbered or labeled, I had no way of knowing in advance which period I was about to enter.

* * *

As I sold off the books, my apartment went through many changes. That was inevitable, for each time I opened another box, I simultaneously destroyed another piece of furniture. My bed was dismantled, my chairs shrank and disappeared, my desk atrophied into empty space. My life had become a gathering zero, and it was a thing I could actually see: a palpable, burgeoning emptiness. Each time I ventured into my uncle's past, it produced a physical result, an effect in the real world. The consequences were therefore always before my eyes, and there was no way to escape them. So many boxes were left, so many boxes were gone. I had only to look at my room to know what was happening. The room was a machine that measured my condition: how much of me remained, how much of me was no longer there. I was both perpetrator and witness, both actor and audience in a theater of one. I could follow the process of my own dismemberment. Piece by piece, I could watch myself disappear.

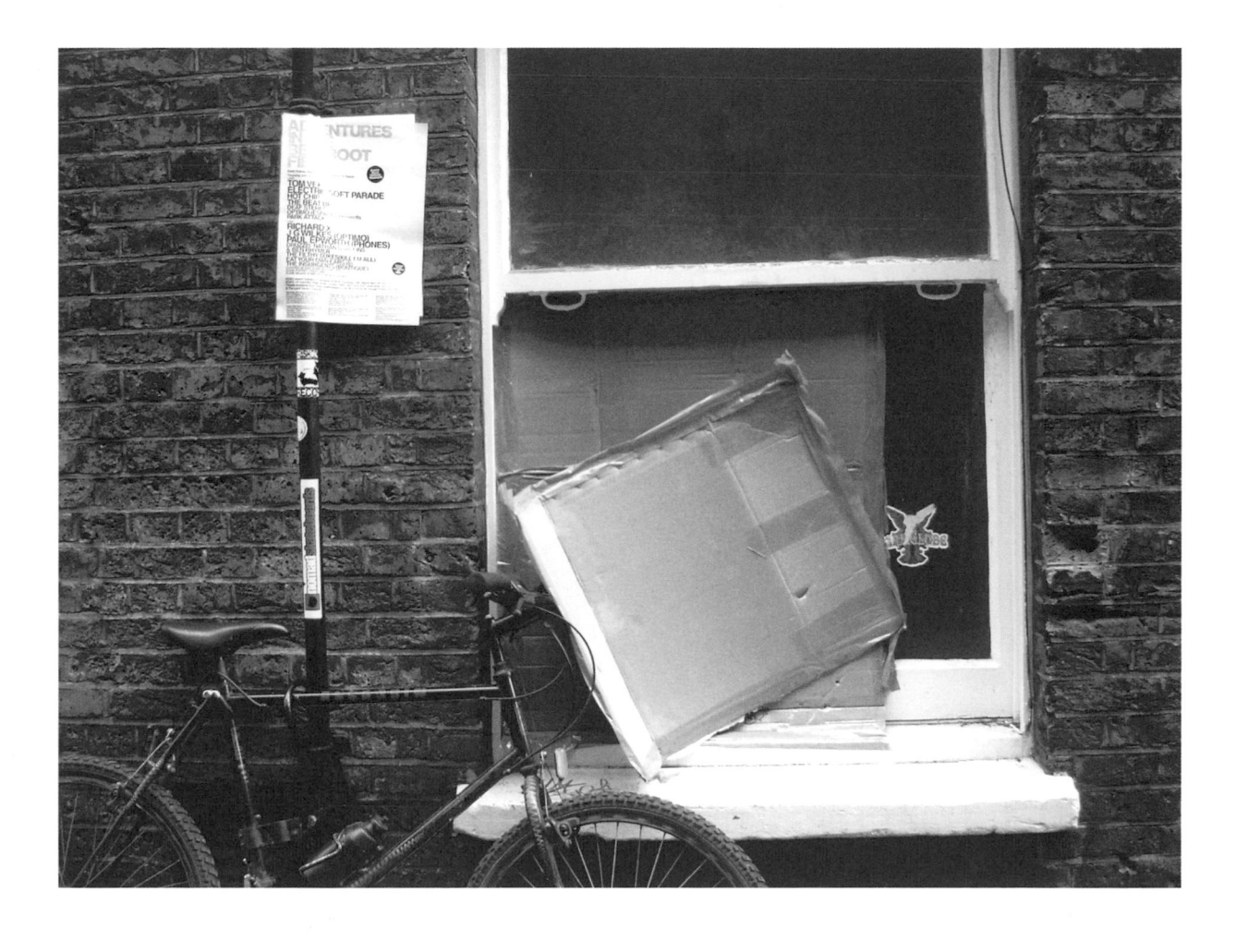

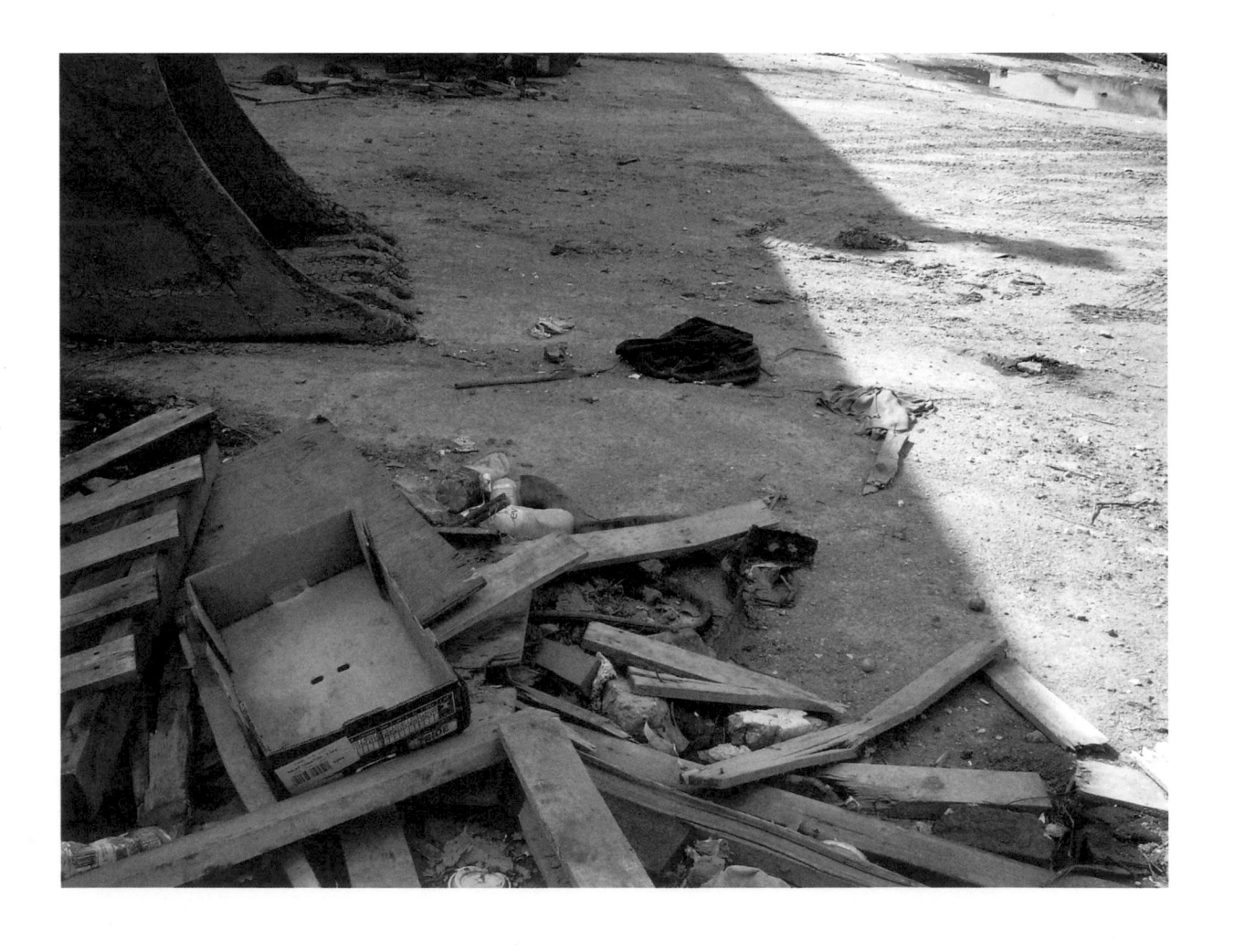

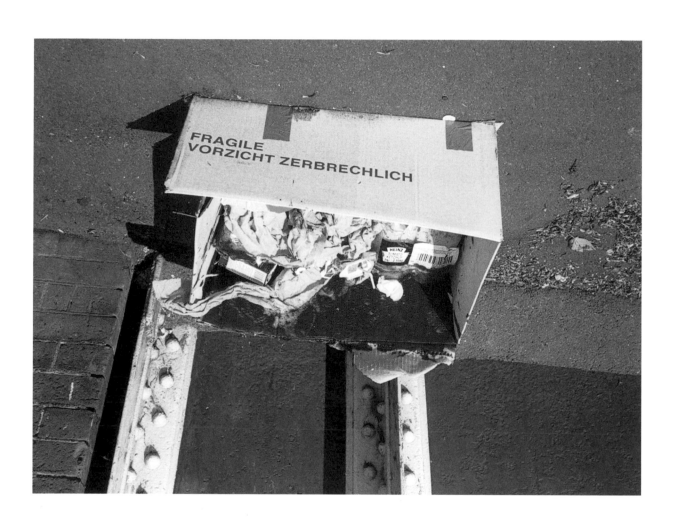

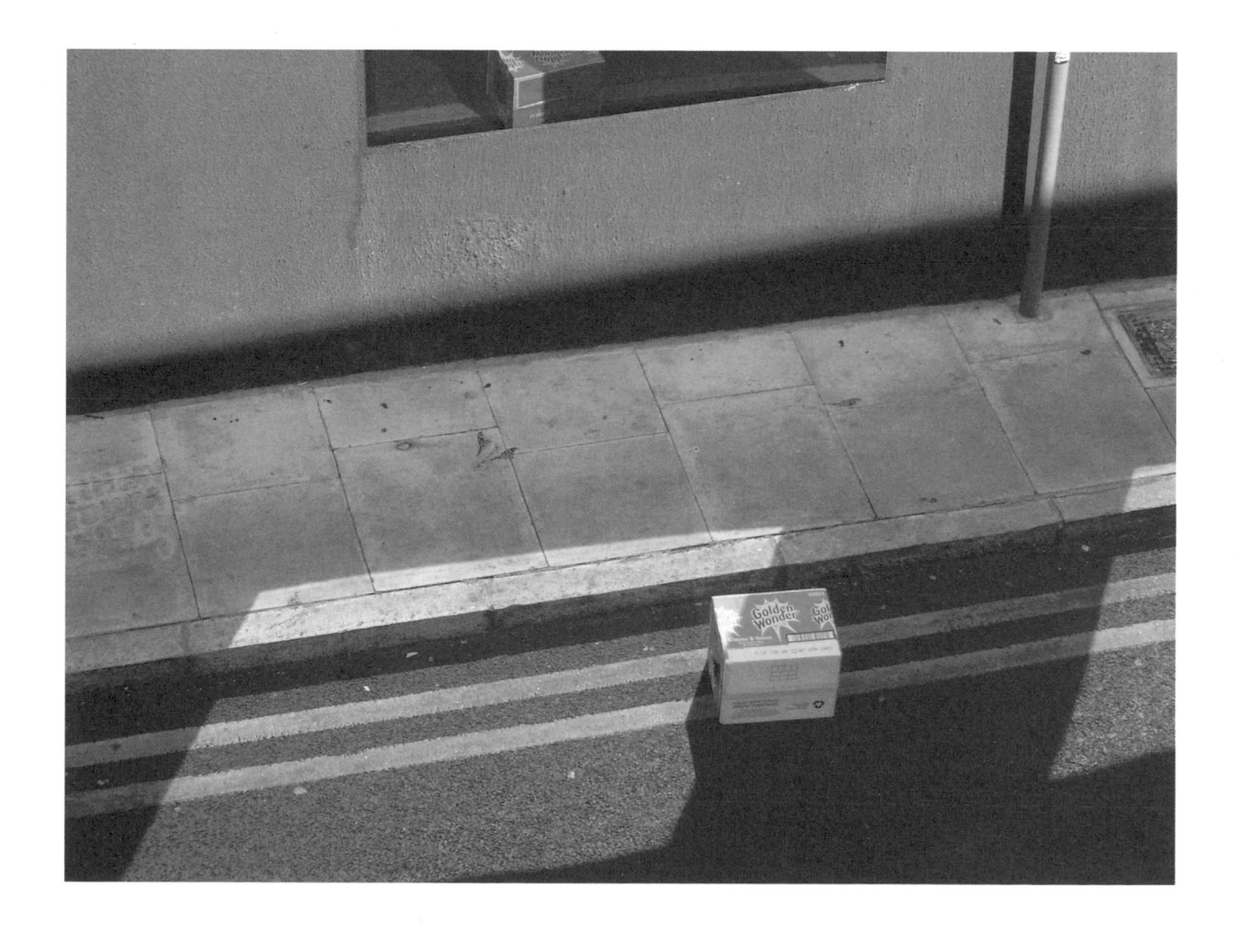

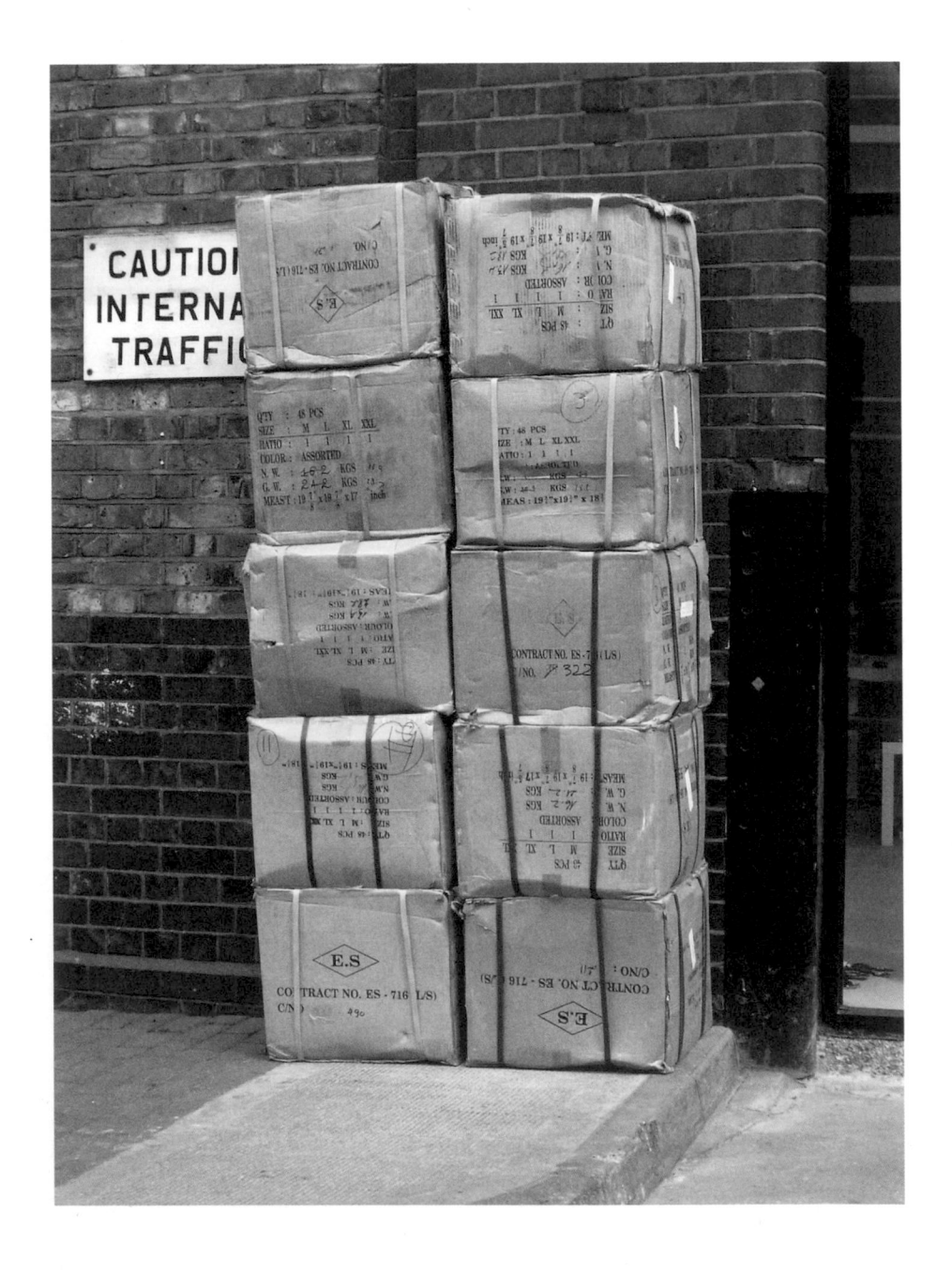

158

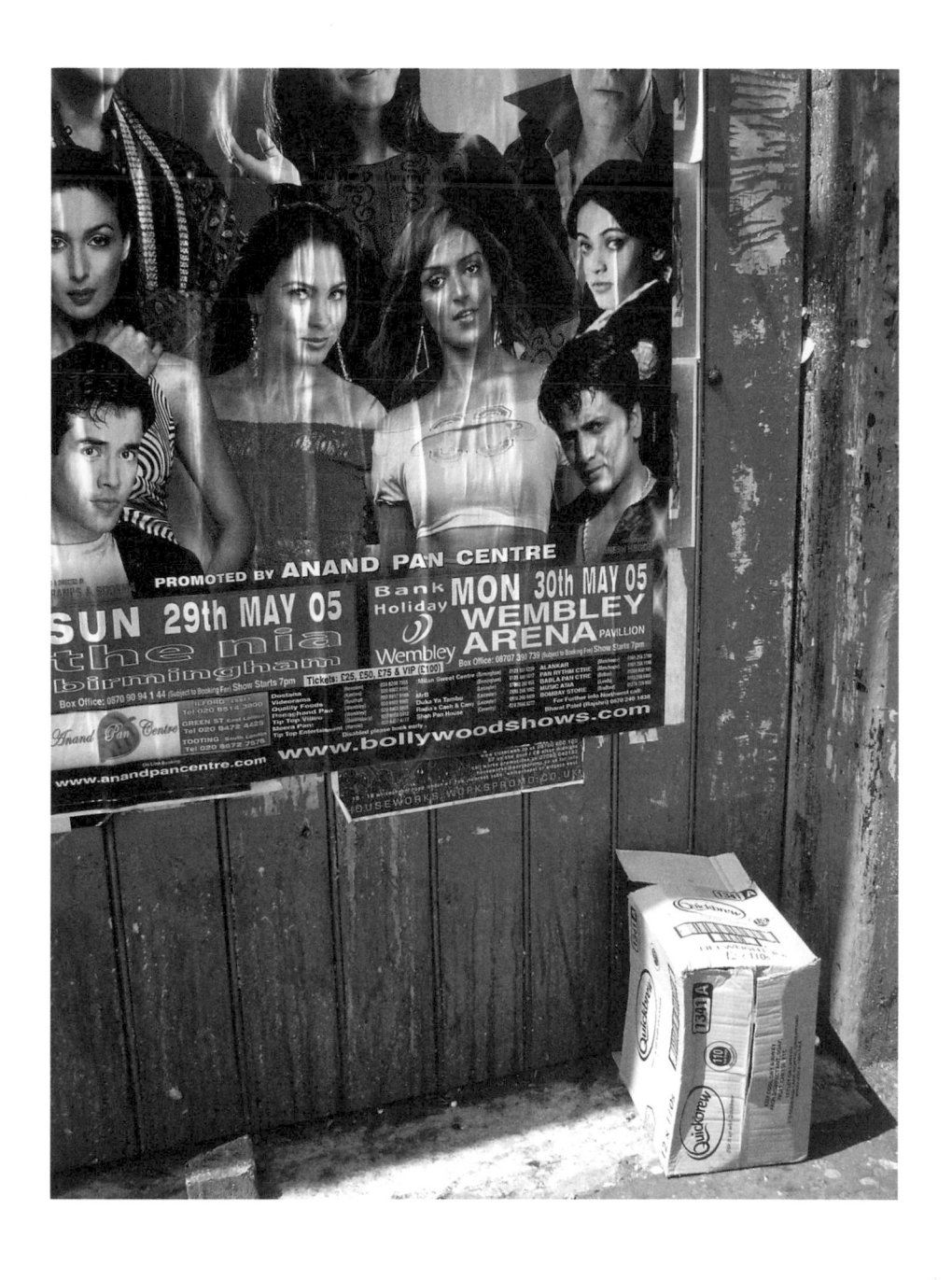

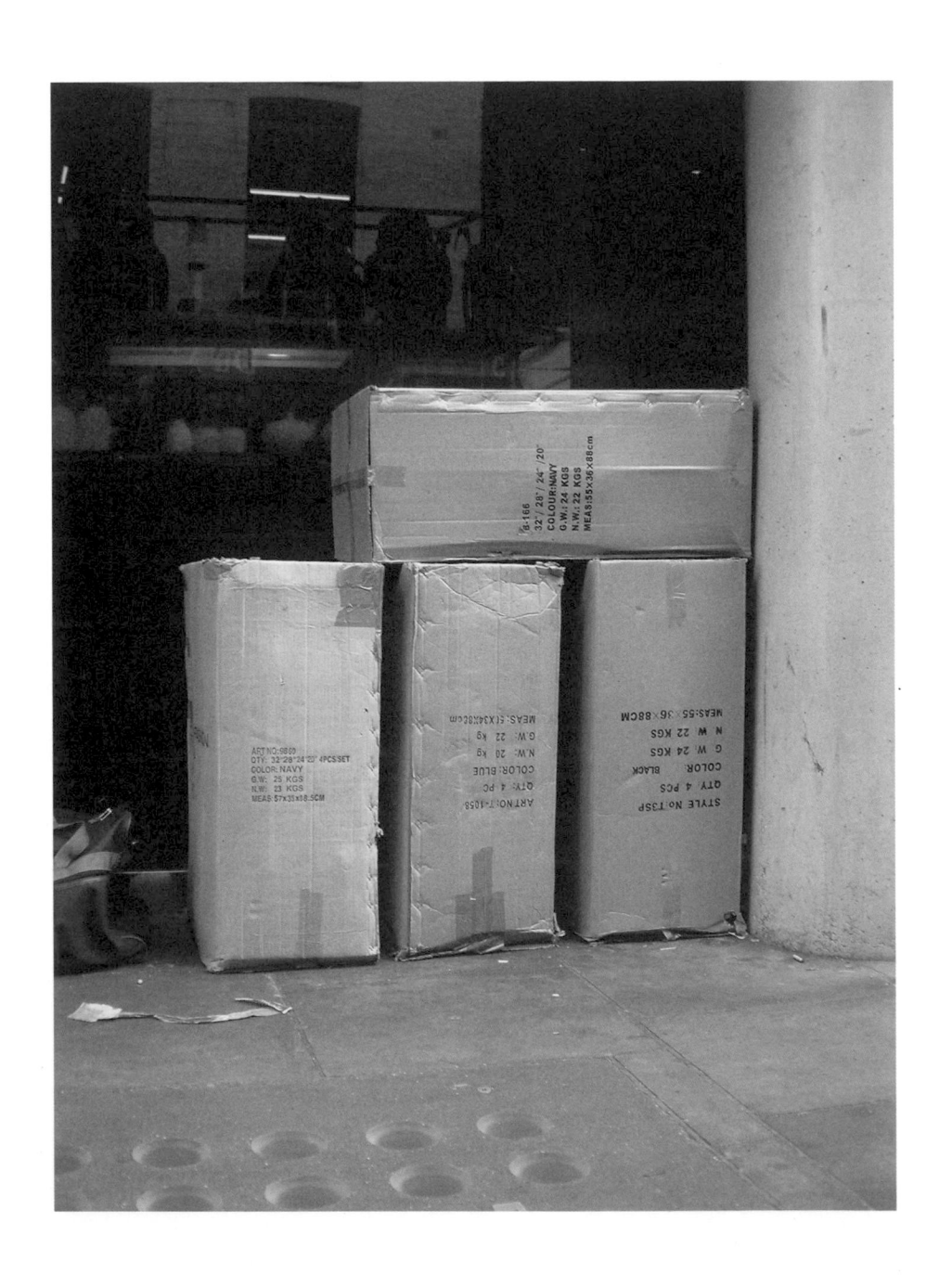

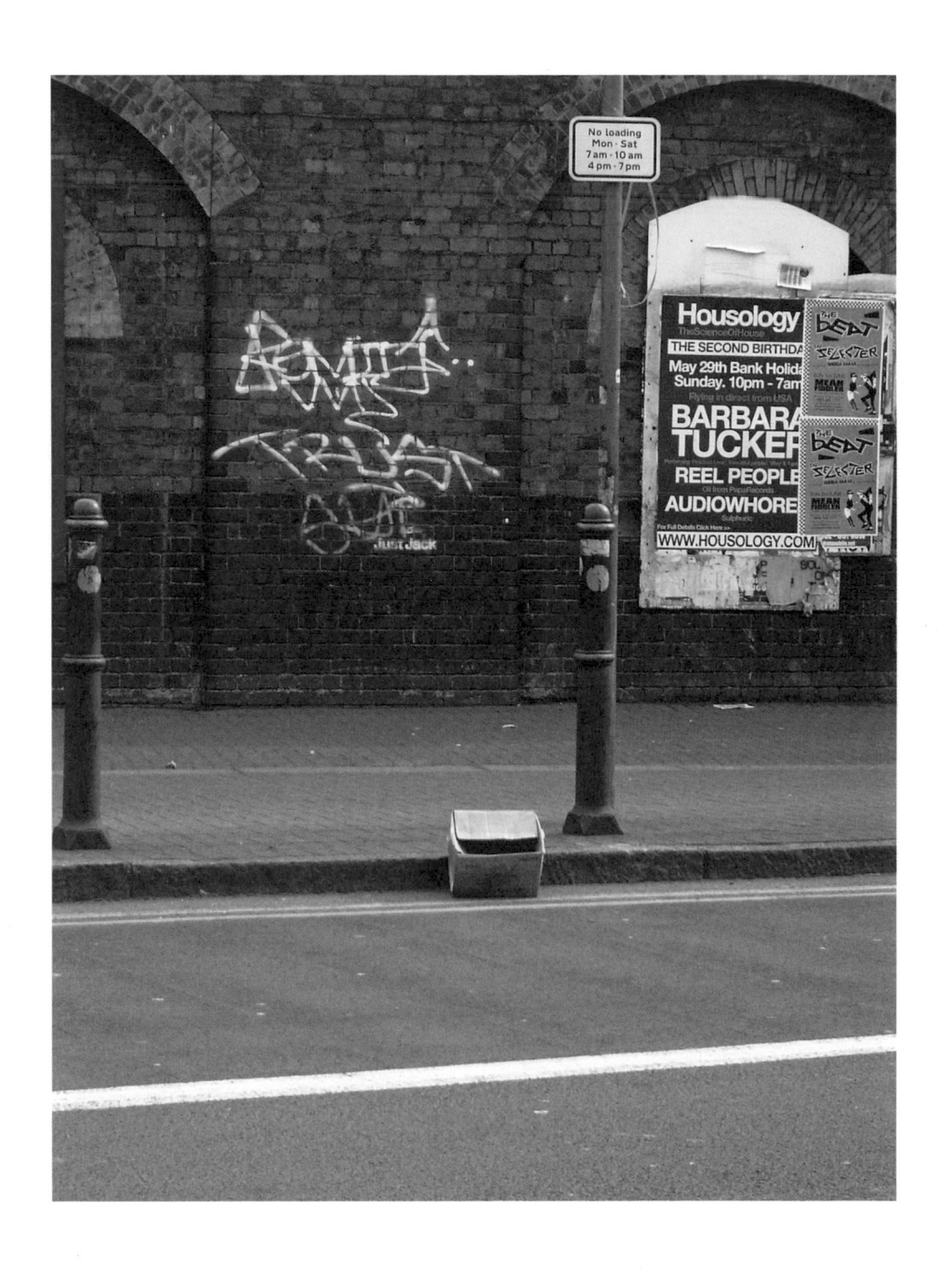

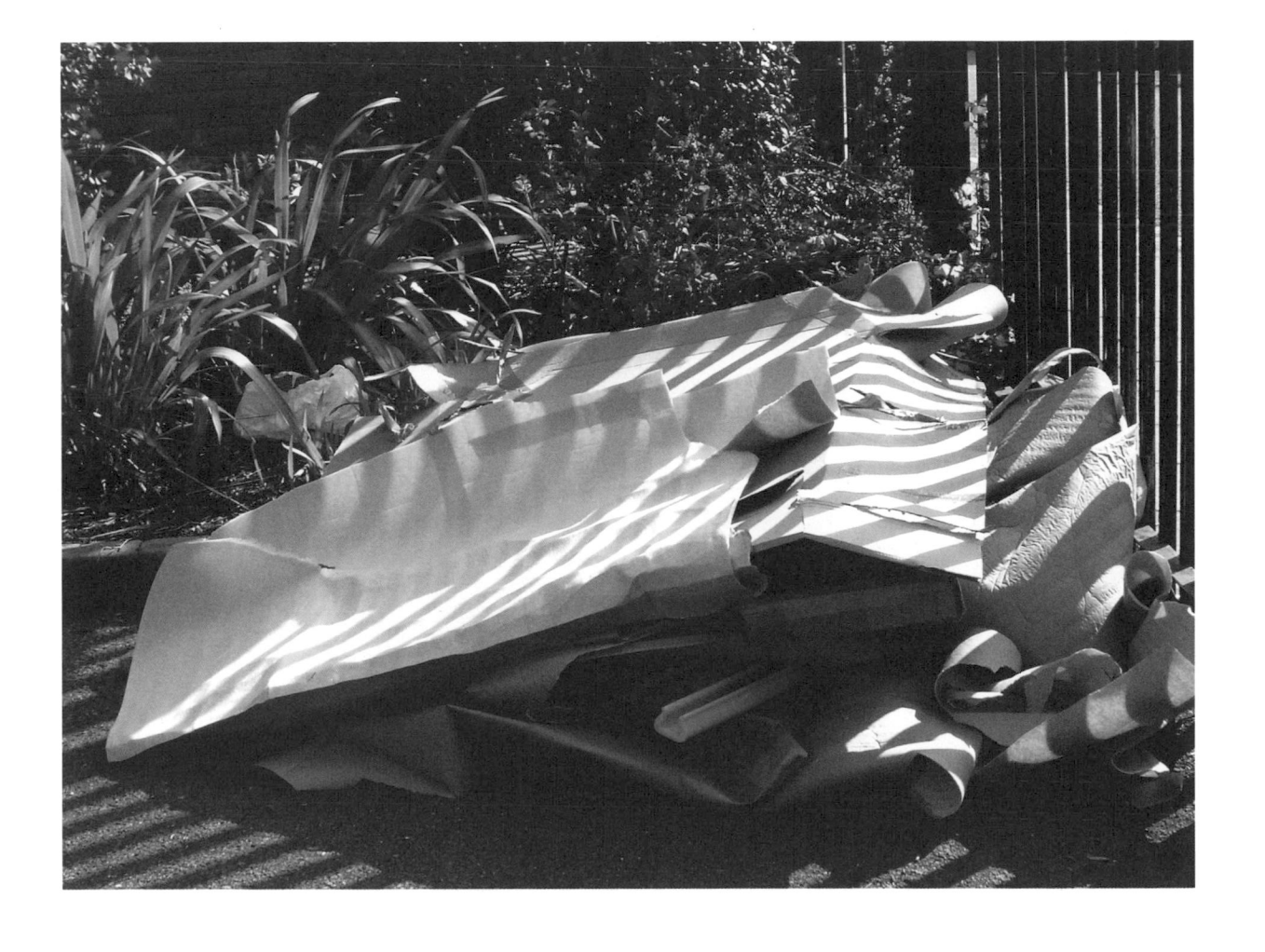

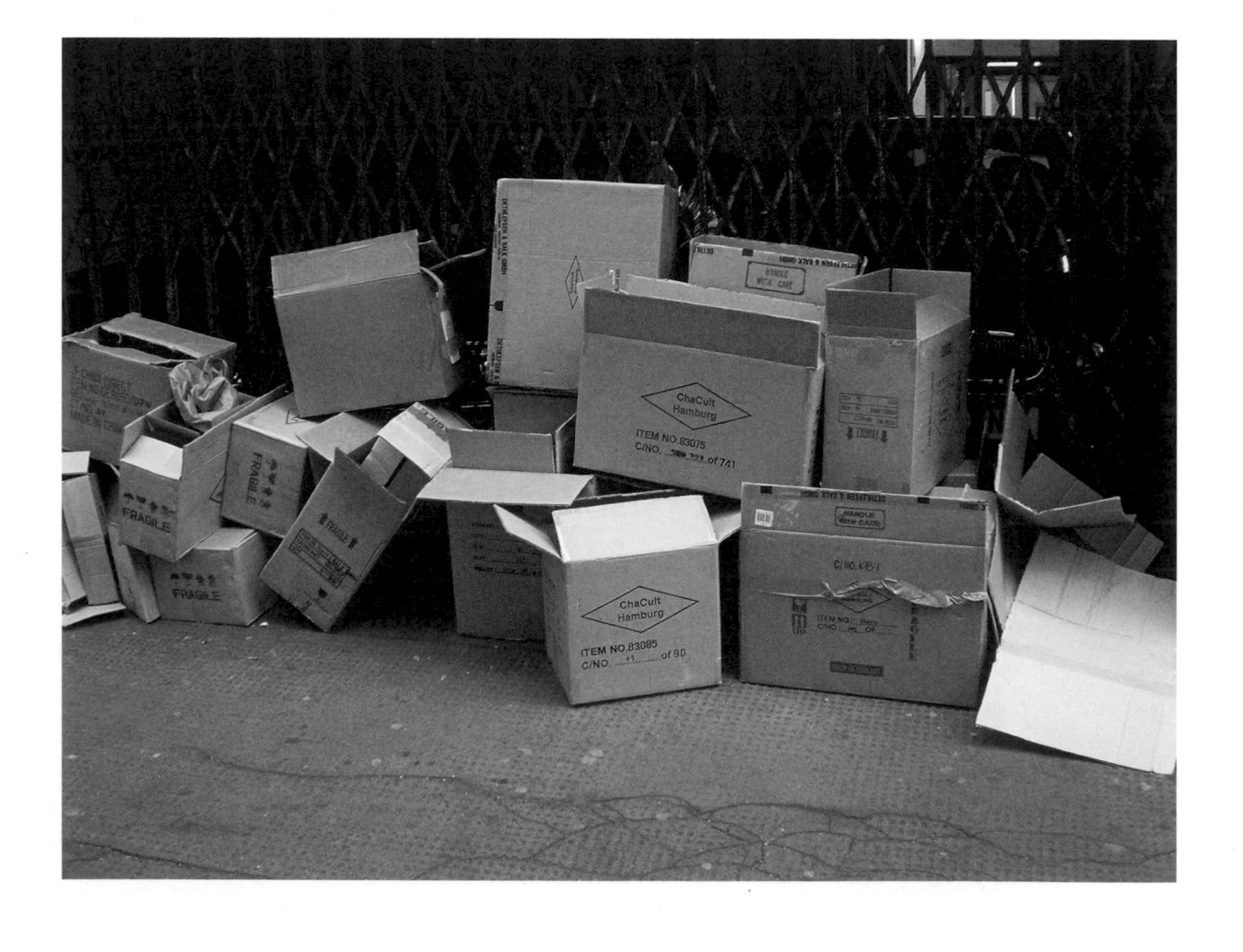

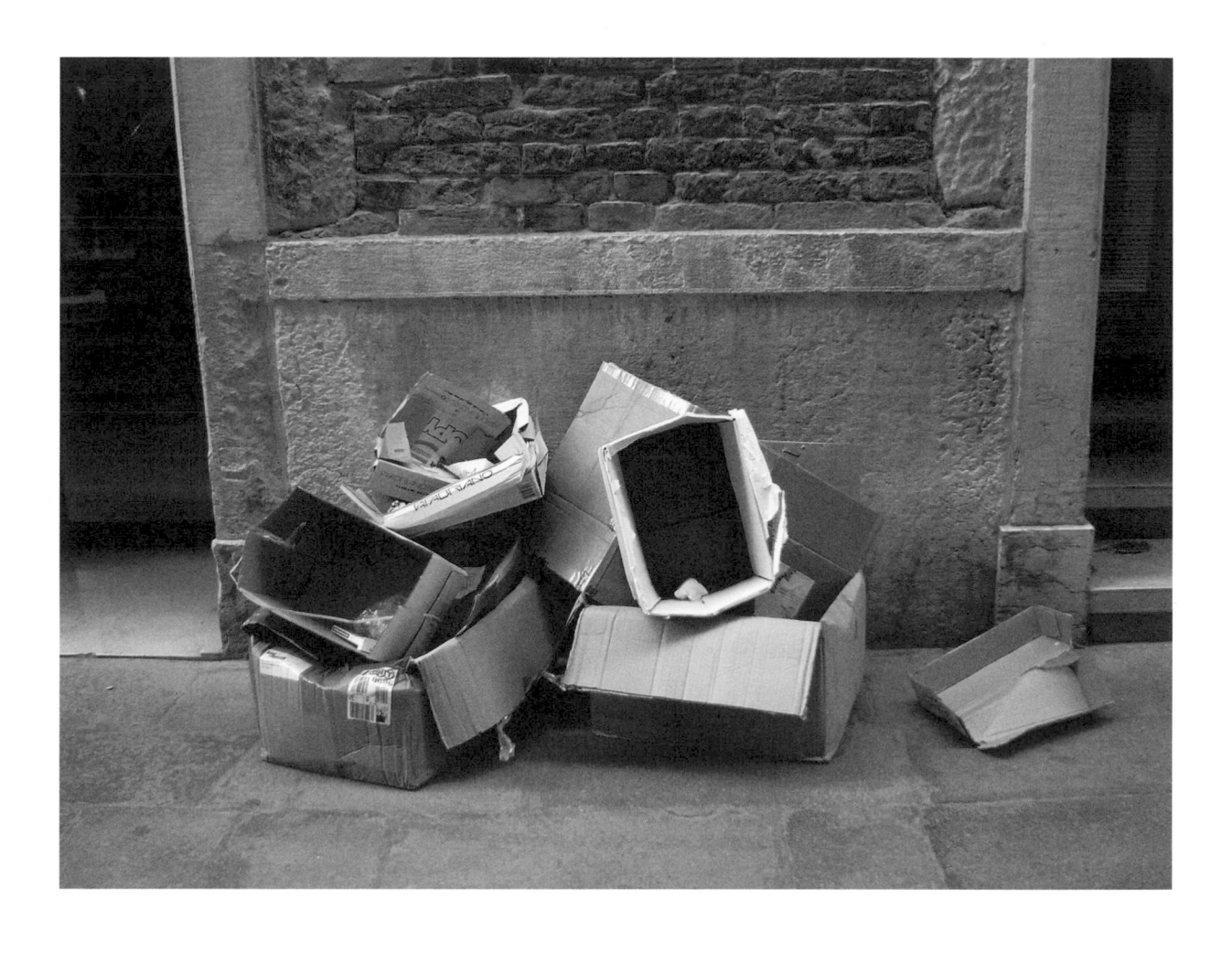

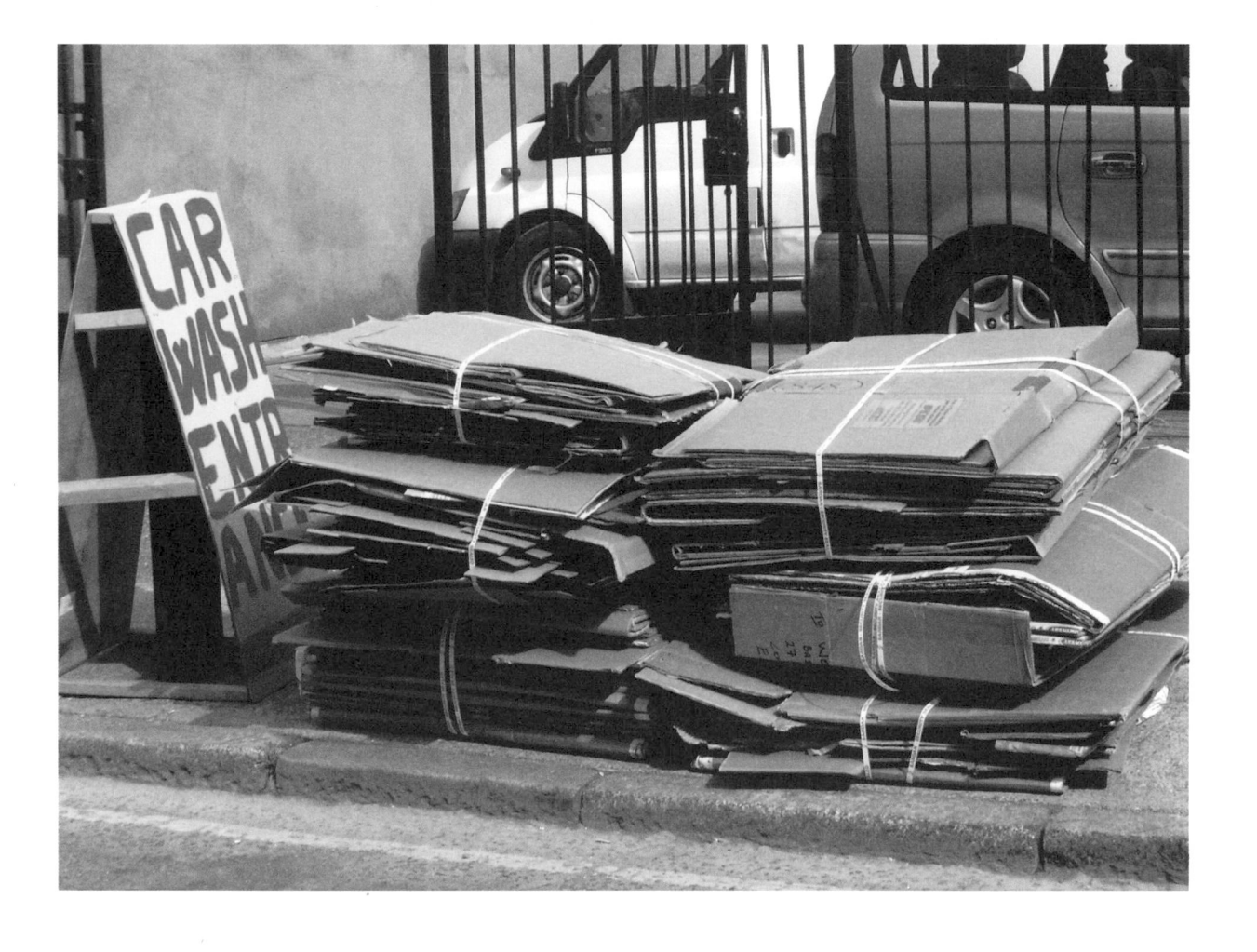

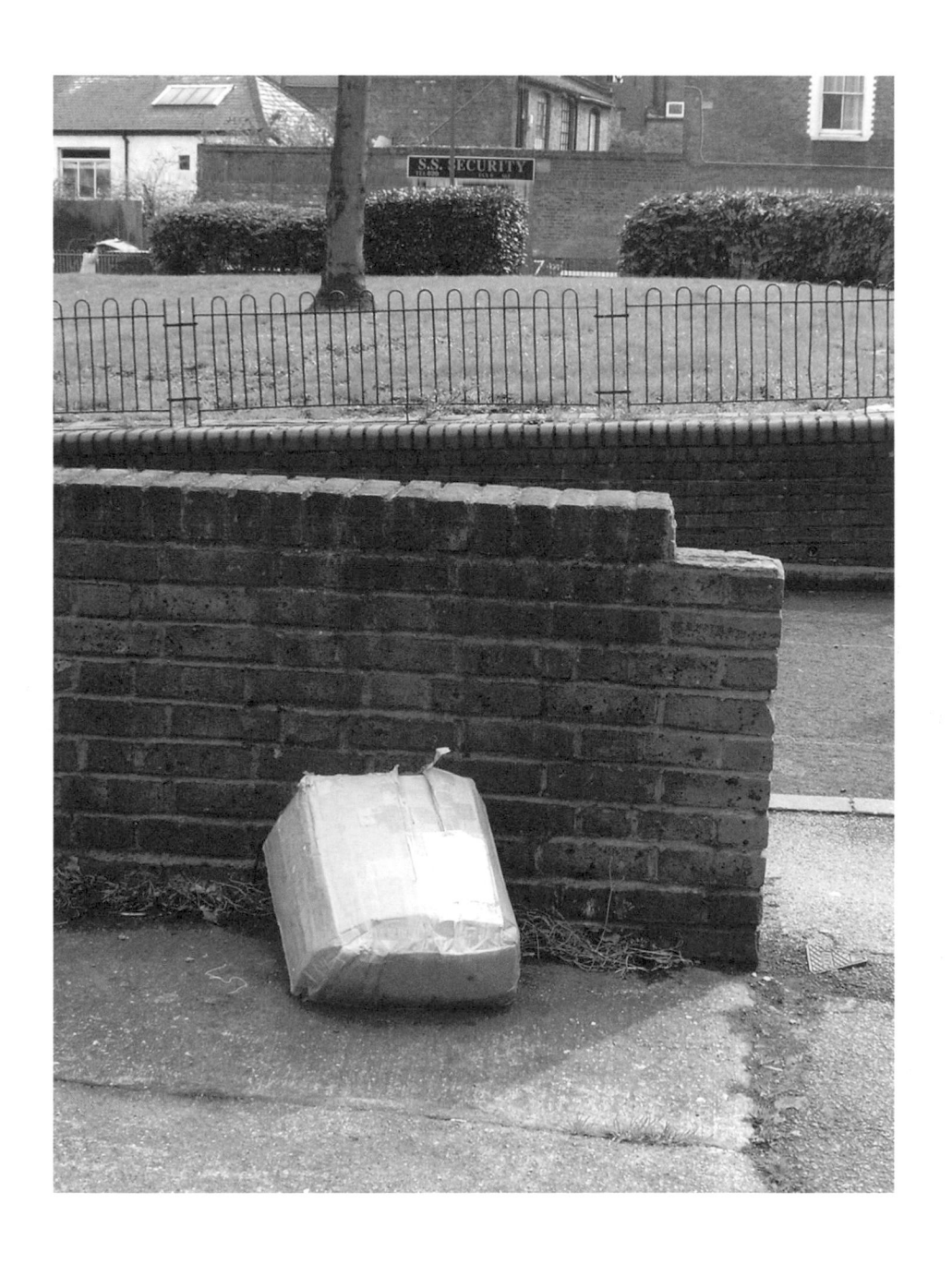

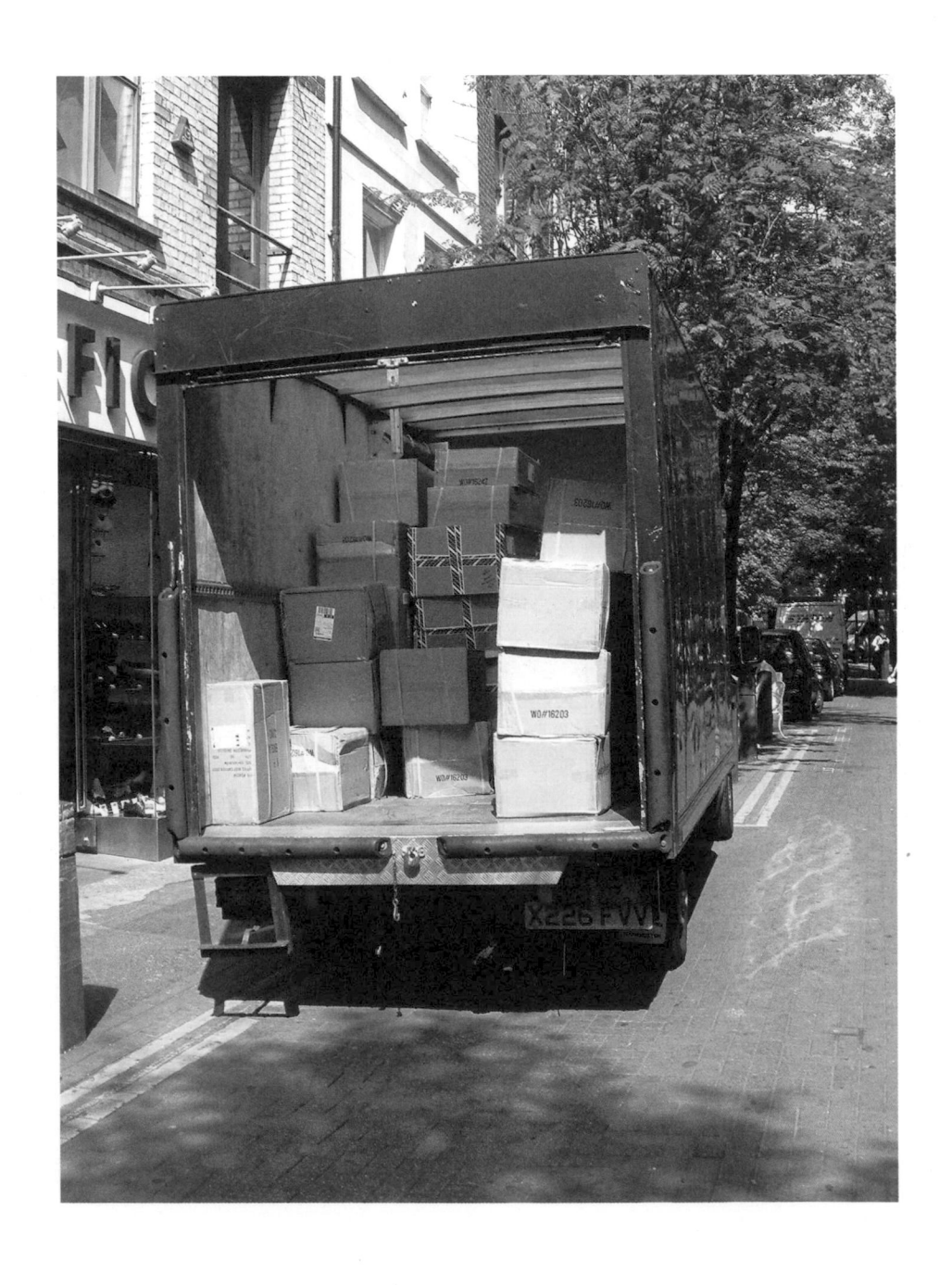

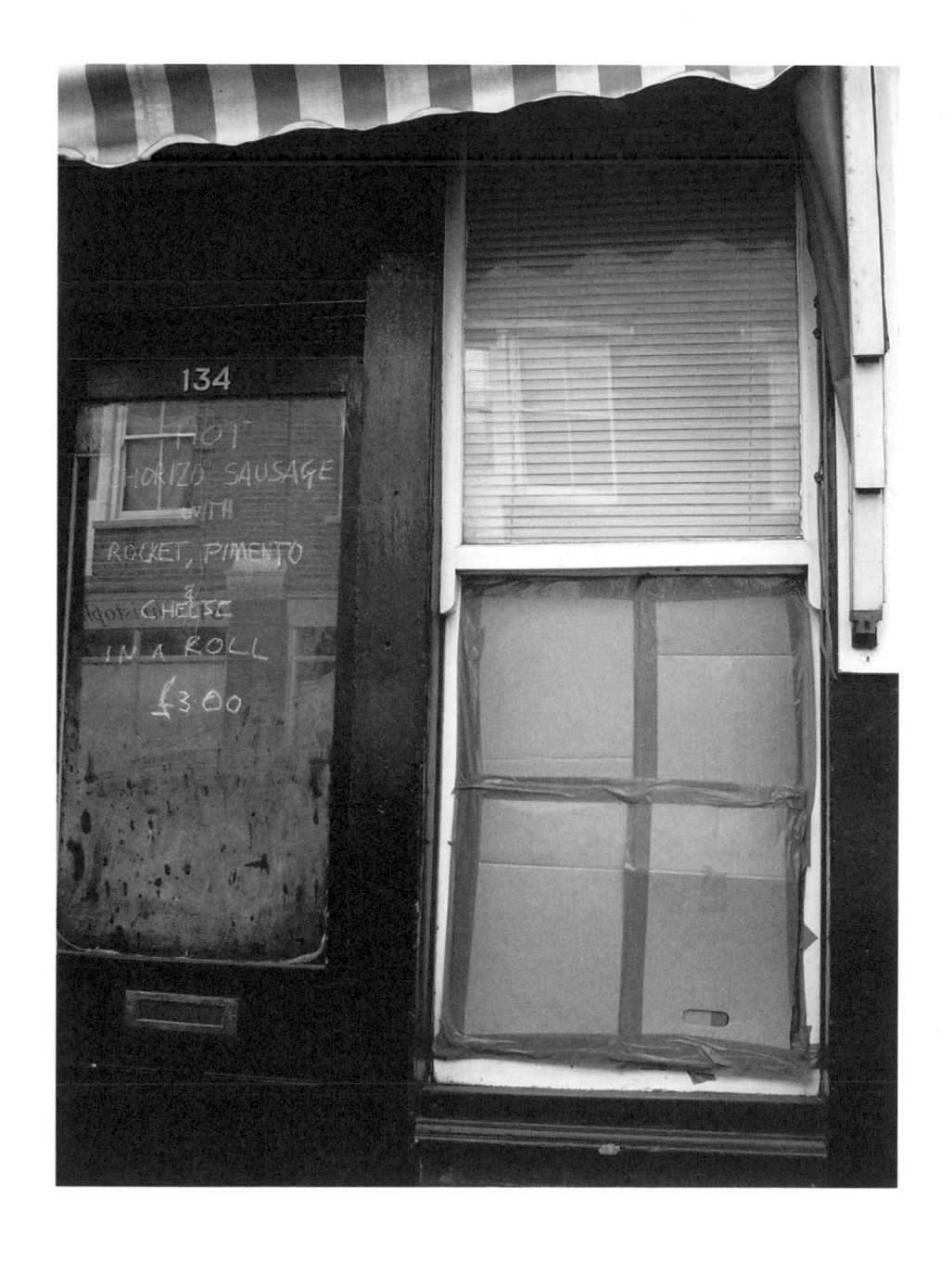

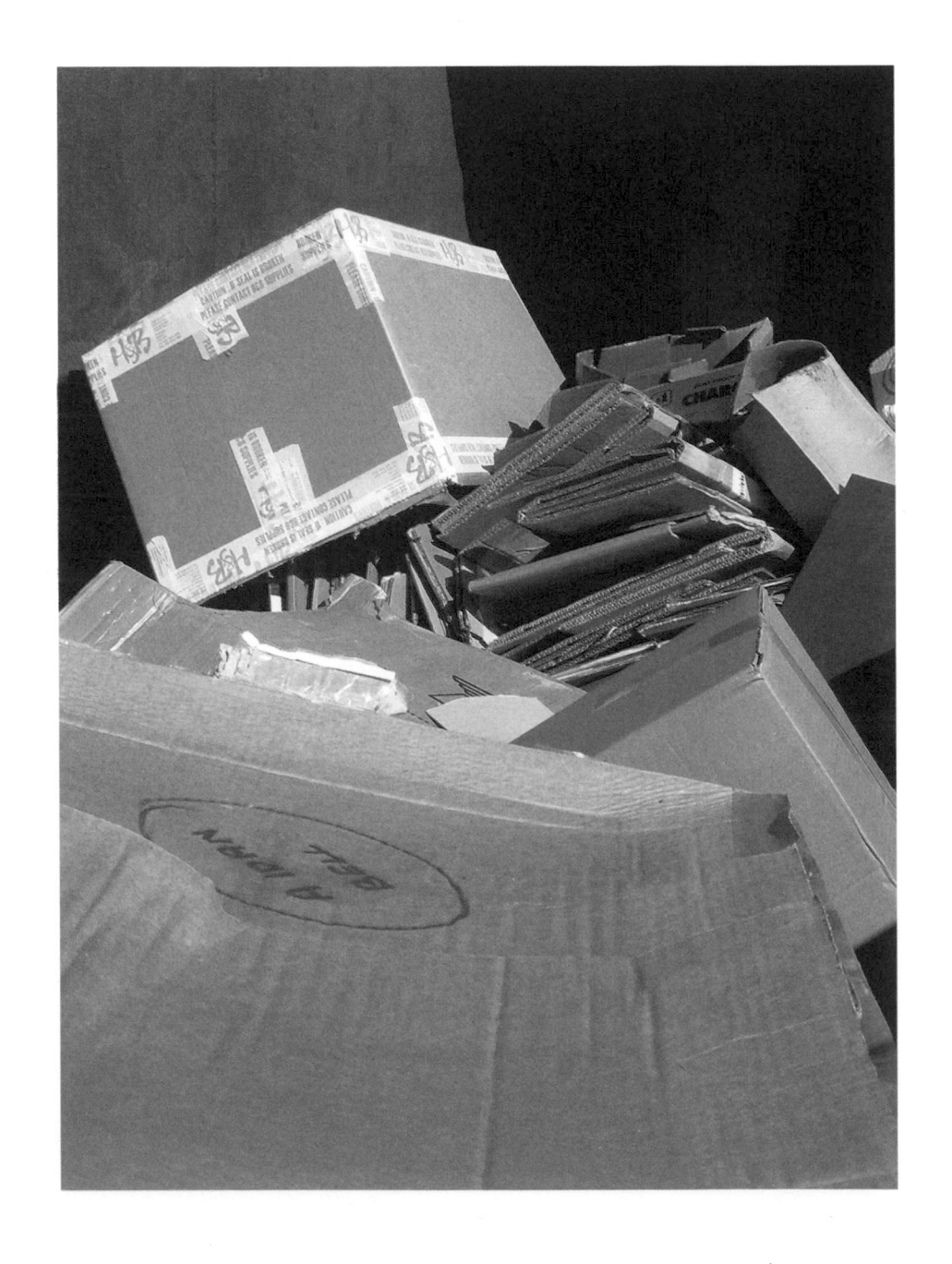

179

Biography

Compiled by Michaela Weiss

Rachel Whiteread was born in London in 1963. She studied painting at Brighton Polytechnic and sculpture at the Slade School of Fine Art. Whiteread is one of the few artists of her generation to have produced important public sculptures, some of which have achieved a monumental status and significance. *Ghost*, her breakthrough piece from 1990, is a plaster cast of a living room, modelled on a typical Victorian terraced house in north London, similar to the one in which the artist grew up. In its melancholic beauty, *Ghost* is a resonant monument both to the individuals who once occupied this room, and to our collective memories of home. Whiteread was awarded the Turner Prize in 1993 just after creating *House* (1993; destroyed 1994), a life-sized replica of the interior of a condemned terraced house in London's East End made by spraying liquid concrete into the building's empty shell before its external walls were removed. Whiteread's winning proposal for the Holocaust memorial for the Judenplatz in Vienna was one of the most prestigious sculptural commissions in Europe in the 1990s, and involved placing the cast interior of a library, including the imprint of books, in the centre of the square. It was unveiled in October 2000. Whiteread represented the UK at the 1997 Venice Biennale and created *Monument* for the empty plinth in Trafalgar Square in 2001. One of her most recent solo exhibitions, *Walls, Doors, Floors and Stairs* at Kunsthaus Bregenz in late spring 2005, where *Untitled (Room 101)* 2003 was on display, was dedicated to the house as the central theme of her work. Whiteread lives and works in London and her work is represented in many private and public collections worldwide.

SELECTED SOLO EXHIBITION CATALOGUES AND BOOKS

Eckhard Schneider, *Rachel Whiteread*, exh. cat., Kunsthaus Bregenz 2005

Chris Townsend, *The Art of Rachel Whiteread*, London 2004

Charlotte Mullins, *Rachel Whiteread*, Modern Artists Series, London 2004

Meghan Dailey (ed.), *Rachel Whiteread: Transient Spaces*, exh. cat., Deutsche Guggenheim, Berlin 2001

Ann Gallagher (ed.), *Rachel Whiteread: Venice Biennale 1997*, exh. cat., The British Council, London 1997

Fiona Bradley, *Rachel Whiteread: Shedding Life*, exh. cat., Tate Gallery Liverpool 1996

James Lingwood (ed.), *Rachel Whiteread: House*, London 1995

Rachel Whiteread: Sculptures/Sculpturen, exh. cat., Kunsthalle Basel; ICA, Boston; ICA, Philadelphia 1994

Jan Debbaut (ed.), *Rachel Whiteread*, exh. cat., van Abbemuseum, Eindhoven 1993

David Batchelor, *Rachel Whiteread: Plaster Sculptures*, exh. cat., Karsten Schubert Ltd, London, and Luhring Augustine Gallery, New York 1993

Friedrich Meschede, *Rachel Whiteread: Gouachen – Gouaches*, exh. cat., DAAD Galerie, Berlin, 1993

Rachel Whiteread: Escultures, exh. cat., Sala Moncada de la Fundacio "la Caixa", Barcelona 1992

GLOBAL IMAGES
pages 89–136

p.89
Dona Z. Meilach, *Box Art: Assemblage and Construction*, Crown Publishing London 1973

p.90
Stanley Kubrick's Archive, Childwick, Hertfordshire
Photo by Stephen Gill

p.91
Cardboard impression, February 2005

p.92
Kunsthaus Bregenz, Austria

p.93
Smithfield Market, London EC1

pp.94–5
From Edward Denison and Richard Cawthray, *Packaging Prototypes*, RotoVision, Crans-Près-Céligny 1991

p.96
Robert Rauschenberg, *Reynolds Wrap (Cardboard)* 1971
Collection of the Artist

p.97
David Batchelor, *Wavelength* 2003
Private collection, London

p.98
Recycling depot

p.99
Ikea warehouse, London N18

p.99
Ikea warehouse, London N18

p.100
Margaret Morton, *Esteban and Ramón, The Tunnel, New York City* 1995

p.101
Trivandrum, Kerala, India 2005

p.102–3
Cardboard boxes stacked in a warehouse

p.104
Scott's cabin, Cape Evans, Ross Island, Antartica

p.105
Stanley Kubrick's Archive, Childwick, Hertfordshire. Photo by Stephen Gill (detail)

p.106
Crane loaded with boxes

p.107
Joseph Beuys, *Corner of Fat in a Cardboard Box* 1963. Stedelijk Museum, Amsterdam

p.108
Bosnian refugee camp, *c*.1995

186

p.109
HIV positive woman with her Memory Box, part of the Memory Box Project in Cape Town, South Africa

p.110
Labelling boxes of food, Amundson-Scott South Pole Station, Antarctica

p.110
Stacking Euros

p.111
Still from *Millions* (dir. Danny Boyle, 2005)
Courtesy of Pathé

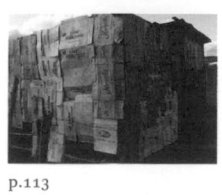
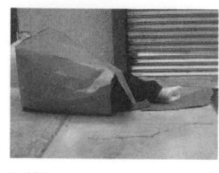

p.112 left
Cardboard shelter

p.112 right
Cardboard playhouse

p.113
Cardboard-box house, Managua, Nicaragua 1992

p.114
Homeless man asleep

p.115
From Francis Alÿs, *Ambulantes II* 1992–2003
Courtesy Lisson Gallery and the artist

p.116
The hiding place of
the sniper who killed
President Kennedy,
Texas School Book
Depository Building,
Dallas, 22 November
1963

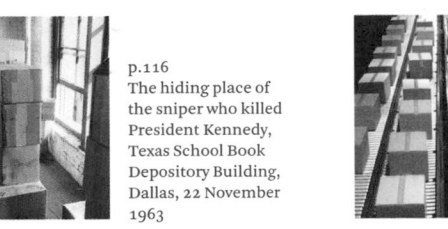

p.117
Warehouse
conveyor belt

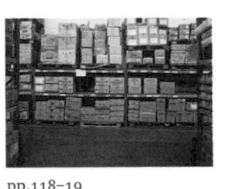

pp.118–19
Loon Fung warehouse, London N17

p.120
Warehouse

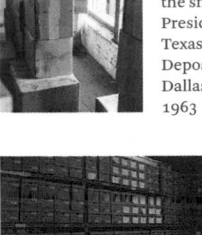

p.120
Warehouse

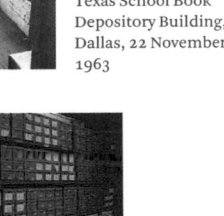

p.120
Warehouse

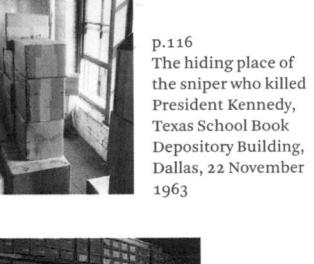

p.120
Warehouse

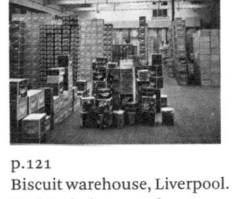

p.121
Biscuit warehouse, Liverpool.
Undated photograph

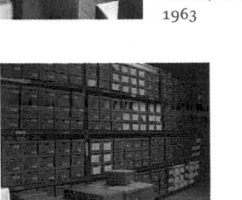

p.122
Found cardboard

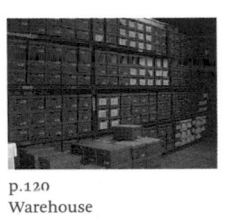

p.123
Cardboard coffins being loaded after mass
suicide among the Order of the Solar Temple
Sect, Granges-sur-Salvan, Switzerland, 1994

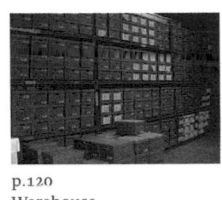

p.124
Boxes of books to
be unpacked at
the Guardian Hay
Festival, Hay-on-Wye
2005

p.125
Loon Fung warehouse,
London N17

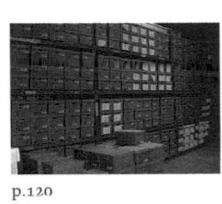

p.126
Thomas Demand, *Archive* 1995. Courtesy
of the Artist and Victoria Miro Gallery

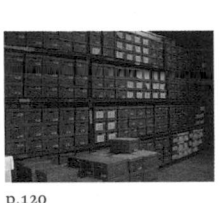

p.127
Still from *On the Waterfront*
(dir. Elia Kazan, 1954)

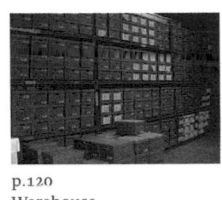

p.128
Santiago Sierra, *Workers who cannot be paid,
remunerated to remain inside cardboard boxes*,
Kunst-werke, Berlin, October 2000. Courtesy
of the Artist and Galerie Kilchmann, Zürich

p.129
Bird's Eye frozen foods factory.
Undated photograph

p.130
From John Burningham, *The Magic Bed*,
Jonathan Cape, London 2003

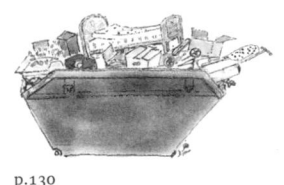

p.131
Still from *Raiders of the Lost Ark*
(dir. Steven Spielberg, 1981)

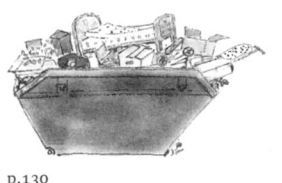

p.132
Cardboard boxes containing human
remains exhumed from the mass grave of
a civil war massacre, Salvador 1981

p.133
Kashmiri boy packing cherries into
a cardboard box, Srinagar, India

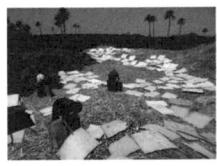

p.134
Drying the cardboard used to press
papyrus, Nile Delta

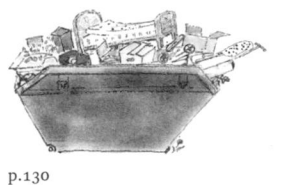

p.135
Still from *Citizen Kane*
(dir. Orson Wells, 1941)

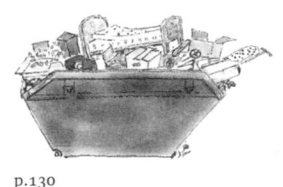

p.136
From Alexis Deacon, *Beegu*, Red Fox,
London 2004

PHOTOGRAPHY

pages 153 – 184

p.153
Gascoigne Place, London E2

p.154
Thames Path, London SE10

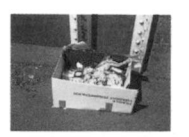

p.155
Pritchard's Road, London E2

p.156
Arnold Circus, London E2

p.157
Whitby Street, London E1

p.158
London E2

p.159
Brick Lane,
London E2

p.160
Berwick Street,
London W1

p.161
Bethnal Green
Road, London E1

p.162
Boundary Street, London E2

p.163
Shacklewell Street, London E2

p.164
Bethnal Green Road, London E2

p.165
Rhoda Street, London E2

p.166
Mercer Street, London WC2

p.167
Giudecca, Venice

p.168
Redchurch Street, London E2

p.169
Club Row, London E2

p.170
Borough Market,
London SE1

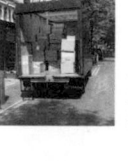

p.171
London E2

p.172
Eastmoor Street,
London SE7

p.173
Brick Lane,
London E2

p.174
Newlyn, Cornwall

p.175
Brick Lane, London E2

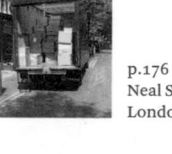

p.176
Neal Street,
London WC2

p.177
Columbia Road,
London E2

p.178
Recycling skip

p.179
London SE1

p.180
London SE7

188

p.181
Denmark Street, London WC2

p.182
Boundary Street, London E2

p.183
Arnold Circus, London E2

p.184
Giudecca Canal, Venice

CAPTIONS FOR ILLUSTRATIONS
ON PAGES 1–39

2 From Robert Foreman, *Architectural Models*,
 The Studio, London and New York 1946
4 Found cardboard
8 (clockwise from top left)
 Rachel Whiteread's studio; Bregenz, Austria;
 Rachel Whiteread's studio; Upper Woburn
 Place, London WC1
9 (clockwise from top left)
 From Tom Dixon, *Rethink*, photography by
 Ashley Cameron, Conran Octopus, London
 2002; polyethelyne prototypes; 'Cuboid
 Carton with Tuck-in Flaps', Edward Denison
 and Richard Cawthray, *Packaging Prototypes*,
 photography by Malcolm Robertson,
 Rotovision SA, Crans-Près-Céligny 1999
10–14 Rachel Whiteread's studio, May 2005
16 Aluminium die cast mould
17 LinPac factory, Corsham, Wiltshire
18 Rachel Whiteread's studio, May 2005
19 Polyethelyne prototypes, Rachel Whiteread's
 studio
20–23 Rachel Whiteread's studio, May 2005
24 The Sellotape box
34 From Philip J. Lawson, *Practical Perspective
 Drawing*, McGraw Hill, New York 1943
35 From G.R. Barnfield and T. Male, *Technical
 Drawing*, vol.1, The English Universities Press,
 London 1963
36–7 From Haresh Pathak, *Structural Package
 Designs*, The Pepin Press, Amsterdam 1999
 www.pepinpress.com
38 From E.T. Ellis, *Paperboard Packet and
 Cardboard Box Manufacture*, Crosby Lockwood,
 London 1931
39 From G.R. Barnfield and T.Male, *Technical
 Drawing*, vol.1, English Universities Press,
 London 1963

CAPTIONS FOR ILLUSTRATIONS
ON PAGES 82–87

82 Aerial view of Tate Modern on Bankside,
 London SE1
83 Installation in progress, Tate Modern,
 September 2005
84 From Raymond Carver, *Elephant and Other
 Stories*, Collins Harvill, London 1988
85 From John Steinbeck, *The Grapes of Wrath*
 (1939), Penguin Books, Harmondsworth 1951
86 From *Metro*, 26 April 2005
87 From George Cope and Phylis Morrison,
 The Further Adventures of Cardboard Carpentry,
 Workshop for Learning Things, Watertown,
 Massachusetts 1973

PHOTO AND COPYRIGHT CREDITS

8, 10–14, 18–24, 83, 93, 118–19, 170, 174 Andrew
 Dunkley and Marcus Leith, Tate Photography
8, 16, 17, 92, 99, 101, 153–7, 158, 159, 161–5, 167–9,
 171, 172, 173, 175, 177, 179, 180, 182–4, 192
 Rachel Whiteread
41–72 Marcus Leith, Tate Photography
89 © 1973 Dona Z. Meilach. Used by permission of
 Crown Publishing, an imprint of Random House,
 a division of Random House Inc.
90, 105 © Stephen Gill
94–5 © RotoVision / www.rotovision.com
96 © Robert Rauschenberg/VAGA, New York/DACS,
 London 2005. Photo: Courtesy of the artist
97 © The Artist. Photo: Courtesy of the Artist
100 © Margaret Morton 1995 from the series *The
 Tunnel*. Images courtesy of the Artist
102–3 © B.A.E. Inc./Alamy
104 © Rich Kirchner/NHPA
105 Courtesy Karina Leppik
106, 121 Courtesy of English Heritage
107 © DACS 2005. Photo: © Stedelijk Museum
 Amsterdam
108 © David Turnley/Corbis
109 © Gideon Mendel/Corbis
110, 112, 160, 166, 176, 178, 181 Philip Lewis
111 Courtesy of Pathé
113 © Network Photographers/Alamy
114 © Elvele Images/Alamy
115 Courtesy Lisson Gallery and the Artist
116, 129 © Bettmann/Corbis
117 © Lester Lefkowitz/Corbis
123 © Forestier Yves/Corbis Sygma
124, 146 © Alamy Images
125 Marcella Leith, Tate Photography
126 © DACS 2005. Photo: © Thomas Demand,
 VG Bild Kunst, Bonn
127, 131, 135 Courtesy of the BFI Archives
128 © The Artist. Courtesy of the Artist and Galerie
 Kilchmann, Zürich
130 © 2003 John Burningham. Used with permission
 of Alfred A. Knopf, an imprint of Random House
 Children's Books, a division of Random House, Inc.
132 © Reuters/Corbis. Photo: Luis Galdamez
133 © Fayazkahli/Reuters/Corbis
134 © Reza; Webistan/Corbis
136 © Alexis Deacon 2003. Used by permission of Red
 Fox, an imprint of Random House Children's Books,
 a division of Random House Group Ltd
146 'The Arrival of the Bee Box', from *Sylvia Plath:
 Collected Poems*, ed. Ted Hughes, Faber & Faber,
 London 1981
149 From the song 'Little Boxes'. Words and music by
 Malvina Reynolds. Copyright 1962 Schrodrer Music
 Co. (ASCAP) Renewed 1990. Used by permission.
 All rights reserved.
150–1 Extracts from Paul Auster, *Moon Palace*, Faber
 & Faber, London 1989
Cover: Based on a design from Haresh Pathak,
 Structural Package Designs, The Pepin Press,
 Amsterdam 1999 www.pepinpress.com

The Unilever Series
An annual art commission sponsored
by Unilever

Published by order of the Tate Trustees
On the occasion of the exhibition at
Tate Modern, London
11 October 2005–26 March 2006

This exhibition is the sixth commission in
The Unilever Series

With additional support from
Gagosian Gallery

Published 2005 by Tate Publishing,
a division of Tate Enterprises Ltd,
Millbank, London SW1P 4RG
www.tate.org.uk/publishing

© Tate 2005

All works by Rachel Whiteread © The artist

British Library Cataloguing in Publication Data
A catalogue record for this publication is
available from the British Library

ISBN 1 85437 571 7

Distributed in the United States and Canada
by Harry N. Abrams Inc., New York

Library of Congress Cataloguing in Publication Data
Library of Congress Control Number
2005933813

Designed by Philip Lewis
Printed and bound in Great Britain by
Balding + Mansell, Norwich

Supporting Tate

Tate relies on a large number of supporters – individuals, foundations, companies and public sector sources – to enable it to deliver its programmes of activities, both on and off its gallery sites. This support is essential in order to acquire works of art for the Collection, run education, outreach and exhibition programmes, care for the Collection in storage and enable art to be displayed, both digitally and physically, inside and outside Tate. Your donation will make a real difference and enable others to enjoy Tate and its Collection both now and in the future. There are a variety of ways in which you can help support Tate and also benefit as a UK or US taxpayer. Please contact us at:

The Development Office
Tate
Millbank
London SW1P 4RG

Tel 020 7887 8945
Fax 020 7887 8098

American Patrons of Tate
1285 6th Avenue (35th fl)
New York, NY 10019
USA

Tel 001 212 713 8497
Fax 001 212 713 8655

Donations

Donations, of whatever size, from individuals, companies and trusts are welcome, either to support particular areas of interest, or to contribute to general running costs.

Gifts of Shares

Since April 2000, we can accept gifts of quoted share and securities. These are not subject to capital gains tax. For higher rate taxpayers, a gift of shares saves income tax as well as capital gains tax. For further information please contact the Development Office.

Gift Aid

Through Gift Aid, you can provide significant additional revenue to Tate. Gift Aid applies to gifts of any size, whether regular or one-off, since we can claim back the tax on your charitable donation. Higher rate taxpayers are also able to claim additional personal tax relief. Contact us for further information and a Gift-Aid Declaration.

Legacies

A legacy to Tate may take the form of a residual share of an estate, a specific cash sum or item of property such as a work of art. Legacies to Tate are free of Inheritance Tax, and help to secure a strong future for the Collection and galleries.

Offers in lieu of tax

Inheritance Tax can be satisfied by transferring to the Government a work of art of outstanding importance. In this case the amount of tax is reduced, and it can be made a condition of the offer that the work of art is allocated to Tate. Please contact us for details.

Tate Annual Fund

A donation to the Annual Fund at Tate benefits a variety of projects throughout the organisation, from the development of new conservation techniques to education programmes for people of all ages and abilities.

American Patrons of Tate

American Patrons of Tate is an independent charity based in New York that supports the work of Tate in the United Kingdom. It receives full tax exempt status from the IRS under section 501(c)(3) allowing United States taxpayers to receive tax deductions on gifts towards annual membership programmes, exhibitions, scholarship and capital projects. For more information contact the American Patrons of Tate office.

Membership Programmes

Tate Members enjoy unlimited free admission throughout the year to all exhibitions at Tate Britain, Tate Liverpool, Tate Modern and Tate St Ives, as well as a number of other benefits such as exclusive use of our Members Rooms and a free annual subscription to Tate Etc.

Whilst enjoying the exclusive privileges of membership, you are also helping secure Tate's position at the very heart of British and modern art. Your support actively contributes to new purchases of important art, ensuring that the Tate's Collection continues to be relevant and comprehensive, as well as funding projects in London, Liverpool and St Ives that increase access and understanding for everyone.

Tate Patrons

Tate Patrons are people who share a strong enthusiasm for art and are committed to giving significant financial support to Tate on an annual basis. The Patrons support the Tate Collection, helping Tate acquire works from across its broad collecting remit: historic British art, modern international art and contemporary art. The scheme provides a forum for Patrons to share their interest in art and to exchange knowledge and information in an enjoyable environment. United States tax payers who wish to receive full tax exempt status from the IRS under Section 501 (c) (3) may want to pay through our American office. For more information on the scheme please contact the Patrons office.

Corporate Membership

Corporate Membership at Tate Modern, Tate Liverpool and Tate Britain offers companies opportunities for corporate entertaining and the chance for a wide variety of employee benefits. These include special private views, special access to paying exhibitions, out-of-hours visits and tours, invitations to VIP events and talks at members' offices.

Corporate Investment

Tate has developed a range of imaginative partnerships with the corporate sector, ranging from international interpretation and exhibition programmes to local outreach and staff development programmes. We are particularly known for high-profile business to business marketing initiatives and employee benefit packages. Please contact the Corporate Fundraising team for further details.

Charity Details

The Tate Gallery is an exempt charity; the Museums & Galleries Act 1992 added the Tate Gallery to the list of exempt charities defined in the 1960 Charities Act. Tate Members is a registered charity (number 313021). Tate Foundation is a registered charity (number 1085314).

TATE MODERN DONORS TO THE CAPITAL CAMPAIGN

Founders
The Arts Council of England
English Partnerships
The Millennium Commission

Founding Benefactors
Mr and Mrs James Brice
The Clore Duffield Foundation
Gilbert de Botton
Richard B. and Jeanne Donovan Fisher
Noam and Géraldine Gottesman
Anthony and Evelyn Jacobs
The Kresge Foundation
The Frank Lloyd Family Trusts
Ronald and Rita McAulay
The Monument Trust
Mori Building Co.Ltd
Peter and Eileen Norton, The Peter Norton
 Family Foundation
Maja Oeri and Hans Bodenmann
The Dr Mortimer and Theresa Sackler
 Foundation
Ruth and Stephan Schmidheiny
Mr and Mrs Charles Schwab
Peter Simon
London Borough of Southwark
The Starr Foundation
John Studzinski
The Weston Family
Poju and Anita Zabludowicz

Benefactors
Frances and John Bowes
Donald L Bryant Jr Family
Sir Harry and Lady Djanogly
Donald and Doris Fisher
Lydia and Manfred Gorvy
The Government Office for London
Mimi and Peter Haas
The Headley Trust
Mr and Mrs André Hoffmann
Pamela and C. Richard Kramlich

Major Donors
The Annenburg Foundation
The Baring Foundation
Ron Beller and Jennifer Moses
Alex and Angela Bernstein
Mr and Mrs Pontus Bonnier
Lauren and Mark Booth
Ivor Braka
Melva Bucksbaum
Edwin C. Cohen
Michel and Hélène David-Weill
English Heritage
Esmée Fairbairn Charitable Trust
Tate Friends
Bob and Kate Gavron
Giancarlo Giammetti
The Horace W.Goldsmith Foundation
The Government of Switzerland
Mr and Mrs Karpidas
Peter and Maria Kellner
Mr and Mrs Henry R Kravis
Irene and Hyman Kreitman
Catherine and Pierre Lagrange
Edward and Agnes Lee
Ruth and Stuart Lipton
James Mayor
The Mercers' Company
The Meyer Foundation
Guy and Marion Naggar
The Nyda and Oliver Prenn Foundation
The Rayne Foundation
John and Jill Ritblat
Barrie and Emmanuel Roman
Lord and Lady Rothschild
Belle Shenkman Estate
Hugh and Catherine Stevenson
David and Linda Supino
David and Emma Verey
Clodagh and Leslie Waddington
Robert and Felicity Waley-Cohen

Donors
The Asprey Family Charitable Foundation
Lord and Lady Attenborough
David and Janice Blackburn
Mr and Mrs Anthony Bloom
Mr and Mrs John Botts
The British Land Company PLC

Cazenove & Co.
The John S. Cohen Foundation
Sir Ronald and Sharon Cohen
Sadie Coles
Carole and Neville Conrad
Giles and Sonia Coode-Adams
Alan Cristea
Thomas Dane
Julia W Dayton
Pauline Denyer-Smith and Paul Smith
The Fishmongers' Company
The Foundation for Sports and the Arts
Alan Gibbs
Mr and Mrs Edward Gilhuly
Helyn and Ralph Goldenberg
The Worshipful Company of Goldsmiths
Pehr and Christina Gyllenhammar
Richard and Odile Grogan
The Worshipful Company of Haberdashers
Hanover Acceptances Limited
Jay Jopling
Howard and Lynda Karshan
Madeleine, Lady Kleinwort
Brian and Lesley Knox
The Lauder Foundation – Leonard and
 Evelyn Lauder Fund
Ronald and Jo Carole Lauder
Leathersellers' Company Charitable Fund
Lex Service Plc
Mr and Mrs Ulf G. Linden
Anders and Ulla Ljungh
Mr and Mrs George Loudon
Nick and Annette Mason
Viviane and James Mayor
Anthony and Deidre Montague
Sir Peter and Lady Osborne
Maureen Paley
William A. Palmer
Mr Frederik Paulsen
The Pet Shop Boys
David and Sophie Shalit
William Sieghart
Mr and Mrs Sven Skarendahl
Mr and Mrs Nicholas Stanley
The Jack Steinberg Charitable Trust
Carter and Mary Thacher
Insinger Townsley
The 29th May 1961 Charitable Trust
Dinah Verey
The Vintners' Company
Gordon D. Watson
Mr and Mrs Stephen Wilberding
Michael S. Wilson

and those donors who wish to
remain anonymous

TATE COLLECTION

Founders
Sir Henry Tate
Sir Joseph Duveen
Lord Duveen
The Clore Duffield Foundation
Heritage Lottery Fund
National Art Collections Fund

Founding Benefactors
Sir Edwin and Lady Manton
The Kreitman Foundation
The American Fund for the Tate Gallery
The Nomura Securities Co Ltd

Benefactors
Gilbert and Janet de Botton
The Deborah Loeb Brice Foundation
National Heritage Memorial Fund
Tate Patrons
Dr Mortimer and Theresa Sackler
 Foundation
Tate Members
The Mary Joy Thomson Bequest

Major Donors
Aviva plc
The Estate of Tom Bendhem
Edwin C Cohen
Lynn Forester de Rothschild
Antony Gormley
Noam and Geraldine Gottesman
Mr and Mrs Jonathan Green

The Leverhulme Trust
Hartley Neel
Richard Neel
Big Lottery Fund
Ophiuchus SA
Tate International Council

Donors
Abstract Select Limited
Acrewood Property Group plc
Howard and Roberta Ahmanson
Katherine Ashdown and Julian Cox
Lord and Lady Attenborough
Mr and Mrs A Ben-Haim
The Charlotte Bonham-Carter
 Charitable Trust
Louise Bourgeois
Melva Bucksbaum and Raymond Learsy
Veronica Borovik Khilcheskaya
Rattan Chadha
Mrs John Chandris
Ella Cisneros
Sir Ronald and Lady Cohen
Alastair Cookson & Vita Zaman
Danriss Property Corporation Plc
Dimitris Daskalopoulos
Mr and Mrs Guy Dellal
Mr and Mrs Doumar
Brooke Hayward Duchin
GABO TRUST for Sculpture Conservation
Kathy and Richard S. Fuld Jr
Natela Galogre
The Gapper Charitable Trust
The Getty Foundation
Mimi Floback
Mr and Mrs Koenraad Foulon
Mr and Mrs G Frering
Glenn R. Fuhrman
Liz Gerring and Kirk Radke
Zak and Candida Gertler
Marian Goodman
Judith and Richard Greer
Calouste Gulbenkian Foundation
Mimi and Peter Haas
Birgid and Richard Hanson
Stanley and Gail Hollander
HSBC Artscard
Leili and Johannes Huth
Angeliki Intzides
Lord and Lady Jacobs
Peter and Maria Kellner
Ellen Kern
C. Richard and Pamela Kramlich
Henry R. Kravis Foundation, Inc.
The Samuel H Kress Foundation
Leche Trust
Robert Lehman Foundation
Mr and Mrs Diamantis M Lemos
Richard Long
William Louis-Dreyfus
Brett and Laura Miller
Lucy Mitchell-Innes
The Henry Moore Foundation
Mary Moore
The Father John Munton Legacy
Guy and Marion Naggar
Friends of the Newfoundland Dog and
 Members of the Newfoundland Dog
 Club of America
Angela Nikolakopoulou
Peter and Eileen Norton, The Peter
 Norton Family Foundation
Outset Contemporary Art Fund
William Palmer
Yana and Stephen Peel
The Honorable Leon B and
 Mrs Cynthia Polsky
Karen and Eric Pulaski
The Radcliffe Trust
Mr and Mrs John Rafter
The Rayne Foundation
Julie and Don Reid
Joyce Reuben
Mr Simon Robertson
Barrie and Emmanuel Roman
Lord and Lady Rothschild
Ken Rowe
Mrs Jean Sainsbury
Claire and Nicola Savoretti
Debra and Dennis Scholl
Michael and Melanie Sherwood
 Charitable Foundation
Harvey S. Shipley Miller
Peter Simon

John A. Smith and Vicky Hughes
Mr and Mrs Ramez Sousou
The Foundation for Sports and the Arts
The Freda Mary Snadow Bequest
Stanley Foundation Limited
Kimberly and Tord Stallvik
David Teiger
Mr and Mrs A Alfred Taubman
Inna Vainshtock
Mr and Mrs Pyrros N Vardinoyannis
Andreas Waldburg-Wolfegg
Ziba and Pierre de Weck
Angela Westwater and David Meitus
Poju and Anita Zabludowicz
Shirly and Yigal Zilkha

and those donors who wish to remain
anonymous

TATE MODERN DONORS

Founding Benefactor
The Paul Hamlyn Foundation

Major Donors
The Deborah Loeb Brice Foundation
The Henry Luce Foundation
Tate International Council

Donors
The Annenberg Foundation
Arts Council England
Arts and Culture Foundation of
 North Rhine Westfalia
Chumsri and Luqman Arnold
Daniel Belin and Kate Ganz
Donald L Bryant Jr Family
Edwin C Cohen
Julia W Dayton
IPAC Plc
Institute for Foreign Cultural Relations
 Stuttgart
The Italian Ministry of Foreign Affairs
 and the Italian Cultural Institute
 in London
John Lyon's Charity
Stephen and Anna-Marie Kellen
London Arts
Robert and Mary Looker
The Henry Moore Foundation
Maurice S. Kanbar and the Murray and
 Isabella Rayburn Foundation
The Judith Rothschild Foundation
Thames and Hudson

and those donors who wish to remain
anonymous

TATE CORPORATE MEMBERS 2005

Tate Modern
Accenture
Britvic Soft Drinks Ltd
Aviva plc
BNP Paribas
Deutsche Bank
EDF Energy
Fidelity Investments International
Freshfields Bruckhaus Deringer
GLG Partners
HSBC
Lehman Brothers
Linklaters
Microsoft Limited
Pearson
UBS

TATE MODERN CORPORATE SUPPORTERS

FOUNDING SPONSORS

Bloomberg
Tate Modern Interpretation (2000–2006)

BT
Tate Modern: Collection (2000–2003)
Tate Online (2001–2006)

Ernst & Young
Tate Modern Visitor Centre (1997–2000)
Matisse Picasso (2002)

Unilever
The Unilever Series
(2000–2008)

BENEFACTOR SPONSORS

Aviva plc
*Century City: Art and Culture in the
 Modern Metropolis* as CGNU plc
 (2001)
Constantin Brancusi (2004)
Henri Rousseau (2005)

Egg Plc
Tate & Egg Live (2003)

The Guardian/The Observer
Media Sponsor for the Tate 2000 Launch
 (2000)
Media Partner for *Century City: Art and
 Culture in the Modern Metropolis*
 (2001)
Media Partner for *Warhol* (2002)
Media Partner for *Tate & Egg Live* (2003)
Media Partner for *Constantin Brancusi*
 (2004)
Media Partner for *Donald Judd* (2004)

HSBC
Frida Kahlo (2005)

Morgan Stanley
Surrealism: Desire Unbound (2001)

Tate & Lyle PLC
Tate Members (1991–2000)

MAJOR SPONSORS

American Airlines
Edward Hopper (2004)

Deutsche Börse Group
Robert Frank (2004)

Tate Members
Eva Hesse (2003)
Donald Judd (2004)
Luc Tuymans (2004)
August Strindberg (2005)
Jeff Wall (2005)

The Times
Media Partner for *Max Beckmann* (2003)
Media Partner for *Edward Hopper* (2004)
Media Partner for *Luc Tuymans* (2004)

UBS PaineWebber Inc
Office for the Tate American Fund
 (1999 onwards)
UBS
Warhol as UBS Warburg (2002)
*Cruel and Tender: The Real in the
 Twentieth Century Photograph* (2003)

SPONSORS

Lloyds of London
Community Partnership Programme
 (2001–2004)

The Daily Telegraph
Media Partner for *Time Zones* (2004)
Media Partner for *Robert Frank* (2004)

Swiss Re
Herzog & de Meuron (2005)

Varilux varifocals
Time Zones (2004)

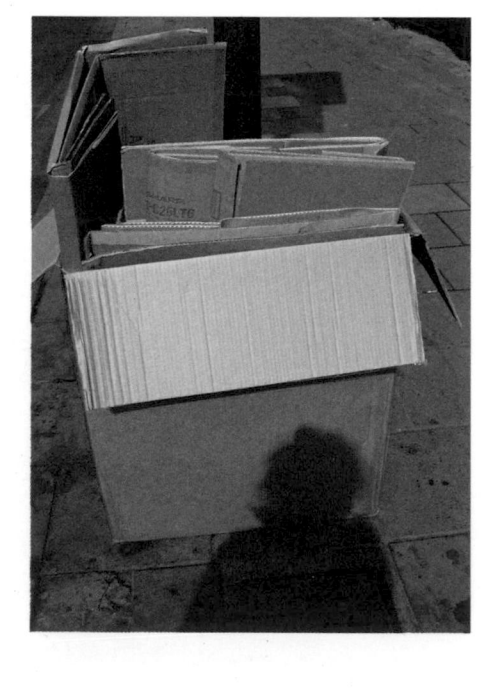

With thanks to Tate Modern – Nicholas Serota, Vicente Todolí and Sheena Wagstaff for agreeing to a vision, to Catherine Wood for her patience, to Phil Monk and Stephen Mellor for their coordination and logic, and to the technical team, Mark, Steve, Mary and Terry.

To Phil Brown, Paul Carter, Alex Dexter, Katy Dexter and Hazel Willis for their help in the studio and on the shop floor.

For the catalogue: to Gordon Burn for his painless interview, Marcus Leith for his help with photography, Philip Lewis for his design and Judith Severne at Tate Publishing.

To Cristina Colomar, Larry Gagosian, Robin Vousden and the staff at Gagosian Gallery, London.

To Claudia Altman-Siegel, Roland Augustine, Lawrence Luhring and the staff at Luhring Augustine Gallery, New York.

To LinPac for their production of the boxes.

To Unilever for their sponsorship.

Finally, with special thanks to Marcus and Connor for being at home, in my heart, and in my head.

A project as enormous as this always involves an arduous journey with the help and support of many. I hope I haven't left anyone behind.

Rachel Whiteread
London, September 2005